Wondrous Strange

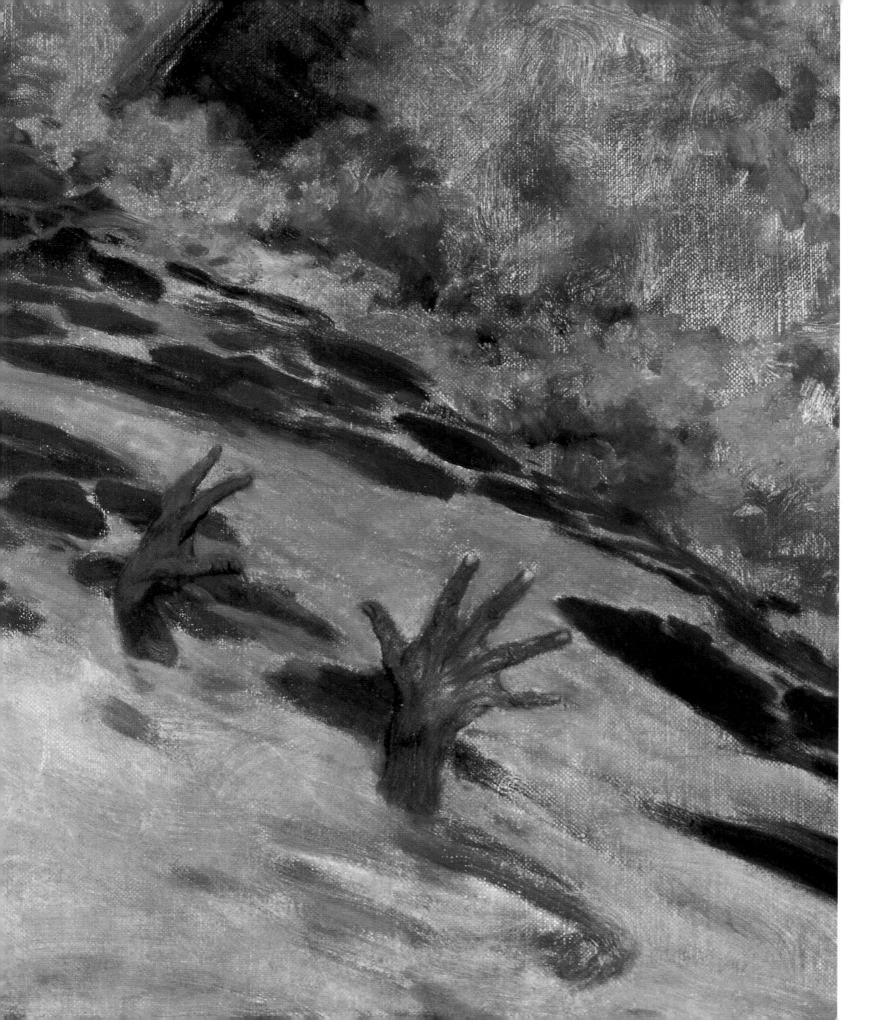

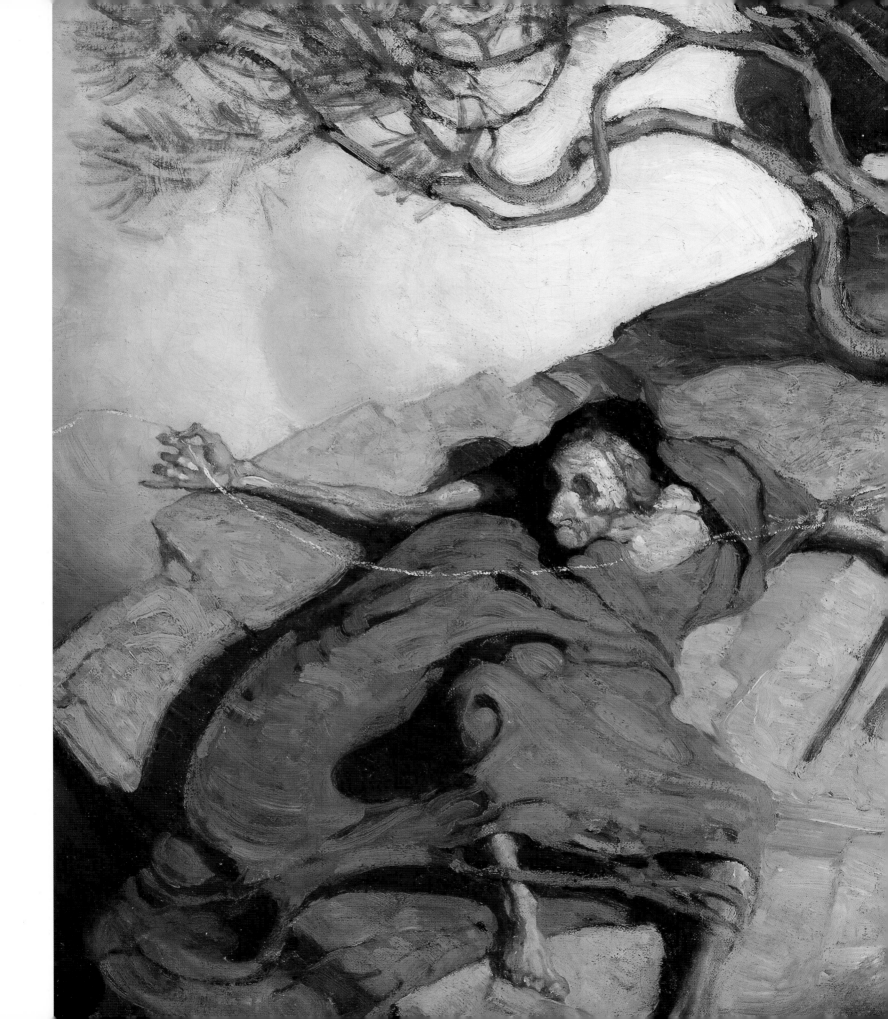

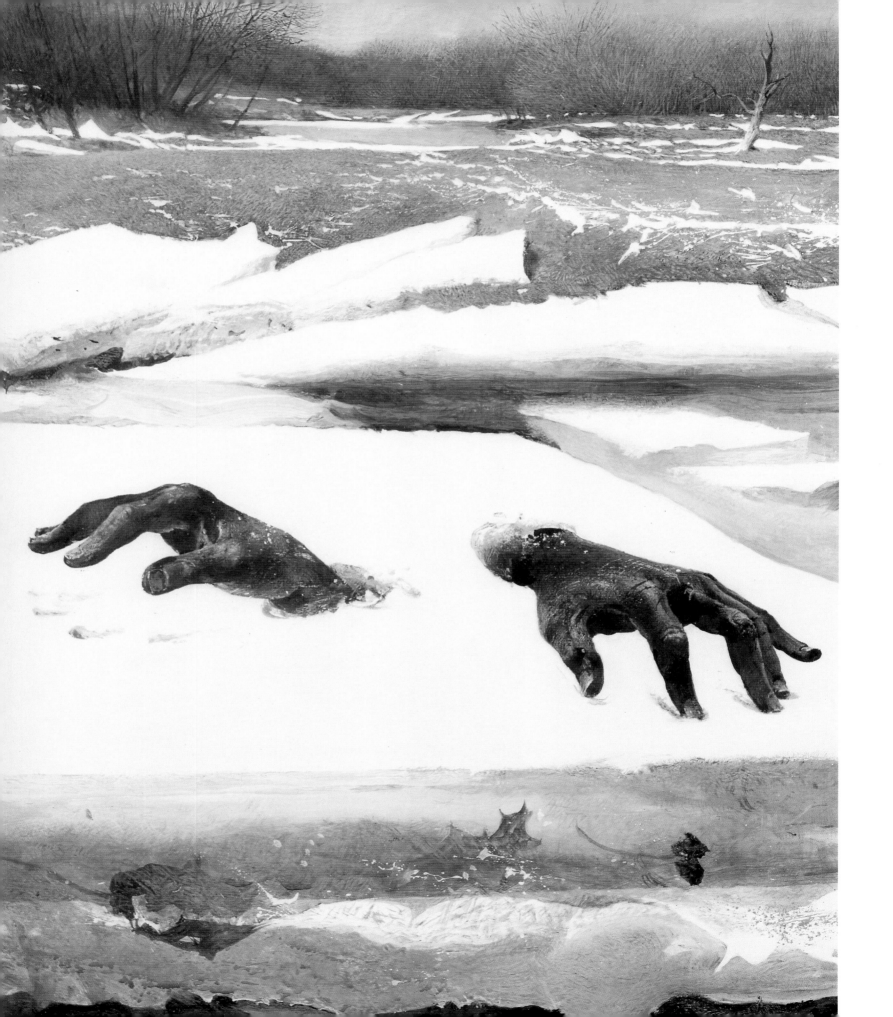

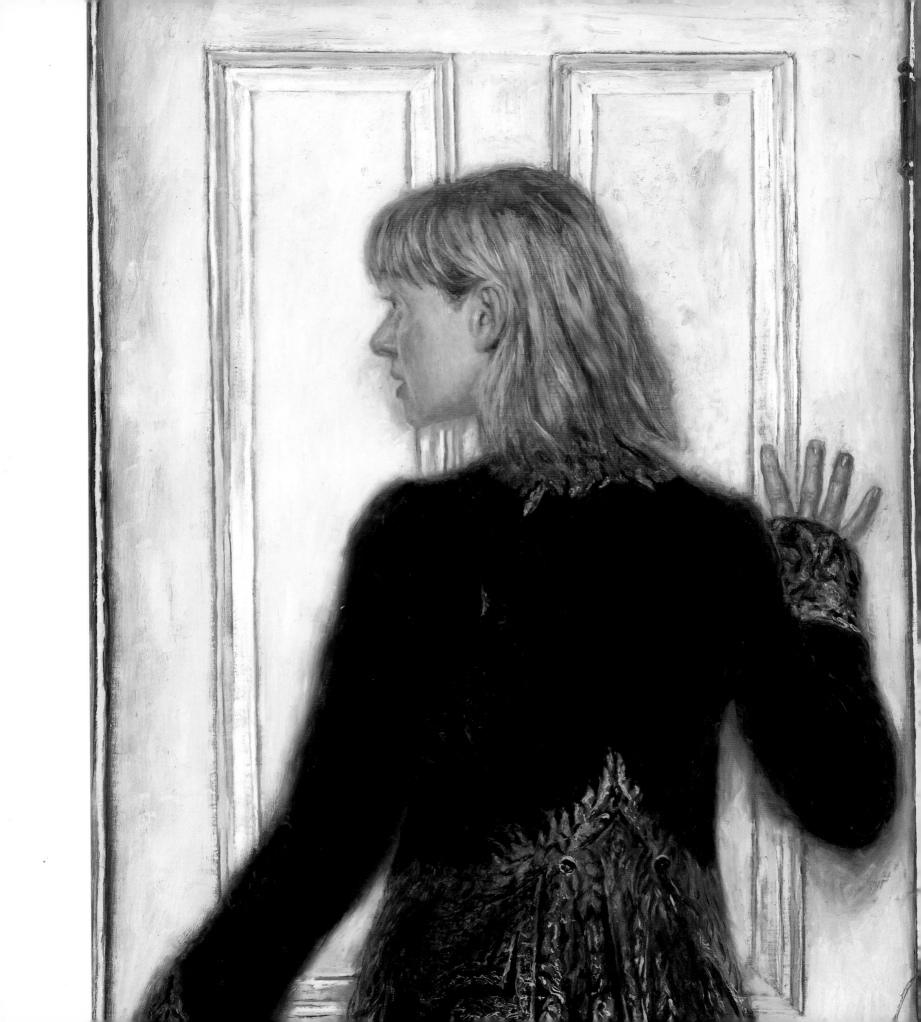

Wondrous Strange

The Wyeth Tradition

HOWARD PYLE N. C. WYETH ANDREW WYETH JAMES WYETH

Foreword by David Michaelis

Introduction by Susan C. Larsen

with Essays by Stephen T. Bruni, Betsy James Wyeth,

Theodore F. Wolff, and Christopher Crosman

A Bulfinch Press Book

Little, Brown and Company · Boston New York Toronto London

Published in association with the Delaware Art Museum and the Farnsworth Art Museum

This book has been published on the occasion of the exhibition *Wondrous Strange:*

Farnsworth Art Museum, Rockland, Maine

June 21–November 8, 1998

Delaware Art Museum, Wilmington, Delaware

December 10, 1998–February 21, 1999

The exhibition has received generous financial support from MBNA America,

DuPont Company, Hercules Incorporated, and Wilmington Trust Company.

First Edition

Bulfinch Press is an imprint and trademark of Little, Brown and Company (Inc.)
Published simultaneously in Canada by Little, Brown & Company (Canada)
Limited

Designed by Jean Wilcox
Printed and bound by Amilcare Pizzi, Milan, Italy

Library of Congress Cataloging-in-Publication Data

Wondrous strange : the Wyeth tradition — Howard Pyle, N. C. Wyeth,
Andrew Wyeth, James Wyeth.
 —1st p. cm. ed.
 Published to accompany an exhibition organized by Delaware Art Museum
and Farnsworth Art Museum.
 "Published in association with the Delaware Art Museum and the Farnsworth
Art Museum."
 "A Bulfinch Press book."
 ISBN 0-8212-2537-5 (hardcover) ISBN 0-8212-2536-7 (museum ed. pbk.)
 1. Pyle, Howard, 1853-1911—Influence—Exhibitions. 2. Wyeth family—
Exhibitions. I. Delaware Art Museum. II. William A. Farnsworth Library and
Art Museum.
ND237.P94A4 1998
759. 13—dc21 98-10910

Illustrations on opening pages:
page 2: Howard Pyle, *"The boat and I went by him with a rush"* (detail)
page 3: N. C. Wyeth, *The Hag of the Rock* (detail)
page 4: Andrew Wyeth, *Breakup* (detail)
page 5: James Wyeth, *Other Voices* (detail)
page 6: Howard Pyle, Andrew Wyeth, James Wyeth, and N. C. Wyeth (adapted
from an original photograph of Andrew and Jamie Wyeth by Michael Ahearn)

Contents

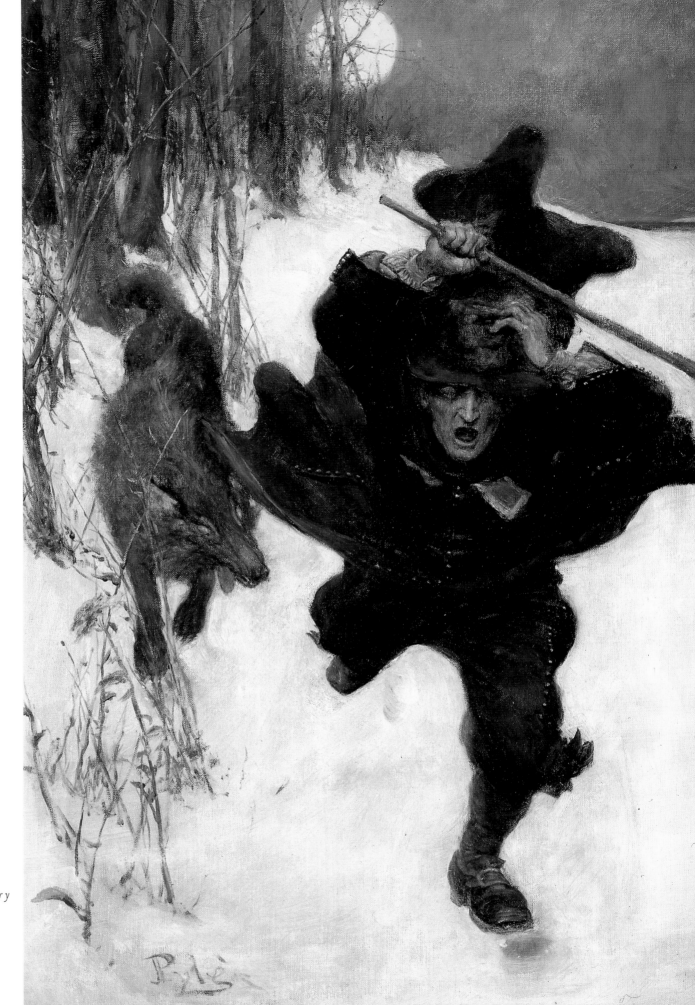

HOWARD PYLE
*"Once it chased
Dr. Wilkinson into the very
town itself,"* 1909

Foreword

David Michaelis

In 1902, at the age of twenty, N. C. Wyeth moved to Wilmington, Delaware, to study painting. One Saturday morning that October, he knocked on Howard Pyle's studio door. There, at 1305 Franklin Street, in student studios adjacent to his own, Pyle was offering a group of provincial young men and women a provincial setting in which to develop a wholly unconventional approach to painting.

Pyle taught picturemaking at a time when a single painted picture, reproduced through the miracle of photogravure printing, could reach into the lives of a million people all at once. Working alone in prosaic, un-wondrous Wilmington, Pyle had discovered that by deliberately merging his feelings with the external world of objects, he could produce pictures that brought American books and magazines alive. At his easel, Pyle "fought, sang, struggled, and sobbed through his work."

In the student studios, meanwhile, Pyle set before new arrivals not just cones and cubes and spheres to draw, but deep feelings to portray: love, joy, fear, hate. He taught the art of picturemaking as an act of self-projection. He tried "to enter *your* thinking mind," one student recalled, "whether it was your conscious or subconscious mind."

N. C. Wyeth would always believe that hypnotic powers had acted on him during his first interview with Pyle. Many other students later commented on the "great awakening power of Howard Pyle"—the way he would "unlock" their true character. The "master," as they called him, was thought to have extraordinary personal powers. His students openly idolized him, later

writing memoirs in which they cast Pyle as a godlike figure, a "grave, dignified George Washington," a "father to his flock." Over and over, these Parson Weems versions pay tribute not just to Pyle's instruction, but to his commanding presence and personal magnetism.

Pyle had an instinct for display. The ritual he made of checking in on his pupils in the course of a day showcased his grand manner to phenomenal effect. Wyeth would later endow these visitations with the mysterious aura of gospel events, cataloguing the sounds made by the master's approach: the "dull jar" of Pyle's studio door, the "slight after-rattle" of its brass knocker, the rustle of ivy as Pyle's tweed coat brushed past the vine-laced doorway, the "faint sound of his footsteps" approaching on the brick walk.

"And then, as we had hoped, our own door was opened and he entered in the dim light and sat among us."

Pyle would talk as the students sat with scraped palettes and dried-out fingers swabbed with turpentine. He pitched his voice in a soft, hushed, hypnotic register. He waited until full dusk to read aloud by kerosene lamp, lifting the raised wick to the pages of Emanuel Swedenborg's teachings. He never read too much, always left them wanting more. "Only too soon," Wyeth recounted, "he would say good night and leave us in the darkness."

The subject of *Wondrous Strange* proceeds from this very kind of visitation—the incarnation of the fantastic in everyday reality. A stranger has come; his knock on the door interrupts the

ordinary flow of life. Letting him into our lives, we realize that someone powerful and mysterious, perhaps godly, is in our midst, and nothing will be the same again.

Howard Pyle embodied a literary genre that both N. C. Wyeth and Jamie Wyeth would come to illustrate, the genre of the "mysterious stranger," in which a divine personage, incarnated as an ordinary man, visits a small village, breaking open the veneer of tranquillity in order to awaken the villagers to their inner selves. Examples of the form range from Balzac's story "Christ in Flanders" to Henri Alain-Fournier's romantic novel *The Wanderer (Le Grand Meaulnes)* to Betsy James Wyeth's tale *The Stray*, with drawings by Jamie Wyeth, in which the villagers of a valley town called "the Ford" must redraw the boundaries of their lives after a tough, clever, independent character named Lynch arrives one rainy day.

In Mark Twain's posthumous novel, *The Mysterious Stranger*, which N. C. Wyeth illustrated in 1916, the snow-covered village of Eseldorf is "a paradise for us boys," untouched by self-knowledge—until Satan's nephew invades the idyll. To the villagers he is known as Philip Traum (*Traum*, in German, means "dream"); for the narrator, Theodor, and his friends, the mysterious stranger functions as Howard Pyle did—as a spell-weaver. Traum illustrates the history of the world for the boys. He reads their minds, introduces them to feelings of rapture, to their own essential cruelty, and to their own fates. Like Pyle, he knows the boys better than they know themselves. Traum demonstrates for Theodor that there is no advantage to choosing among "several possible careers" or even to altering the choices of a life. One must accept oneself. The fatal mistake is fighting oneself.

When Howard Pyle died of Bright's disease on November 9, 1911, Wyeth was twenty-nine and still wrestling with Pyle's influence on his life. In death, Pyle remained a continuous presence.

One summer morning in 1939, a knock came on the door at the Wyeth household in Port Clyde, Maine. N. C. Wyeth, now fifty-six, answered the door. He found himself looking into the face of Howard Pyle—the same large head and wide-set eyes, the same straight nose and cavelike eye sockets. The man resembled his old teacher so exactly that Wyeth felt he might faint.

The man was Merle Davis James, editor of the rotogravure section of the Buffalo *Courier Express* and a painter himself. He had been urged to look up N. C. Wyeth by a mutual friend. James lived in East Aurora, New York, with his wife, Elizabeth (Browning), and three daughters, Louise, Gwendolyn, and Betsy. Until then, the Jameses had summered in a cottage across the St. George River on Muscongus Bay. That summer, the family had moved to an old saltwater farm in Cushing. James invited Wyeth to visit, but it was N.C.'s son Andrew who took James at his word, and the very next day—his twenty-second birthday—Andy went alone to Cushing. The James place was announced by a sign: M.D. JAMES, and Andy decided that James must therefore be a medical doctor. He knocked on the front door of the white clapboard farmhouse and asked for "Dr. James." The housekeeper, Anna, told Andy he had the wrong place—there was no doctor here—and started to close the door. Just then a young woman appeared.

Betsy James was seventeen years old. She had never heard of Andrew Wyeth. She knew little of N. C. Wyeth, less of Howard Pyle. But, as she wrote later, that "knock at the front door on July 12 changed my life forever." In under a year, she

would marry Andrew Wyeth and become the foremost (and most often misunderstood) influence in his work. Eventually, she would give birth to Nicholas Wyeth and Jamie Wyeth, edit the letters and papers of N. C. Wyeth, and become an authority on the work of Howard Pyle, N. C. Wyeth, and Andrew Wyeth.

Betsy James Wyeth is the one person in the world who could have created this exhibition. Her own life has forced her to come to terms, personally, through trial after trial, with each of these artists. The intensity of her relationship with all three Wyeths makes her the true linking figure in what has too often been simplified as a male succession, brushes handed down father-to-son across three generations. Dynastic patterns are understandably attractive to historians; the more so with the fathers and sons in this exhibition, each of whom as a young man looking for new territory in art was unafraid to owe artistic allegiance to the father, or fathers, who came before him.

But the work itself cannot be fit into a neat historical arrangement. The medium of painting—even narrative painting—defies chronological order. We experience paintings as we do dreams, in single, vividly felt scenes, only later applying a sequence to what we've seen. Unlike a film, in which a series of images develops the story, a painting must tell the whole story all at once, in a single frame.

The images in *Wondrous Strange* re-open our eyes not so much to scenes we know from life itself, but to the dreamlike collision of the fantastic and the real—*fantastic* in its Greek etymology, *phantastikos*, able to create and represent mental visions. This is the quality of wondrous strangeness that Betsy James Wyeth has identified in Howard Pyle, N. C. Wyeth, Andrew Wyeth, and Jamie Wyeth and in their relationships to one another. Seen together, their work side by side, each seems always to be thinking of things that he wishes he could tell the father or the son he has lost. These works are the versions of their lives which, if they could, they would tell one another in dreams.

ADAPTED FROM *N. C. WYETH: A BIOGRAPHY*, BY DAVID MICHAELIS, PUBLISHED BY ALFRED A. KNOPF, SEPTEMBER 1998.

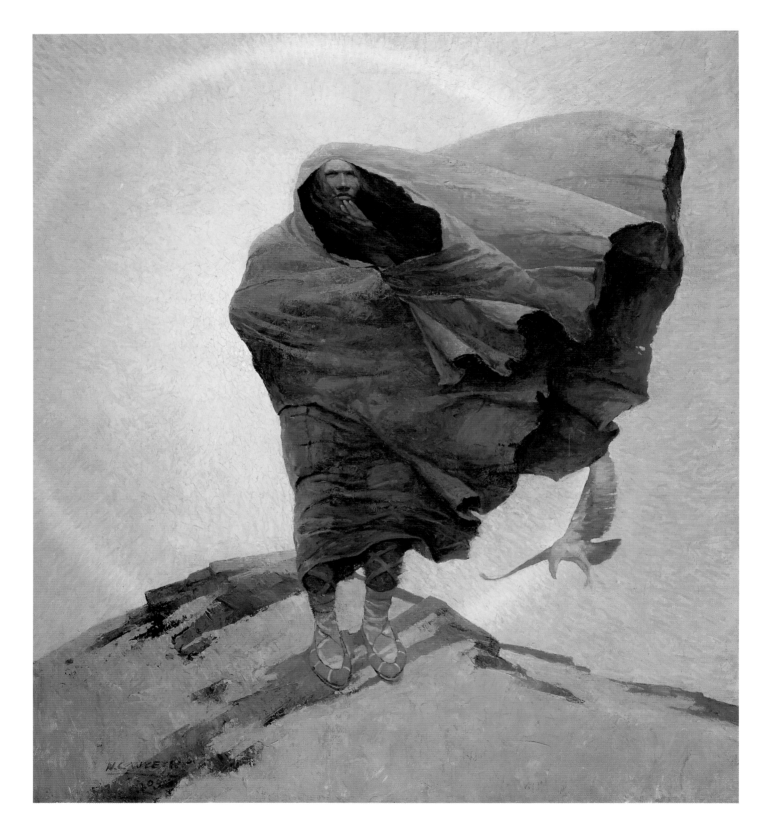

Winter ("Death"), 1909

Introduction

Susan C. Larsen

HORATIO: OH DAY AND NIGHT, BUT THIS IS WONDROUS STRANGE!

HAMLET: AND THEREFORE AS A STRANGER GIVE IT WELCOME

THERE ARE MORE THINGS IN HEAVEN AND EARTH, HORATIO,

THAN ARE DREAMT OF IN YOUR PHILOSOPHY.

—*HAMLET*, ACT I, SCENE 5

The paintings in this volume have a vivid and exciting tale to tell. It is full of literary flights of fancy, exotic adventure, spiritual journeys, romantic encounters, and childrens' fables played out on the stage of everyday life. It begins in the late nineteenth century in a time not unlike our own. In the aftermath of the Civil War, American life was transformed by many new industries, the popularization of photography, the coming of high-speed railroad service, the telegraph, and new nationally distributed magazines that encouraged higher levels of literacy across the nation. American households featured new varieties of consumer goods, including imported ones, but still relied upon the productivity and ingenuity of family members for essential foodstuffs, garments, and the underpinnings of cultural life.

One of the principal entertainments of the home was that of reading aloud from standard and popular classics of literature handed down in illustrated volumes and shared by an extended family circle. These were supplemented by popular publications, such as *Century*, *Collier's Weekly*, *Harper's Monthly*, and *Scribner's*, featuring a host of illustrators who reigned as important interpreters of texts in the years before and just after the photograph came into use as a primary source of imagery.

Children and adults read together, buoyed by novel and imaginative illustrations accompanying familiar stories, long before the coming of radio, the motion picture, and television would change this familiar social dynamic forever. American artists perfected their abilities to work in a vivid narrative and dramatic style. The creation of "storied pictures," as book and magazine illustration was called, offered not only steady work but also access to a vast and democratic audience spanning generations, geography, and social classes. Printing technologies changed rapidly, adding color, clarity, and new design possibilities to books and magazines. Artists responded to these new formats with ever more ambitious illustrations. Printed materials grew more affordable and available even as communities established an impressive array of public libraries across America. The great and enduring affection still widespread among the American public for artists like Howard Pyle, Harvey Dunn, Frank Schoonover, Thornton Oakley, and Elizabeth Shippen Green, and for N. C. Wyeth, Maxfield Parrish, and Jessie Wilcox Smith (all students of Pyle) and others, stands as an intriguing precedent for the almost universal popularity of visionary storytellers like Walt Disney, George Lucas, and Steven Spielberg in our own media age. During the golden age of magazine illustration, from the late 1880s until the end of World War I, the public's appetite for tales of action, adventure, horror, exotic travel, moral uplift, and romance was satisfied by illustrators of classics created to amaze and delight their audiences. The best of these artists found a domain of wonder within their own life experience and were

able to transmit something more than mere sensationalism. Spiritual and metaphysical subjects in literature offered artists an opportunity to connect the earthly realm with the domain of dreams and visions.

Principal among these artists was Howard Pyle, whose complex visual interpretations of literature did honor to the higher aspirations of his authors. He grew up as an avid reader of popular and classical literature, as well as folk tales. Pyle's parents eventually left their Quaker circle for that of the Swedenborgians, whose convictions concerning spiritual links between this life and the afterlife added to the young Pyle's ambition to depict spiritual dimensions in his art. In his mid-teens he went to Philadelphia to study with a Dutch-trained artist, F. A. Van der Weilen, who provided a practical course in the essentials of drawing, composition, and the handling of studio materials. Pyle's reading expanded greatly, ranging from the scientific and philosophical domain of Charles Darwin to the imaginative yet earthbound world of William Dean Howells.

Pyle grew up during and just after the Civil War and was prompted to retell and celebrate early American history, as were other artists of the period. His native Brandywine Valley provided a context for his imaginative reenactments of actual battles. He would go on to create images of the Revolutionary War, such as *The Fight on Lexington Common* (1898; pages 28–29).

Within Pyle's Wilmington community there existed a remarkable and useful storehouse of wonder and delight, the legendary Pre-Raphaelite collection assembled by Samuel Bancroft Jr. With both precision and imagination and a high degree of decorative craft, the English Pre-Raphaelites who flourished in the period 1848–60 were artistic and social revo-lutionaries who perfected an odd and unique style of romantic realism. Their values and stories could have been an inspiration to Pyle, who seems to share with the earlier brotherhood an interest in a return to medieval sensibilities.

Between 1887 and 1907, Pyle published a great many stories and illustrations of pirates in historical fact and fiction. Pyle featured Blackbeard, Captain Kidd, and Sinbad in their adventures on the high seas and in the Spanish colonies of the New World. These are tales of "bold and lawless deeds" generally featuring youthful protagonists who learn of the world through perilous, exciting, and even brutal adventures. In these, Pyle's mastery of lighting, costume, staging, and pictorial narrative demonstrate his natural gifts as a dramatist.

Works such as *Marooned* (1909; pages 54–55) offer a break in the action for a moment of desperate introspection. *The Mermaid* (1909; page 53) in its exotic romantic languor reveals a tale of love and loss in a moment of ecstatic reverie. Many a reader found his or her own taste for adventure and romance stimulated by these well-told tales. Few readers would object to these violent, visionary, horrifying, and exotic events as long as they existed safely within the pages of a book or magazine.

The unique character of Howard Pyle's work as an artist was beautifully characterized by his longtime editor H. M. Alden: "His work as author and artist was, for us all, and a good part of it especially for youth, a fresh revival of the Romantic. Though it occupied the field of wonder, it had no Rossetti-like transfiguration and exaltation, no vagueness. Without any loss of the wonder his meanings were plain." [1] Pyle often pointed out that the root meaning of the word "illustration" was "to make clear."

A hallmark of Pyle's character was his need to teach and share his thoughts and techniques with young students. While enjoying the role of teacher, he became increasingly selective and practical. A mass audience enjoyed his steady stream of images and stories, but few of his readers, students, or colleagues had any idea how they came into being. Growing tired of the rituals of the classroom, Pyle resigned his position as professor in 1900 and established his own Howard Pyle School of Art in Wilmington with a summer school in Chadds Ford, Pennsylvania, already begun in the summer of 1898. N. C. Wyeth joined Pyle's school in October of 1902 and was immediately struck by Pyle's electrifying personality and his imaginative gifts. Fellow student Thornton Oakley recalled of Pyle, "He spoke of the underlying spirituality of the subject. We were told to throw ourselves into the subject we have chosen heart and soul."[2] Oakley's commentary on fellow classmate N. C. Wyeth is equally vivid: "No more exuberant personality have I ever known, none more bubbling with the ecstasy of living. Of powerful frame he was, of arm length extraordinary. His was an eager, searching spirit, a spectacular career, one full of color, color figurative and color actual."[3] N. C. Wyeth loved Howard Pyle's chilling image of raw New England country terror in a winter landscape of the Salem Wolf and Dr. Wilkinson (1909; page 10). Wyeth's own Winter ("Death") (page 14), from the same year, has a very different character. It is monumental, supremely quiet, centered, elemental. From the outset, N. C. Wyeth's illustrations had a commanding presence, a feeling for the riveting gaze of the viewer.

Blind Pew (1911; page 62), a scene from Robert Louis Stevenson's Treasure Island, is one of seventeen illustrations Wyeth created for the book issued by Scribner's. We are placed directly in the pathway of the old blind man, who is seized with terror as though our very presence might be the cause of his alarm. The theatrical nature of Howard Pyle's compositions often demanded the presence of multiple figures like many players on a vast stage. N. C. Wyeth's genius as an illustrator arises from quite another turn of mind. Wyeth compresses action into a controlled, delimited space defined by detail, color, and implied scale. He focuses the action upon a few figures who tell his story with gestures, facial expressions, and rippling outlines defined by dramatic lights and darks. The viewer is brought close to the action, often face to face. N. C. Wyeth has made the printed page the true setting of his story. The Giant (1923; page 87), a tour-de-force of imaginative projection, makes real the child's sense of wonder at nature as it celebrates the human power of fantasy emerging out of reality. It is interesting to learn that N. C. Wyeth turned down assignments when a work of literature found no resonance within his own spirit, as he did when he refused to illustrate Jules Verne's great sea epic, Twenty Thousand Leagues Under the Sea, because he felt he had already captured the undersea character of Captain Nemo in one of his illustrations for The Mysterious Island.

N. C. Wyeth's son, Andrew Wyeth, began his own career in the 1930s. The familiar strengths of his father's work served Andrew Wyeth very well in those early years, but the younger Wyeth made the important decision to go his own way, that of the painter who creates his artistic world out of his own primary experiences. Christmas Morning (1944; page 100) takes the viewer into a metaphysical realm as the young Wyeth meditates on the death of a family friend, presenting it as a trancelike

journey along a fluid path to a vanishing point only partly seen. Dawn becomes a metaphor for death and loss while its unearthly shimmering light suggests the hope of spiritual continuity.

Out of the phosphorescent light of *Night Hauling* (1944; page 111) we are startled to uncover the outline of Wyeth's boyhood friend Walter Anderson hauling traps out of a bay in Maine in the midst of the night. This elegantly mysterious picture speaks eloquently of Wyeth's fascination with his friend's lawless daring, his odd courage, his recklessness. It is indeed a "storied picture" but not in the old sense. Wyeth has found his subject in the midst of his own personal world. The saga of Walter Anderson would occupy the artist right up to the final moment of his friend's life, interpreted in the great painting *Adrift* (page 118) of 1982. Although Anderson did not die on the sea, he lived in and on the sea. His spirit finds its true home in this odd and beautiful image of Walt as an old man, asleep, adrift, perhaps dead, like a warrior sent out to sea for the final time.

Dreamlike and ghostly is the artist's own image in *The Revenant* (page 101) of 1949, meaning one who returns from death or after a long absence. It has a quicksilver quality about it, something truthful to those moments when we catch a glimpse of ourselves in a dusty mirror, in the reflection from a shop window, the glint of recognition in a friend's smile.

Admirers who characterize Andrew Wyeth as a painter of calm certainties miss the odd, willful, and marvelous incongruities lying in wait within the best of his work. The majestic *Night Sleeper* (1979; page 96) proposes a host of riddles. Wyeth's mill in Chadds Ford, Pennsylvania, is etched by moonlight while his beloved dog Nel sleeps in a nearby building. A silvery river cuts through a seemingly discontinuous landscape on the right-hand side. Nel's world can be seen through the two windows, perhaps also the terrain of her dreams. These two views of the Wyeths' property seem like separate realities, surreal and complete in themselves. Strangest of all is the architecture of the panel itself, its big, bold geometric divisions and strong contrasts separating three elements of Wyeth's intimate world yet also holding them together.

Although celebrated as a great American realist, Andrew Wyeth has generally offered mystery rather than certainty in his art. The power of the unseen at work in nature and in human life gives his art its power and unique presence. *Omen* (1997; page 123) was created during the spring, when a great comet appeared in the night sky. It happened to coincide with the year of the artist's eightieth birthday. Many people commented upon their strong emotional reaction to the comet's nightly appearance, using terms like elemental, wondrous, awe-inspiring. Clearly, like his father, N. C. Wyeth, Andrew has sought and found certain strategies to communicate with a broad, now international audience. That audience has the opportunity to go deep into his art, to find the elusive spirit that has animated these exquisite panels from the outset of this artist's adventure.

From the start of his career, Andrew Wyeth has been very much aware of those things that endure and those that pass away. His is an art which does not dwell upon itself or upon topical issues of the day, but one that ponders elemental, timeless moments of wonder in the presence of nature. Wyeth's regard for nature includes human beings, their actions, qualities of mind, and outward appearance.

Like his father, James Wyeth understands the uniqueness of human beings and the unspoken mystery of individual personalities. His sense of drama is instinctive and often reminiscent of the complex staging of Howard Pyle or the dramatic com-

pressed images of James's grandfather, N. C. Wyeth. The sharp features of a Maine youth, Orca Bates, lend a bit of severity to portraits such as *Orca* (1990; page 139), where the boy stands squarely in the midst of whaling implements, oddly congruent with the dark forms of harpoons, marine prods, and trident. *The Wanderer* (1992; page 154) is a softer, more poetic vision of Orca hovering at water's edge looking at a distant town. In *Screen Door to the Sea* (1994; page 134), the young man confronts the viewer, illuminated by emotion, silhouetted in the opening of a screen door while the sea swirls outside, darkly through the screen and blue with sunlight where the doorway opens. We are once again confronting a "storied picture" but are asked to consider the meaning of this story using the experience of the painting. Are we standing in darkness or daylight? Are we looking at the present moment or witnessing a phantom of long ago? How much of ourselves do we bring forward from one stage of life into another?

Unique to James Wyeth are his highly original and purposeful paintings of animals. They have power of personality, a place in the arrangements between man and nature, and a mysterious hold upon the human imagination. *Portrait of Lady* (1968; page 153) places us face-to-face with a black-faced sheep whose woolly coat shines like a backlit mass of gold. Decades later, the sober gentle face of a shorn sheep in *Brandywine Raceway* (1989; page 152), the horizon illuminated by the light from a distant racetrack, quietly speaks volumes about the vicissitudes of life borne by animals in our midst. James Wyeth has lived much of his life in the countryside and knows the ways of farmers' and his own livestock. If we see these subjects' images as disturbing or strange, perhaps it is because we have seldom considered such life all around us or find it painful to contemplate their

lives and fate. Like his father, who has often treated death in the midst of life and looked squarely at hardship without sentimentality, James Wyeth evidences a rare sensitivity to a wide range of creatures.

Living at the water's edge, on an island and at times isolated by weather and tides, James Wyeth has a grudging fondness for the ravens, gulls, and crows that stop along their routes for food, rest, and even amusement. *The Rookery* (1977; page 149) depicts a wild place where man's intrusion is not appreciated. At other times, the activities of birds parallel those of humans, as in *Gull's Egg* (1988; page 148), featuring a raven surreptitiously approaching the nest of a gull to steal its precious egg.

What can we make of this perennial fascination of the Wyeths for things known without seeing, things beautifully seen but never completely known? They have, as a family of artists, held on to an American legacy from the previous century, an awareness of transcendental moments in the midst of everyday life. So much in twentieth-century urban America conspires against such awareness, yet it is so fundamental to American intellectual and spiritual traditions. Perhaps that is why this art continues to fascinate and enjoy the admiration of its wide audience. We might well suggest to those who choose to dwell in a world without wonder, "There are more things in heaven and earth . . . than are dreamt of in your philosophy."

1. Henry M. Alden, "A Tribute," *Harper's Monthly Magazine*, 124, no. 1240 (January 1912), p. 256.
2. Thornton Oakley, "Conversation with Richard Lykes, October 22, 1946," quoted in Richard Lykes, "Howard Pyle, Teacher of Illustration," *Pennsylvania Magazine of History and Biography*, 80 (July 1956), p. 358.
3. Thornton Oakley, "Remarks on Illustration and Pennsylvania's Contributions to its Golden Age," in *Pennsylvania Magazine of History and Biography*, 71 (January 1947), p. 10.

Howard Pyle

Essay by Stephen T. Bruni

DO YOU KNOW AN AMERICAN MAGAZINE 'HARPERS MONTHLY'? THERE ARE WONDERFUL SKETCHES IN IT, WHICH STRIKE ME DUMB WITH ADMIRATION, AMONG OTHERS . . . SKETCHES FROM A QUAKER TOWN IN THE OLDEN DAYS, BY HOWARD PYLE. I AM FULL OF NEW PLEASURE, BECAUSE I HAVE NEW HOPE OF MAKING THINGS MYSELF THAT HAVE SOUL IN THEM.

—VINCENT VAN GOGH

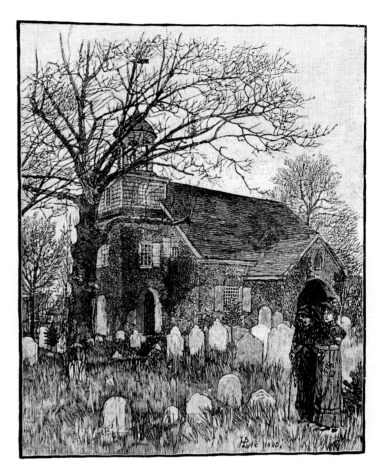

HOWARD PYLE. Illustration from "Old Time Life in a Quaker Town." *Harper's Monthly Magazine*, January 1881.

Could it have been that Vincent van Gogh, in a letter to his brother Theo, saw something in Pyle's sketches that struck a chord with his own struggle to imbue the real world with a truly imaginative expression, one capable of transporting the viewer to a land far more wondrous strange? Or is it simply coincidence that he expresses his admiration for an unfamiliar artist in words that mirror the sentiments of the many Pyle students who cherished their time with "the Father of American Illustration"? As Maxfield Parrish, one of the many who sought out Pyle for his talent and aura, commented: "It is not so much the actual things that he taught us as contact with his personality that really counted. Somehow, after a talk with him you felt inspired to go out and do great things, and wondered by what magic he did it."

Howard Pyle had an unrivaled ability to inspire all who came in contact with him or his art to delve more deeply into their own consciousness, to find that "other awareness" that enlightens and enlivens our being. No better example exists than the three generations of Wyeths whose artistic output maintains an uncanny allegiance to challenging the mind's eye to see that which is not readily apparent in a conventional view of the tangible landscape before us. For N. C., Andrew, and Jamie Wyeth, it is the act of manipulating the comfortable and logical into a more provocative and mysterious experience that ties them to "the master."

Born in 1853, the same year as van Gogh, Pyle spent his youth in a world unencumbered by radio, television, movies, or the Internet. Through the sheer rapture of listening to his mother reading aloud from Dickens, Hawthorne, Thackeray, Shakespeare, and Milton, he eventually came to realize that imagination was the all-important key to unleashing a proliferation of visual literacy in an educated, though image-starved, audience. While deeply rooted in the practical approach to life dictated by a devout Quaker and, later, Swedenborgian upbringing, Pyle's romantic, emotional, and extroverted sensibilities stood in stark contrast to ancestral conventions. The very same "nose to the grindstone" ethic that he would respectfully defy informed his lifelong allegiance to perfecting a balance between the dexterity of the hand and the cultivation of the mind and spirit. He demanded of himself and his protégés an unrelenting dedication to precision in draftsmanship and loyalty to fact. Without these elemental prerequisites the imagination and spirit would fail to capture the viewer. Pyle carried this insatiable appetite for perfection through to his untimely death in Florence in 1911, where he had traveled to experience the mural techniques of the Italian masters that he so admired.

Now, eighty-seven years hence, *Wondrous Strange* offers us the opportunity to understand the immense impact that Pyle had on both his turn-of-the-century followers and on the three generations of American artists—N. C., Andrew, and Jamie Wyeth—who have perpetuated his ideals. It is paramount that we give our main attention to the images reproduced in this volume, for it is the pictorial product that excites us and remains in our collective memories. Pyle's illustration of the Salem Wolf and Dr. Wilkinson (1909; page 10), N.C.'s *Blind Pew* (1911; page 62), Andrew's *Spring* (1977; pages 108–109), and Jamie's *Meteor Shower* (1993; pages 156–157) require no more than close visual observation and a lack of preconceived notion to understand what Mark Twain must have felt when he wrote to Pyle after seeing the Round Table series: "They were never so finely told in prose before. And then the pictures—one can never tire of examining them and studying them."

Unique among his contemporaries, Pyle provided access for viewers to play a role within the unfolding drama rather than positioning them as trespassing voyeurs. Imagine, for a moment, the excitement one must have felt at the very end of the nineteenth century to be invited or, in the case of Pyle's *Fight on Lexington Common* (1898; pages 28–29), recruited into the militia to witness a truly historic moment. In the relative distance we can hear the crack of a deadly British volley, but the smoke obscures a clear view of the enemy. At first glance, we may be out of harm's way. Fortunately, the figure to our far left warns of the oncoming flank just to the right and now slightly behind us as he lifts his rifle to cover our position. One lone and obviously young militiaman quickly retreats to reload, but at that very moment he is frozen at center stage, astonished to find us foolishly standing there. As if in a bad dream, we are unarmed, unable to defend ourselves. Now one hundred years later, we have comparatively "low-tech" virtual reality to replace our imagination.

Pyle was obviously fascinated by the romance and adventure of historic events, which he painstakingly researched for fact and accuracy. But his most passionate preoccupation was with the lore of the pirate, inspired, no doubt, by his many family excursions to the Delaware shore, which he ardently

documented in photographs. The scoundrels of the open seas were inexhaustible fodder for an imagination run wild, and it is here that Pyle created his most lasting images. Could the stardom of Douglas Fairbanks or Errol Flynn have ever existed if not for Pyle's (and later N. C. Wyeth's) contributions to the notion of adventure? It is interesting that Steven Spielberg drew directly from Pyle in his making of the movie *The Goonies* (1985). A contemporary story of children caught up in the search for pirate treasure, the movie opens with the unfolding of a dusty manuscript illustrated with Pyle's *"So the treasure was divided"* (1905; pages 44–45) as a harbinger of the fantasy to follow.

Howard Pyle and his imagination live on, but like Maxfield Parrish, we too must wonder "by what magic he did it." Perhaps his own words give the answer:

"If my characters really live it is only because they are somewhat true to humanity as seen obscurely through my green glass spectacles of fancy."

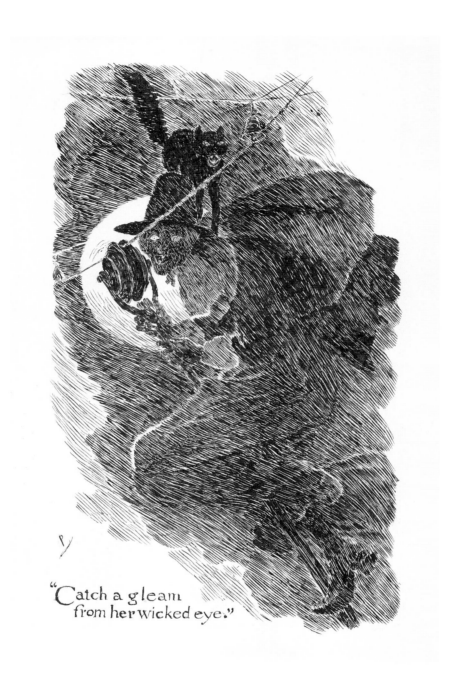

"Catch a gleam
from her wicked eye."

HOWARD PYLE
"Catch a gleam from her wicked eye,"
1892

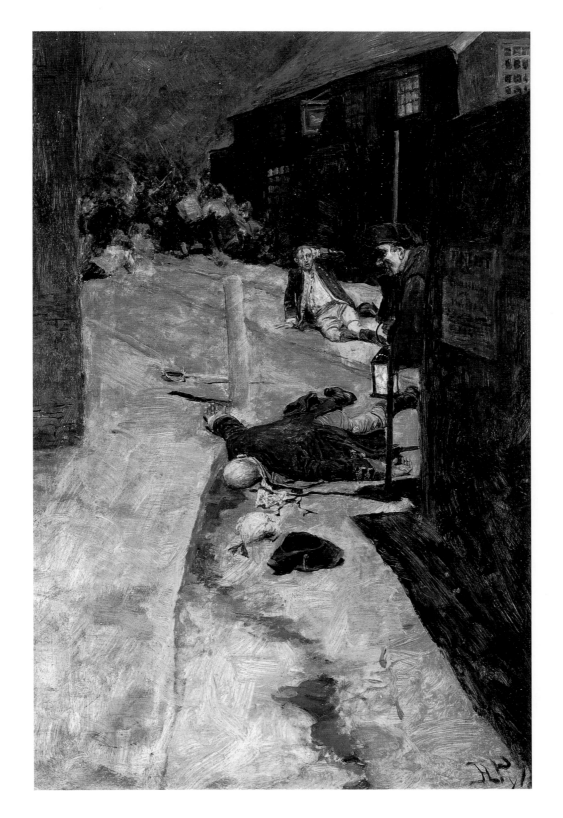

HOWARD PYLE
*"Barbarously murdered the first, and
grievously wounded the latter,"* 1895

[25]

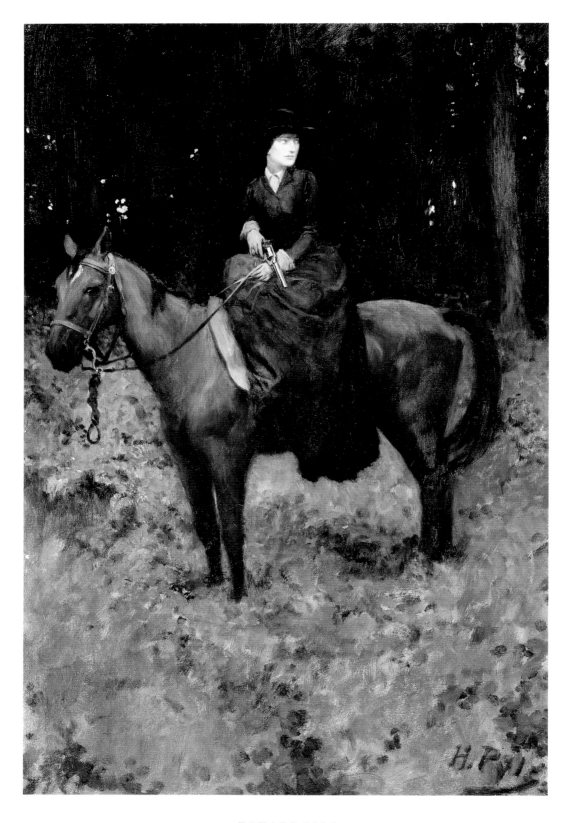

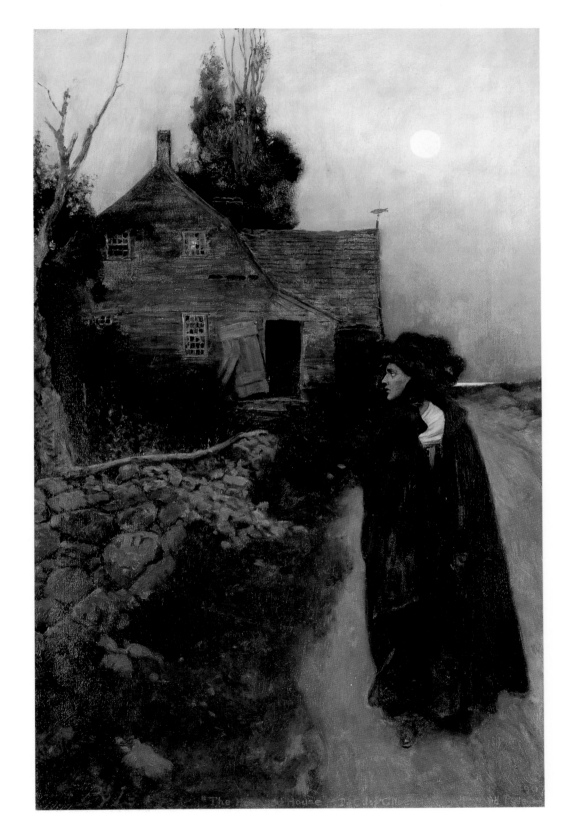

"Catherine Duke quickened her steps," 1904

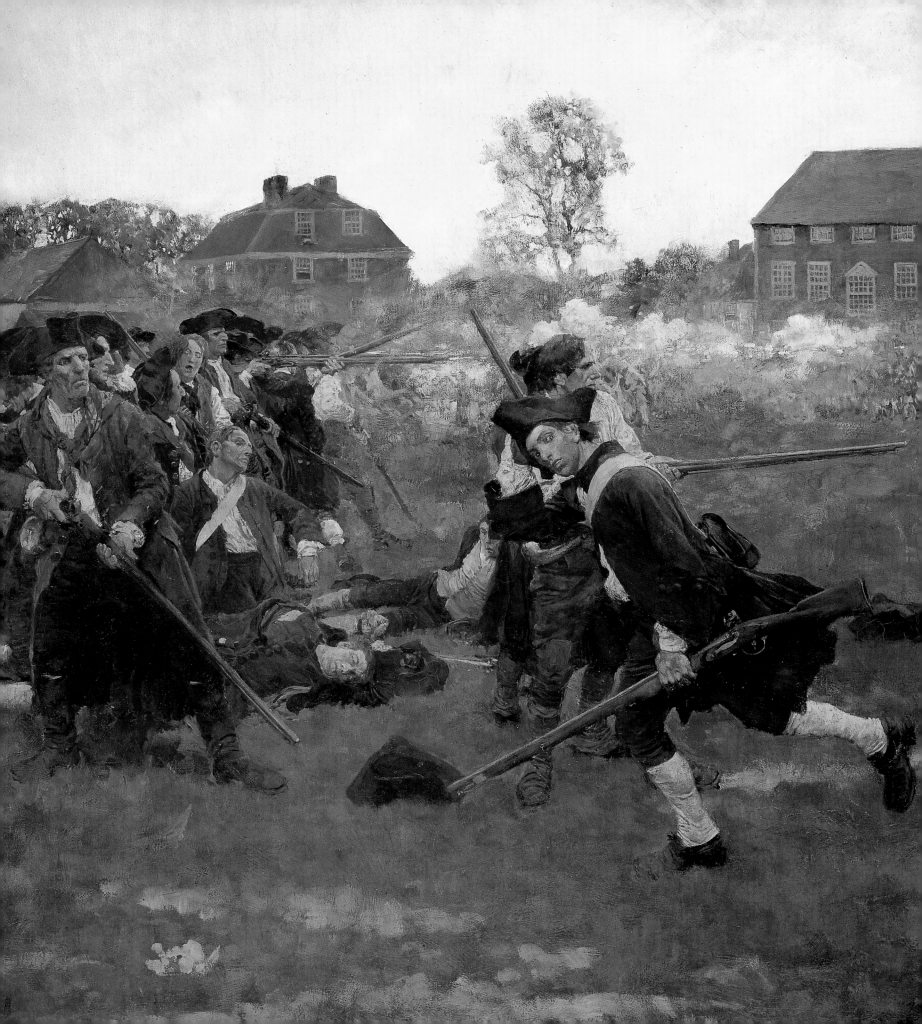

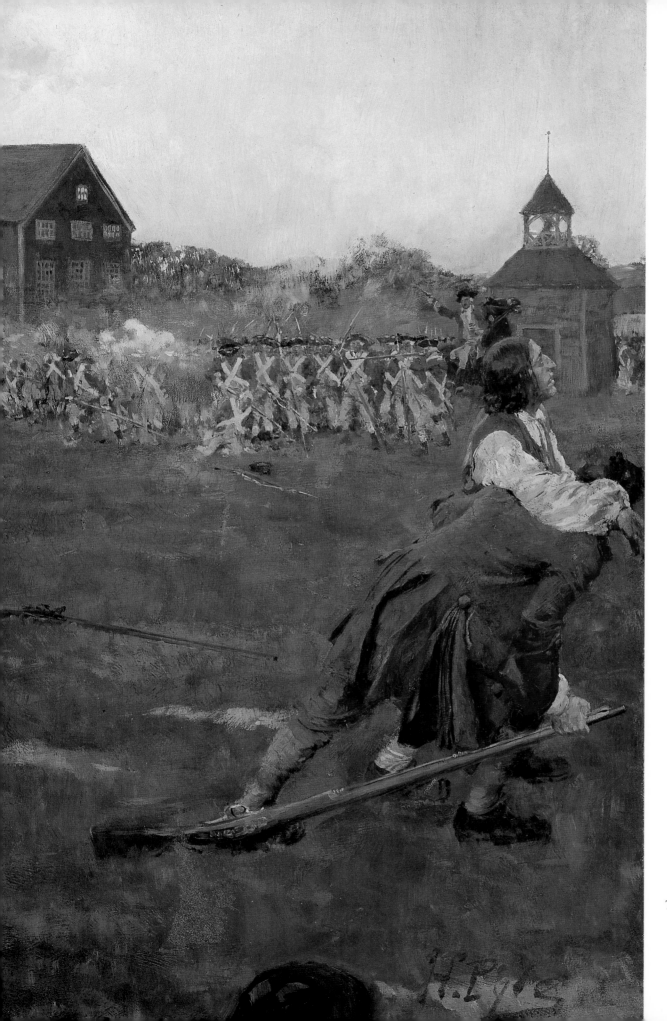

HOWARD PYLE

The Fight on Lexington Common,
1898

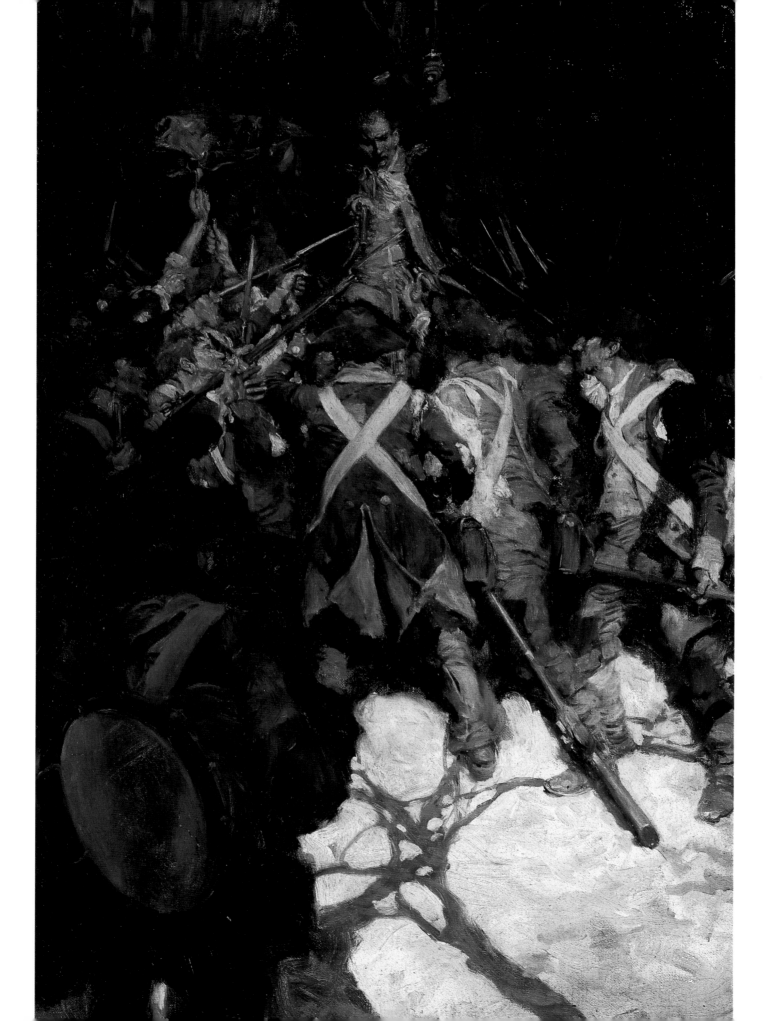

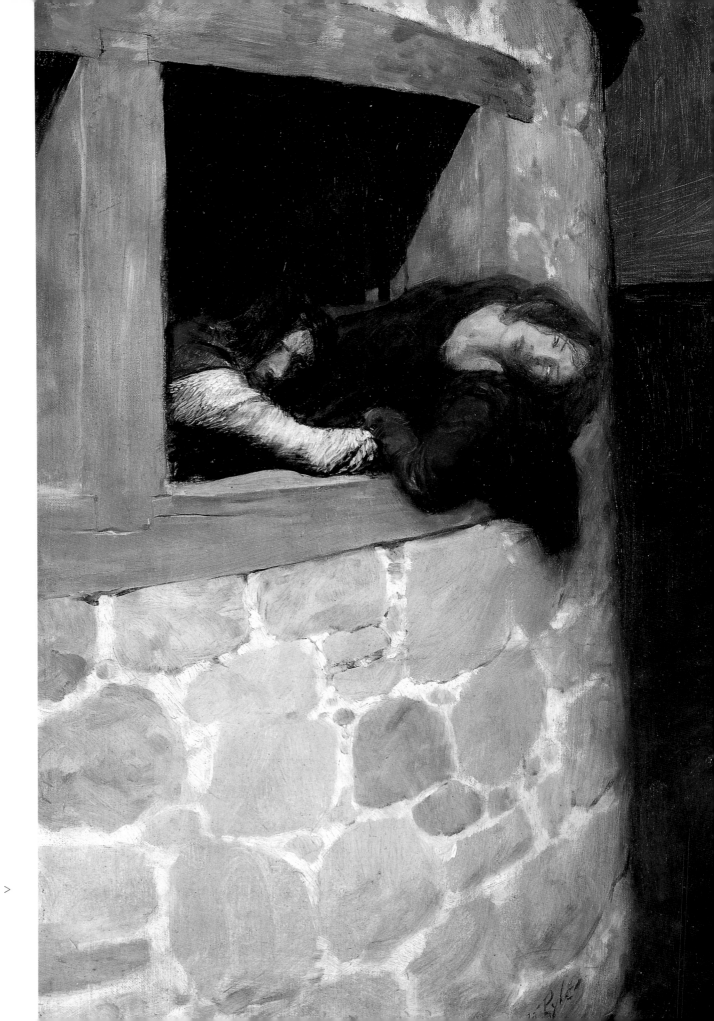

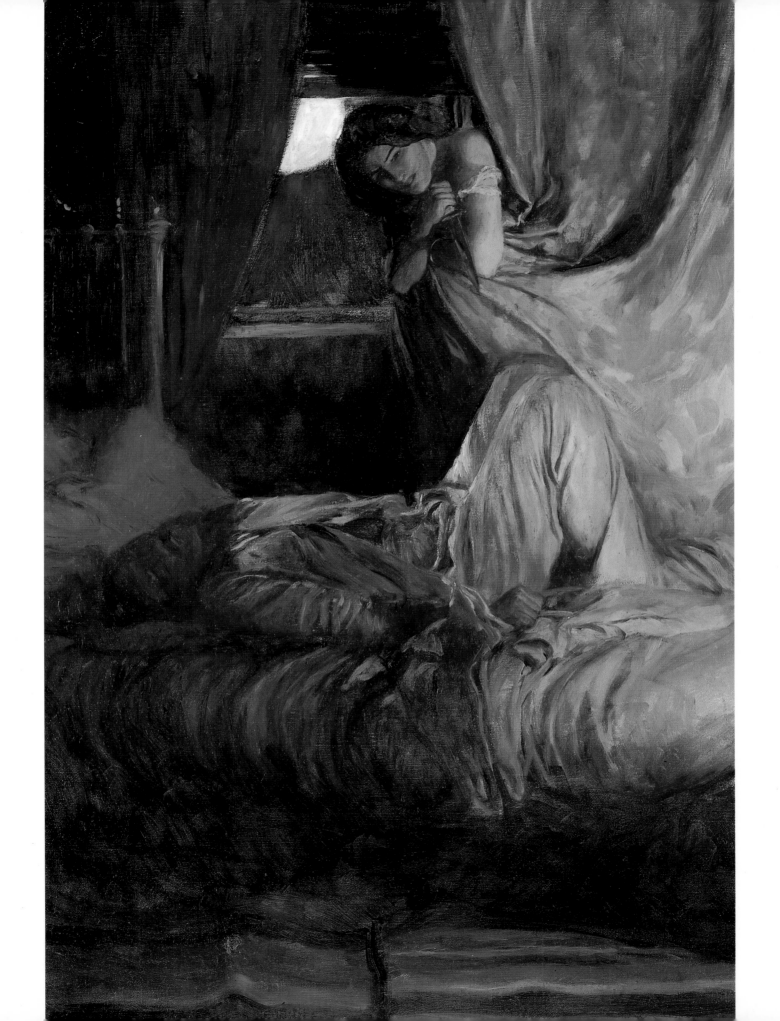

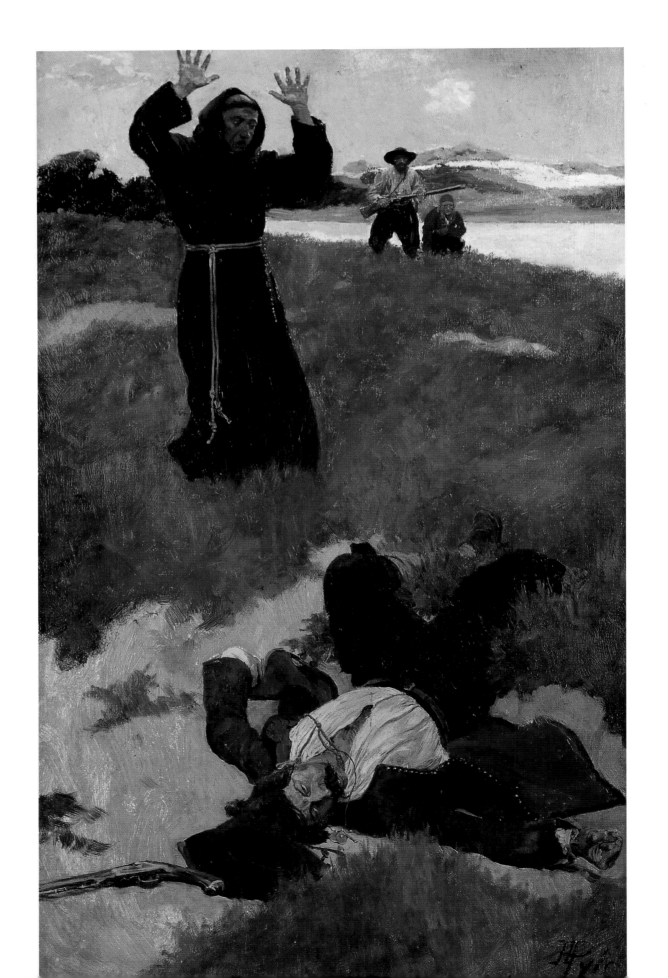

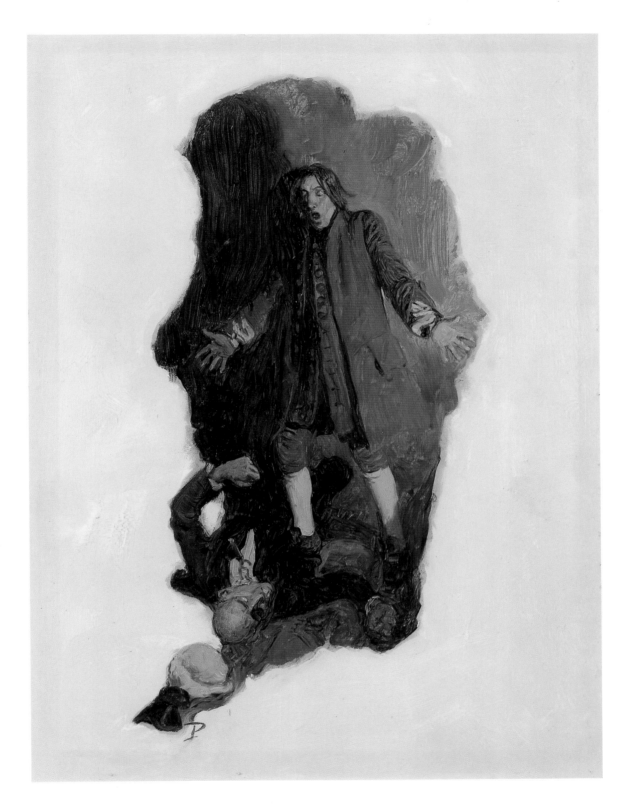

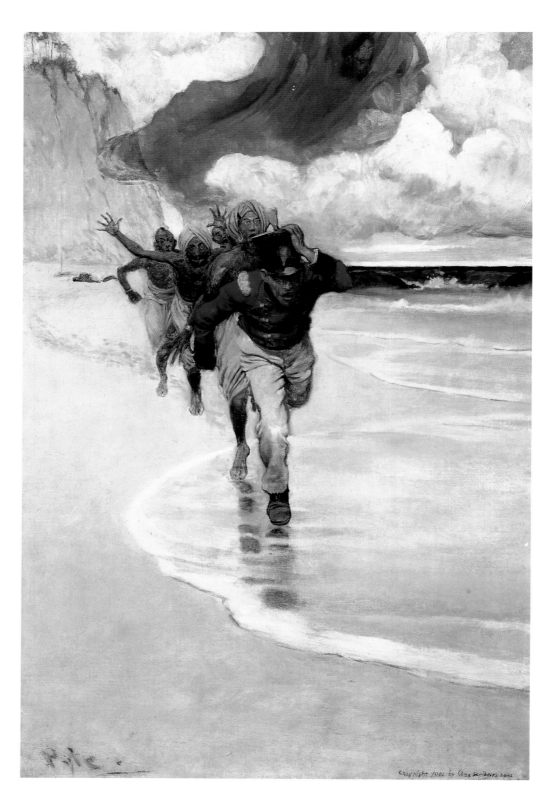

HOWARD PYLE
*"We started to run back to the raft for
our lives,"* 1902

HOWARD PYLE >
*"The boat and I went by him with a
rush,"* 1902

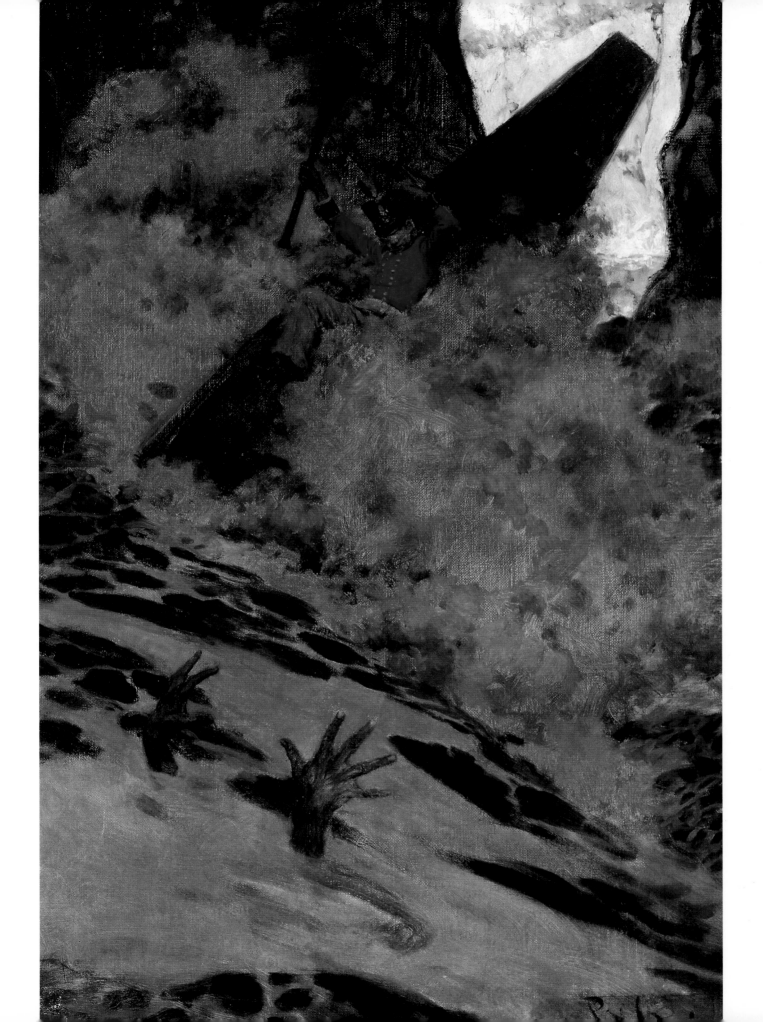

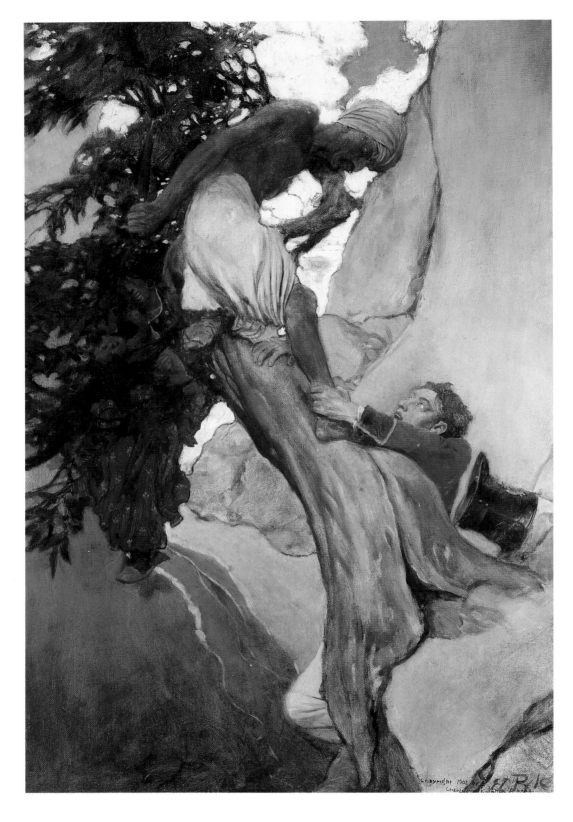

HOWARD PYLE

"I clutched at his ankle," 1902

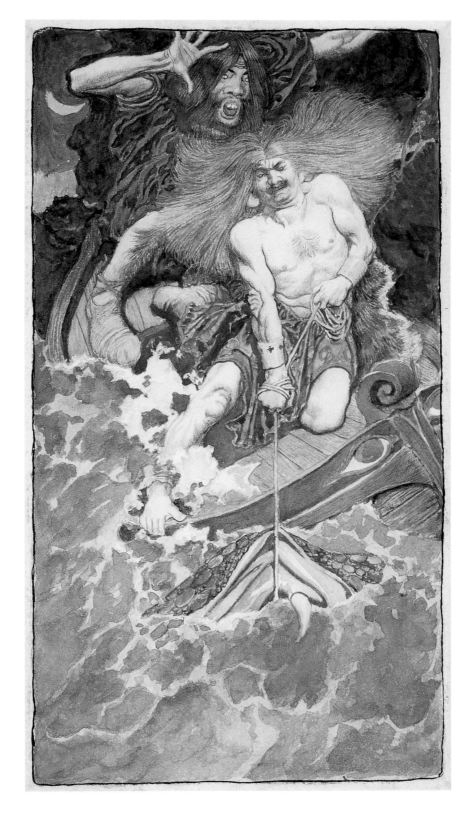

HOWARD PYLE

The Fishing of Thor and Hymir, 1902

The Pirates Fire upon the Fugitives,
1895

HOWARD PYLE
"The rest were shot and thrown overboard,"
1907

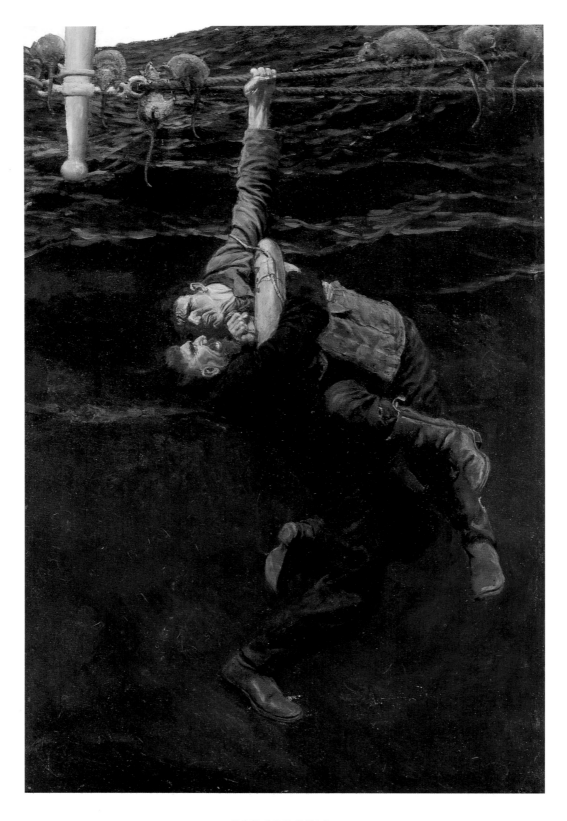

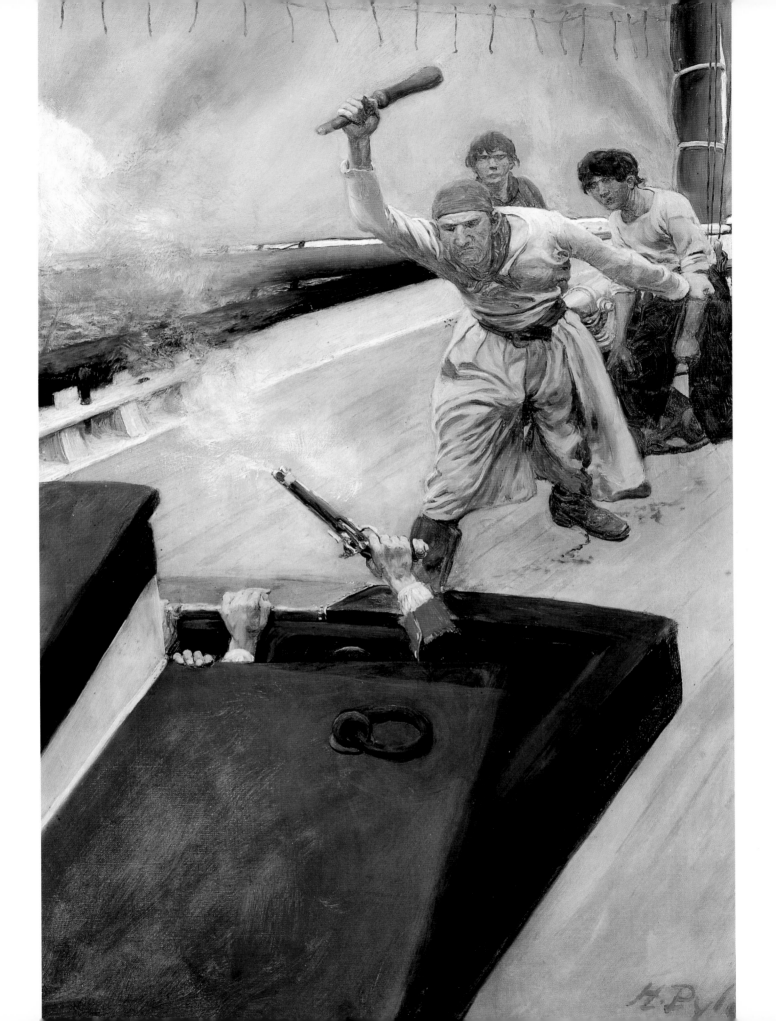

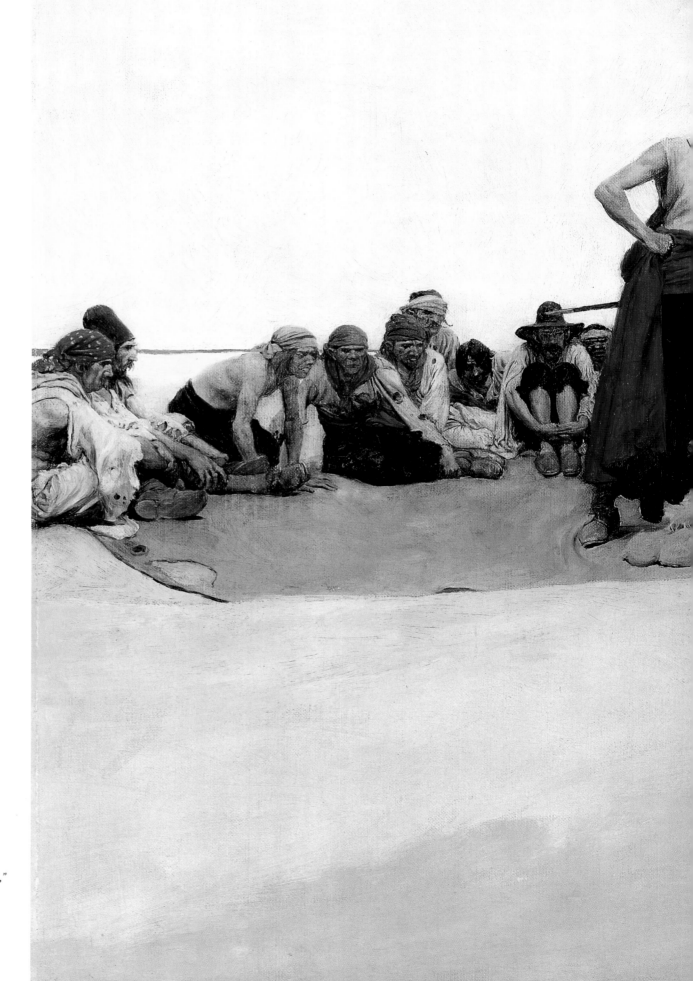

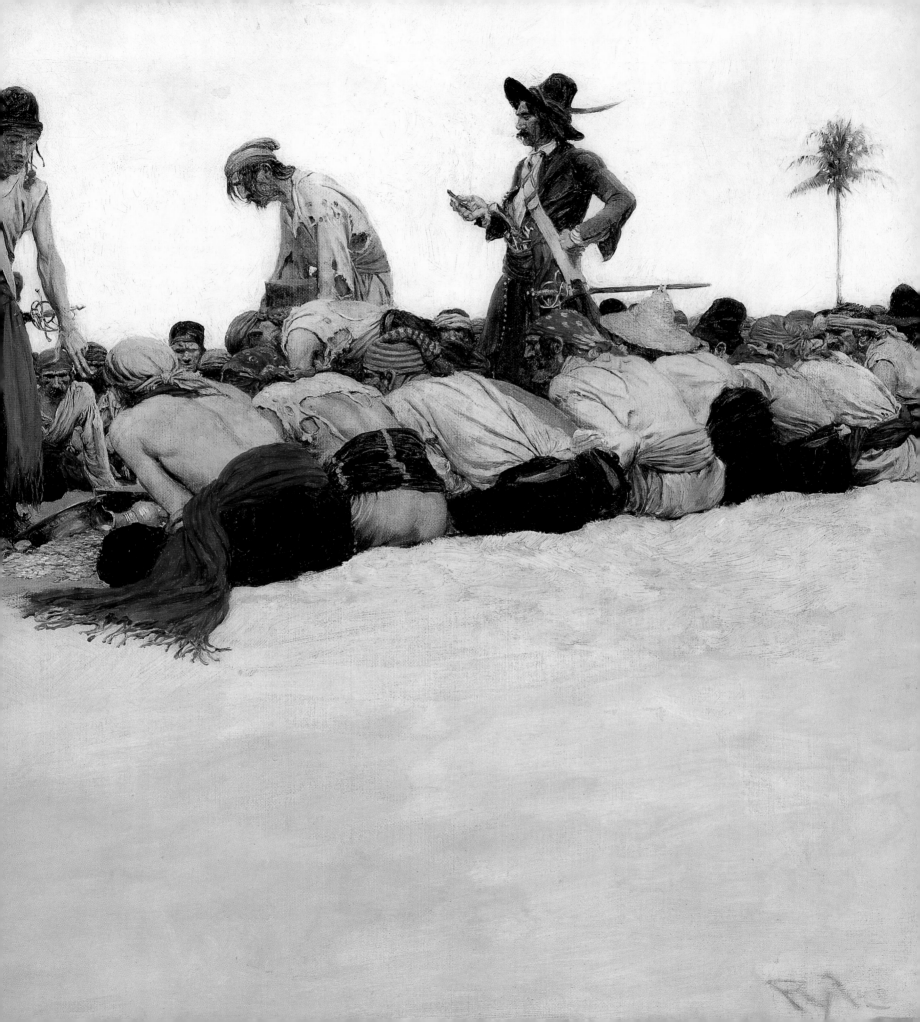

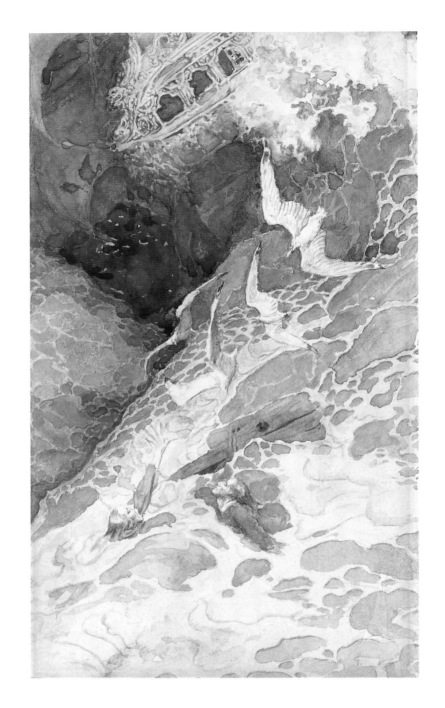

HOWARD PYLE

The Flying Dutchman, 1900

HOWARD PYLE >

The Flying Dutchman, 1902

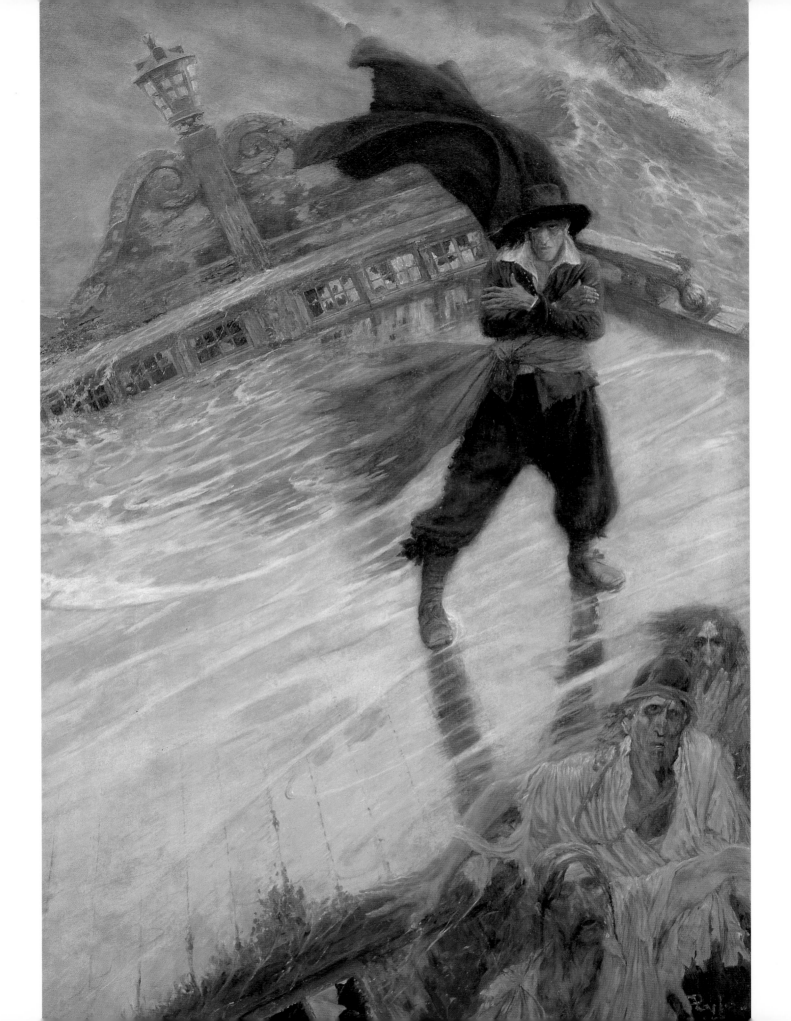

HOWARD PYLE

*"Pirates used to do that to their captains
now and then,"* 1894

HOWARD PYLE >

*"The gigantic monster dragged and
hacked the headless corpse of his victim
up the staircase,"* 1896

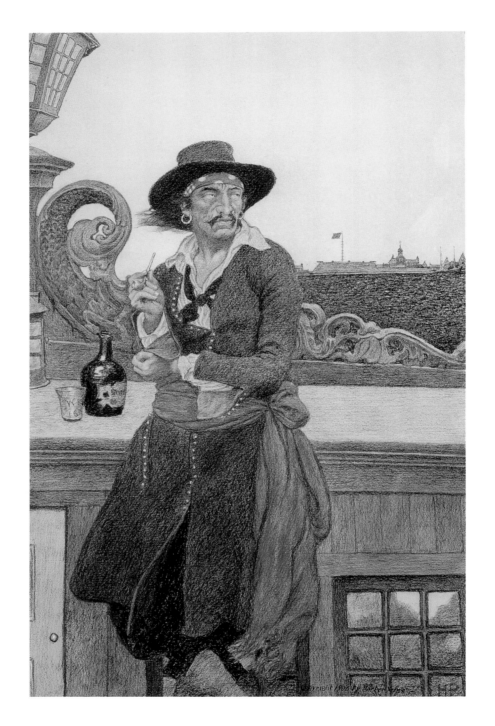

*Kidd on the Deck of the "Adventure
Galley," 1902*

>
An Attack on a Galleon, 1905

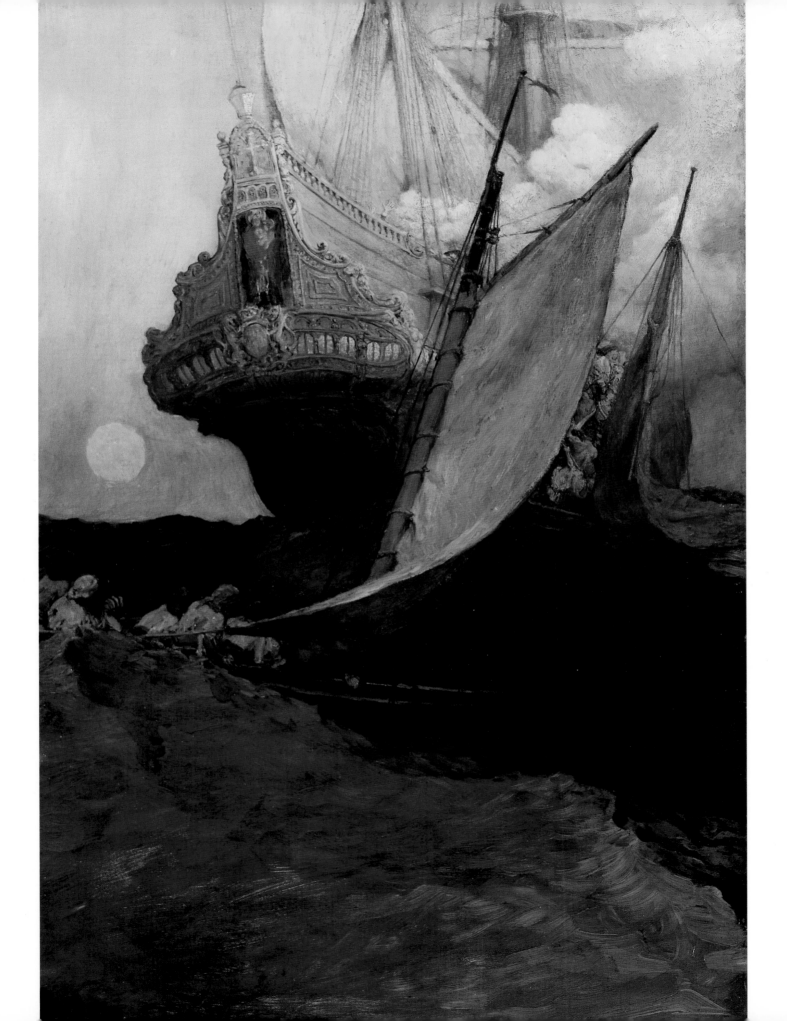

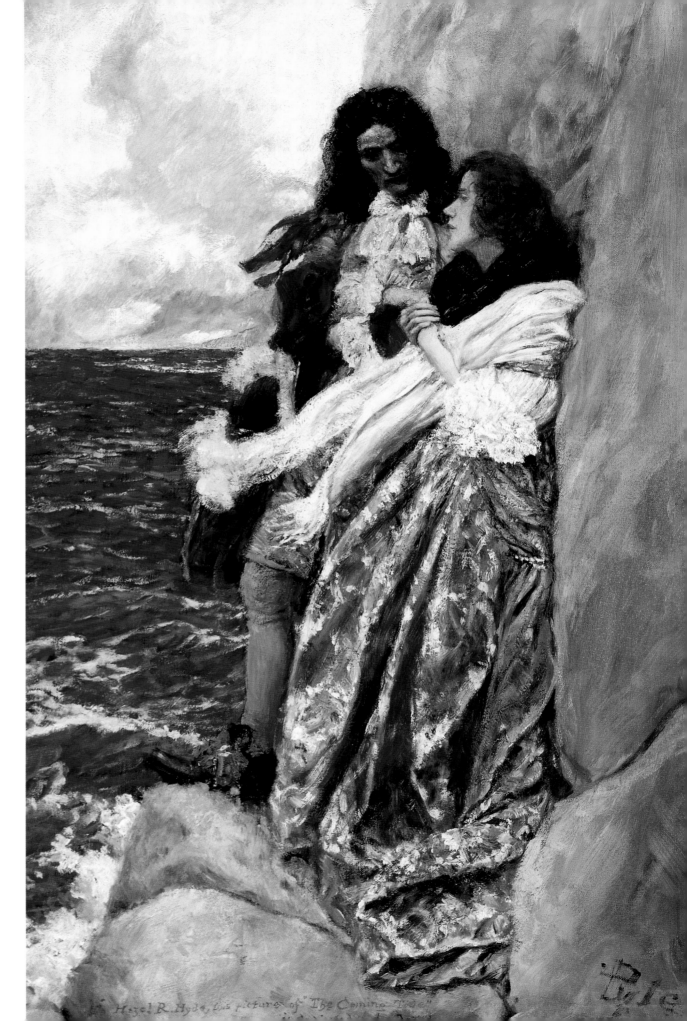

HOWARD PYLE

*"Who are we that heaven
should make of the old sea a
fowling net?"* 1909

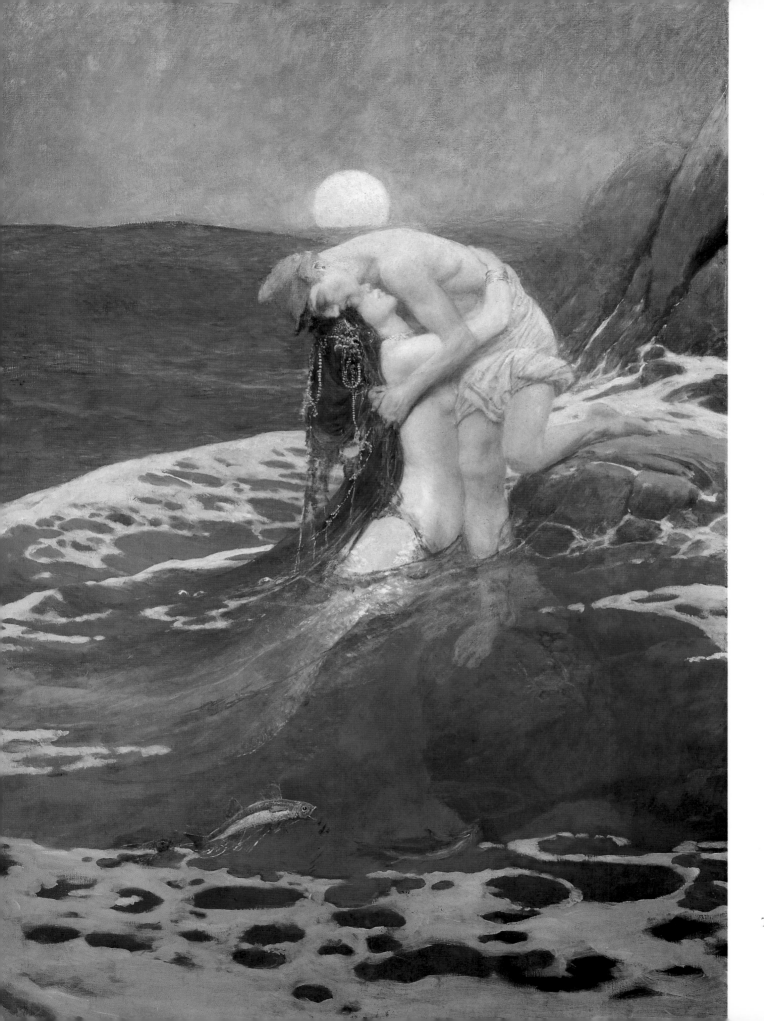

HOWARD PYLE
The Mermaid, 1909

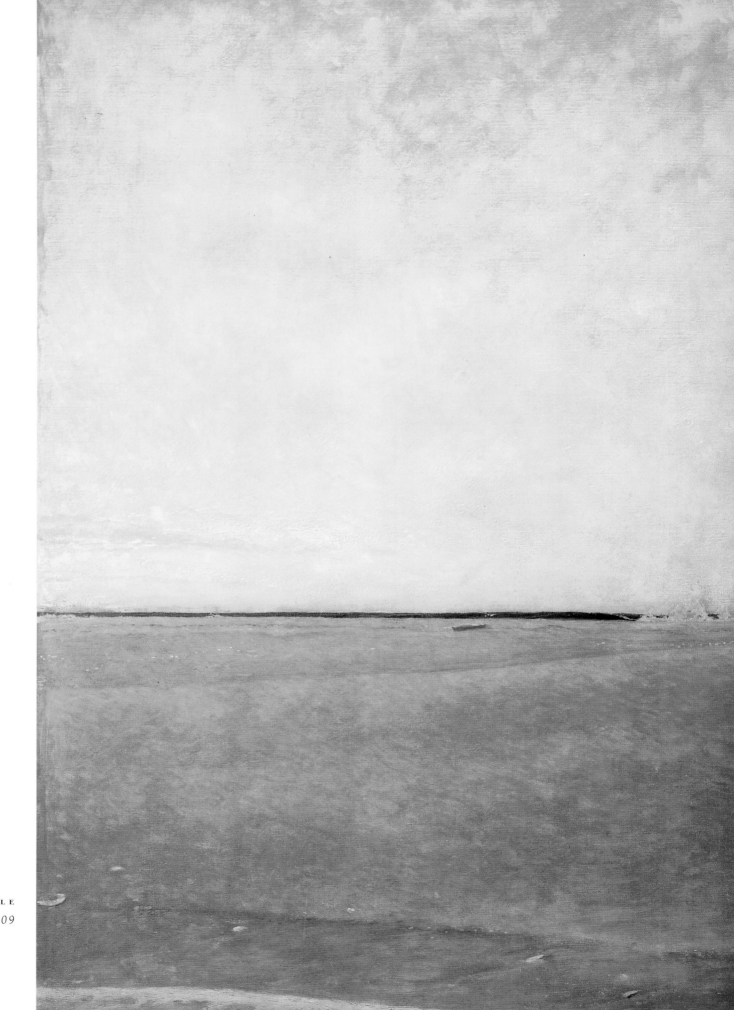

HOWARD PYLE
Marooned, 1909

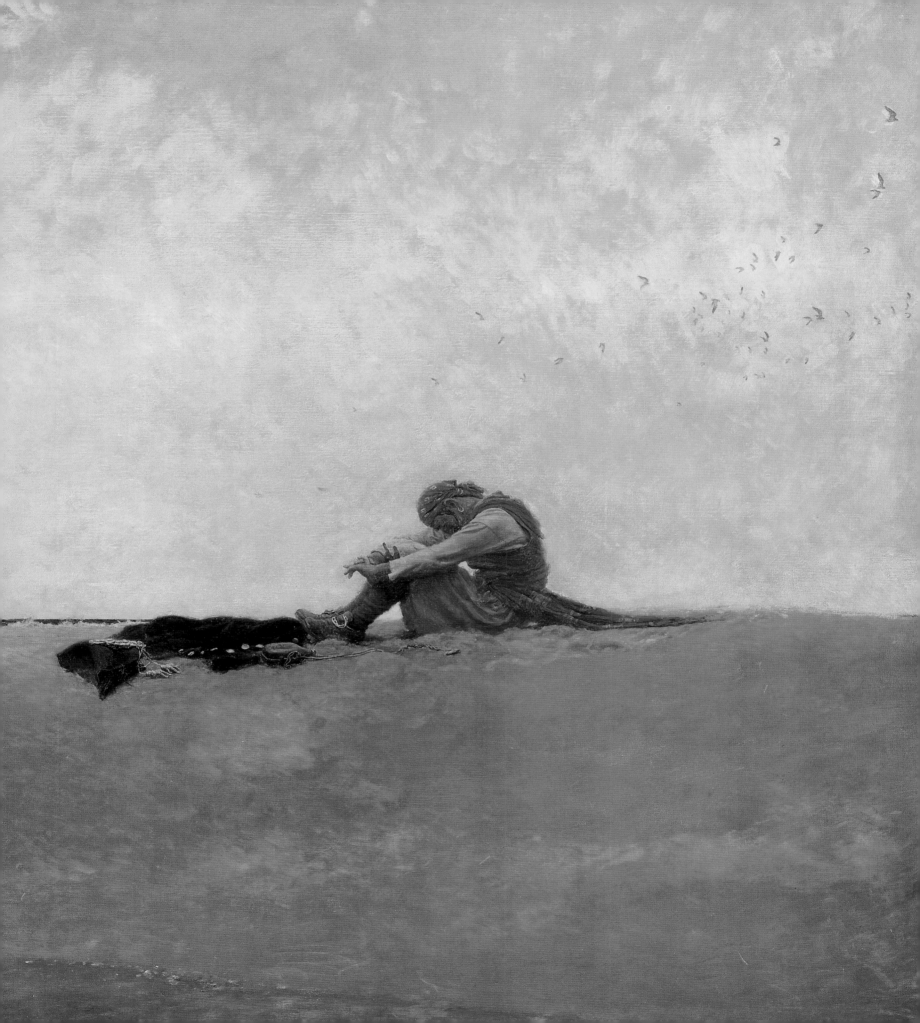

N. C. Wyeth

Essay by Betsy James Wyeth

In a Dream I Met N. C. Wyeth

In my dream I remember the day was slightly hazy, without shadows, as if the house lights had dimmed, the heavy curtains had parted, and I was viewing the opening act onstage through very sheer fabric—like chiffon. Because I was watching the events unfold from that veiled distance, it was hard to tell whether it was springtime or a hazy, warm day in the late fall, for the rolling hills were tawny and yet the later events took place on a green lawn with tall trees whose leaves blew in the warm wind.

I lay on the field grass and looked up at the endless blue sky overhead and watched two butterflies fluttering without direction, in erratic patterns until they touched wings briefly before flying out of sight. Time seemed to stand still and I was the only human being left on earth. Although I knew my husband was only a short distance away working on a painting, I still felt removed—not a part of his life. An outsider. A visitor from another land—another life. And so I had wandered away across the open hills.

I reached the top of one and looked down on a group of buildings clustered under tall trees whose long, drooping branches blew like long hair in the wind—rising and falling, swaying back and forth. For a moment, I thought the valley below might be under water and the limbs were really long strands of seaweed writhing in the currents and the buildings the hull of a sunken ship.

The sound of laughter coming up from below brought one back to reality. My vision narrowed into sharp focus, like looking through high-powered binoculars at the group of buildings that I recognized at once were Howard Pyle's studio with his students' studios close by.

The laughter was coming from two young ladies who had come out of Pyle's studio onto his small open porch and were walking down the few steps followed by a tall, deeply tanned, muscular young man. When they reached the ground they ran with abandon across the broad lawn as if teasing or seducing the young man to follow them. I was reminded of Botticelli's *Primavera*.

I was jealous and also desired this virile young man's attention, for now I realized he was young N. C. Wyeth, who had been in his grave thirty-six years. His physique was superb, for he was not yet twenty-three and just back from a cattle roundup on the open range outside Denver, Colorado, and a rugged month of riding the Pony Express between Two Grey Hills, New Mexico, and Fort Defiance. He would never be that physically perfect again.

Around and around the beautiful young ladies danced with their long blond hair and sheer, flowered gowns blowing. My longing to draw the young man's attention away from them turned into lustful desire. If I succeeded I knew it would change forever the direction of his life. So I left the scene of laughter, beauty, and gaiety to hurry back across the hills to where my husband sat, still deeply absorbed in his painting. He was totally unaware of my presence and never noticed when I picked up a drawing pad lying on the ground beside him.

When I neared the valley I realized for the first time that a high, white-paneled fence surrounded the yard like a corral. I

was just tall enough to look through the top rails and watch the graceful ballet-like May dance still being enacted for the young man who lay on the grass with his back toward me, his right arm bent to support the weight of his fine head.

I turned the power of my penetrating desire on him. He turned his head and discovered something that at first appeared to be the sleek black mane of a horse. In a few seconds he climbed over the top rail and dropped to the ground to find me standing there. I knew instantly that he was under my spell.

His closeness was almost overpowering and I remember being surprised that his matted, thick curly hair was much blonder than I would have thought. His wide-set brown eyes much kinder without the glasses he later wore. A narrow faded red bandana was tied around his neck above his close-fitted black shirt. His leather boots came up over his full calves. There was a familiar handsomeness about him that reminded me of the virile young knights he would one day paint. I should have known he was really painting himself.

His first words were spoken with intensity.

"Who are you? Where did you come from?"

I held out the drawing pad for him to see. He took it and began to slowly turn pages to study each drawing with growing interest. After he had looked at several he turned another page and found a drawing of me.

"These are remarkable! Who did them?"

"The man who will someday be your son."

In utter amazement he again asked, "But who are you?"

"I shall marry that son and after your death will edit your life as seen through the letters you have already written and those that you are still to write."

He looked across the hills as if for a brief moment he had caught a fleeting glimpse of his future, but when he turned back I had already faded from sight. He turned and slowly climbed back over the high fence and crossed the lawn, where the pale beauties stood in wonder as he passed on by.

I knew the memory of our meeting would fade from his mind like a dream out of the depths of sleep, but something he would never quite be able to explain had clarified his vision and shown him the direction his life would take.

The last glimpse I had from the hilltop was of a river that meandered through the valley where Howard Pyle's studio and the other buildings once stood. I could see N. C. Wyeth's figure, stooped with age, walking slowly up the fieldstone path that led to the large white studio he built on the hillside that overlooked the valley below where once I had wandered in a dream.

When I arrived back to where I had left my husband he had already packed his painting equipment in the car and had just begun to wonder where I had gone. Then he noticed the drawing pad under my arm. He quickly thumbed through it but realized all the pages were blank except for two butterflies that had been pressed there years before. They dropped to the ground. Their fragile wings tore loose and blew away in the wind.

March 1981
Chadds Ford

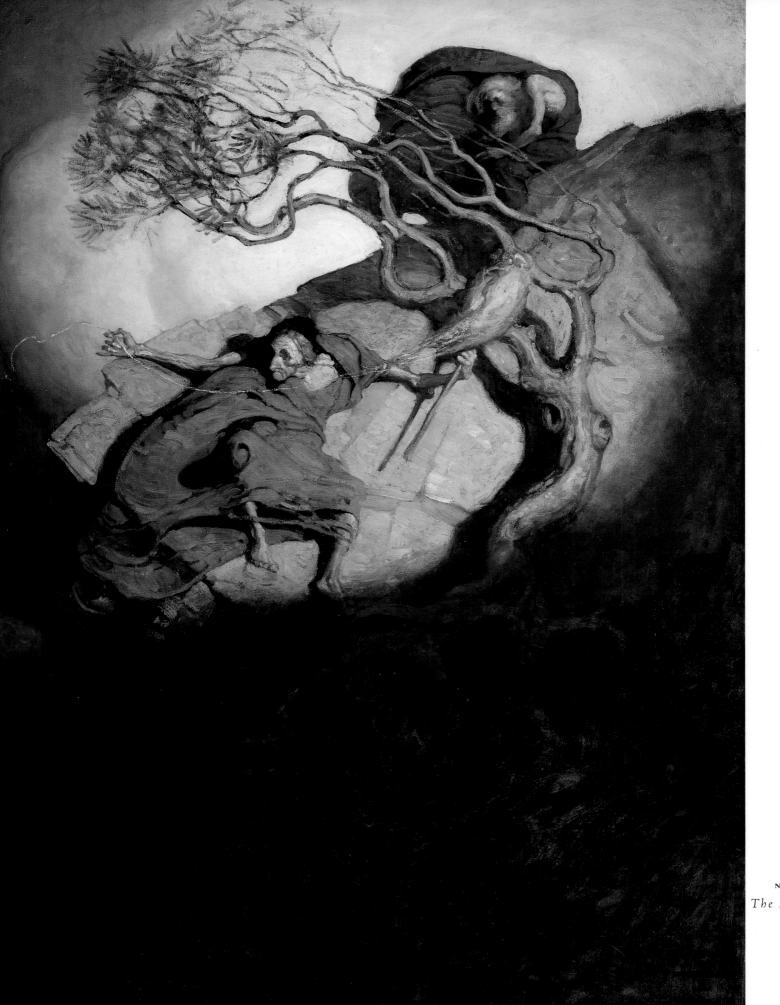

N. C. WYETH

The Hag of the Rock,
1912

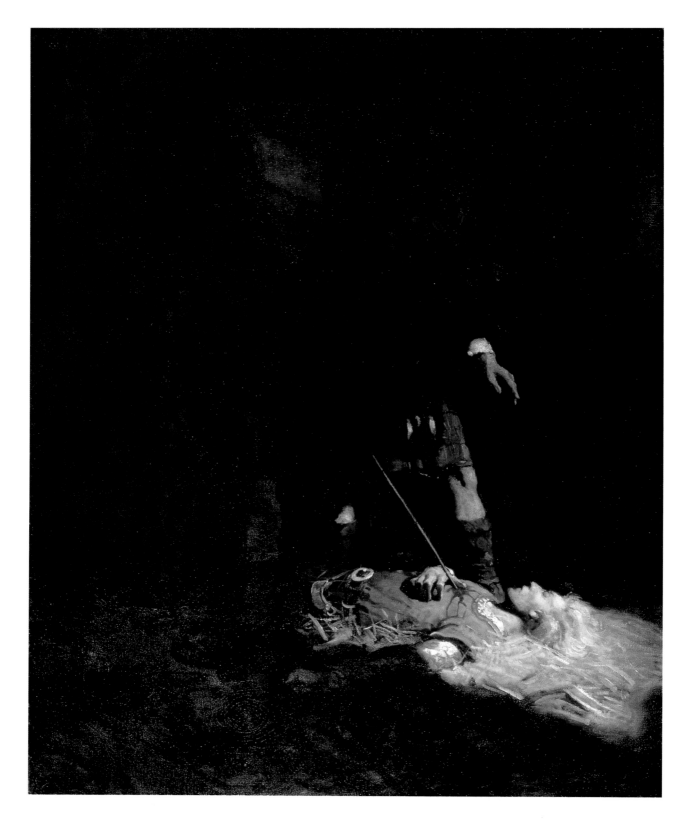

N. C. WYETH
Death of Edwin, 1921

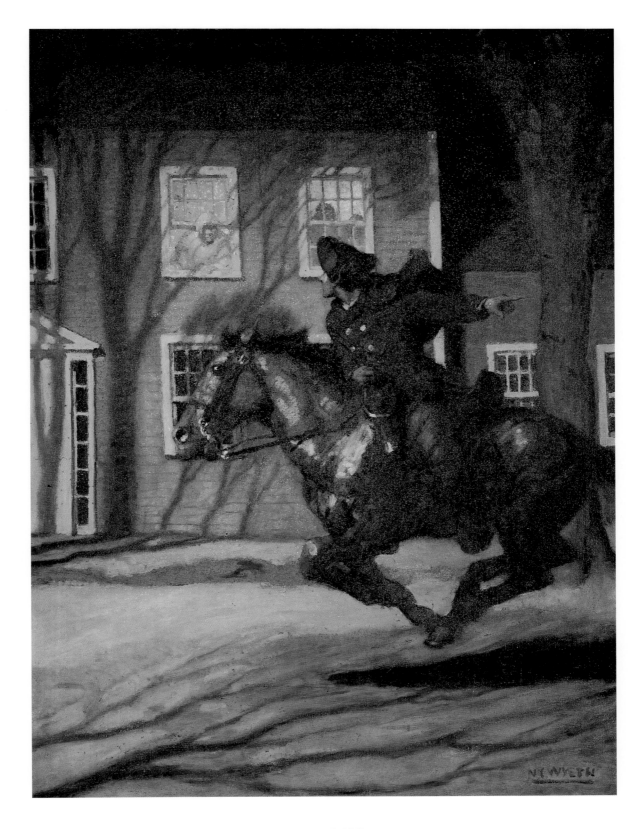

N. C. WYETH

Paul Revere, 1922

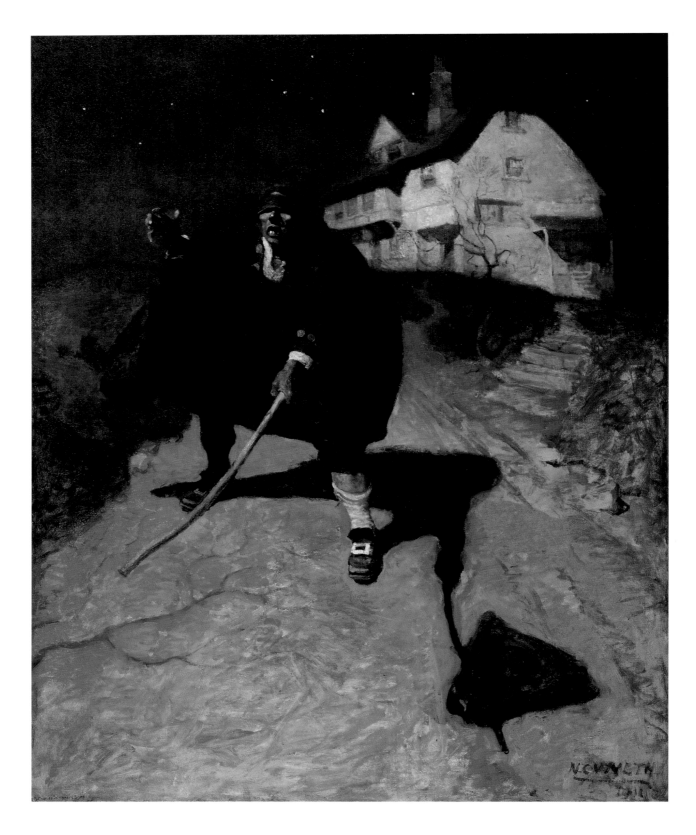

N. C. WYETH

Blind Pew, 1911

N. C. WYETH >

Captain Bill Bones, 1911

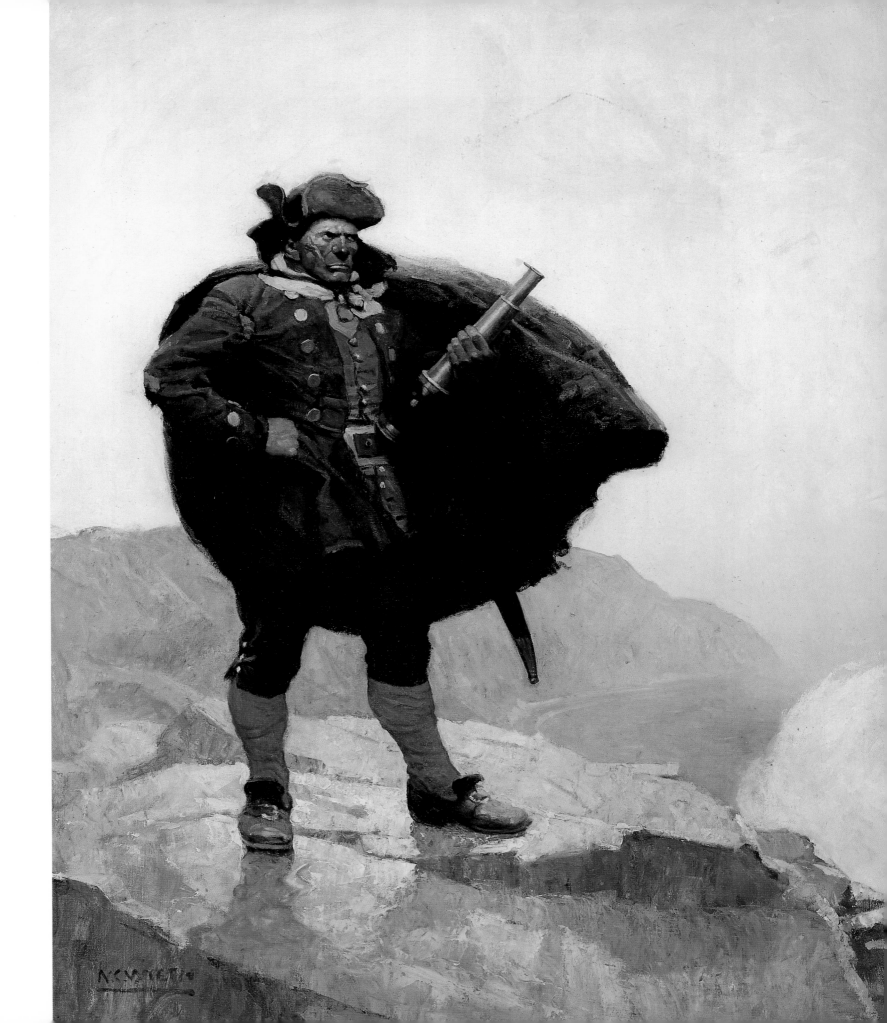

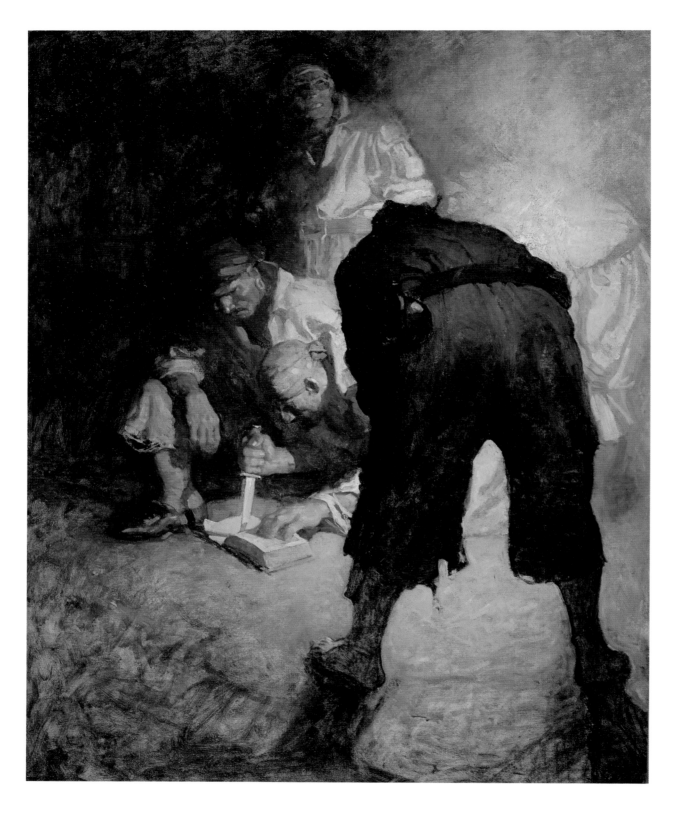

N . C . W Y E T H

The Black Spot, 1911

N . C . W Y E T H >

The Treasure Cave! 1911

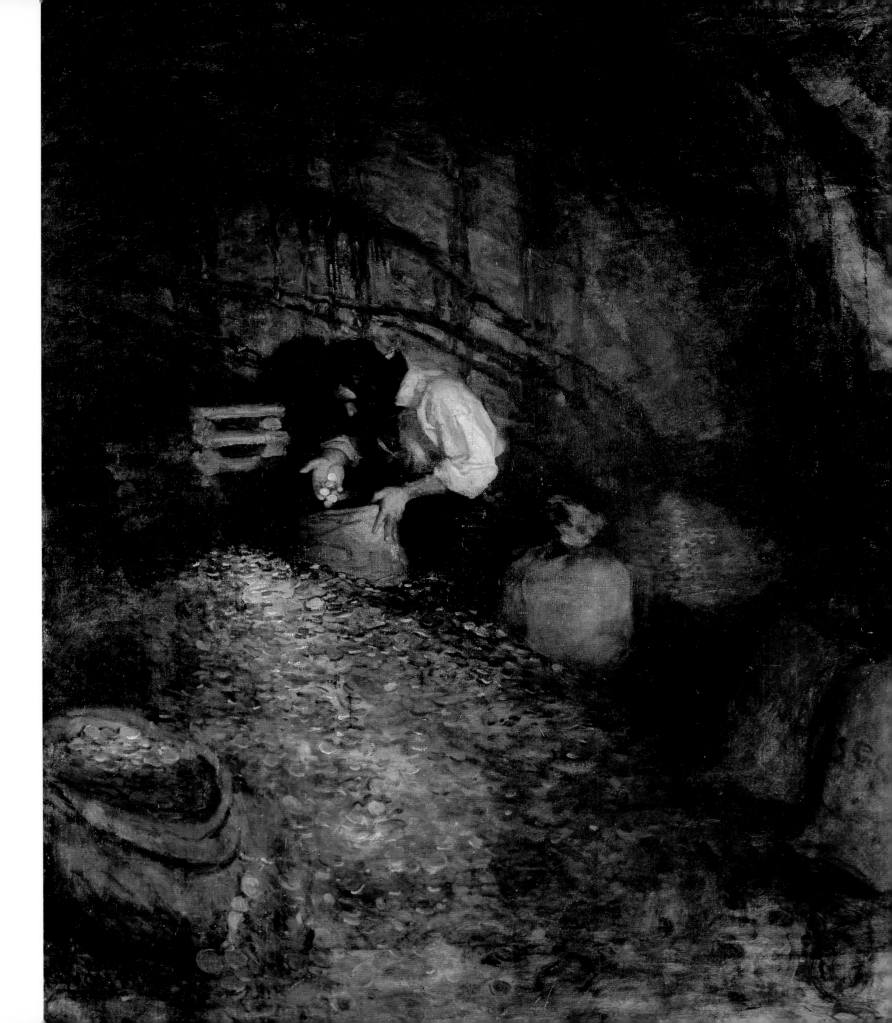

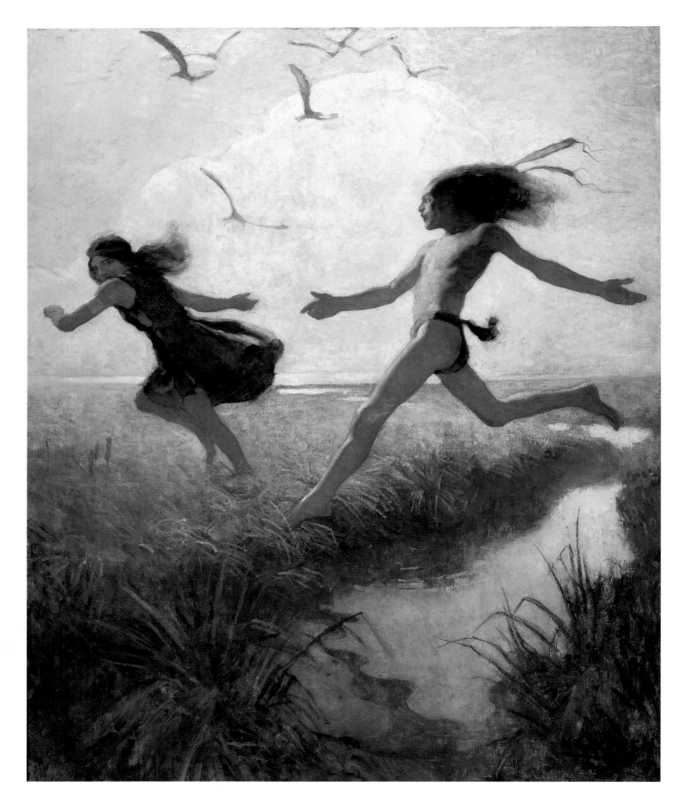

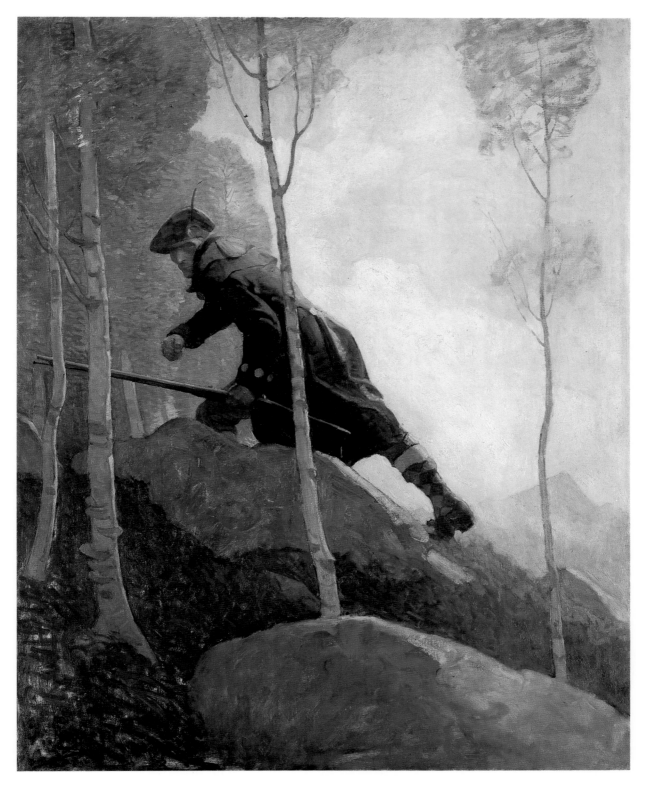

N. C. WYETH

The Murderer of Roy Campbell, 1913

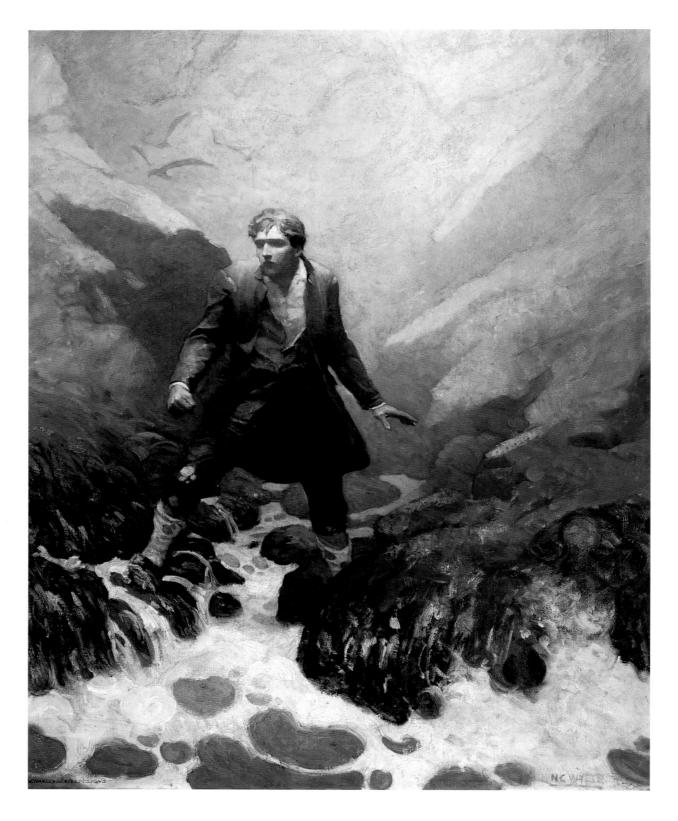

N. C. WYETH

On the Island of Earraid, 1913

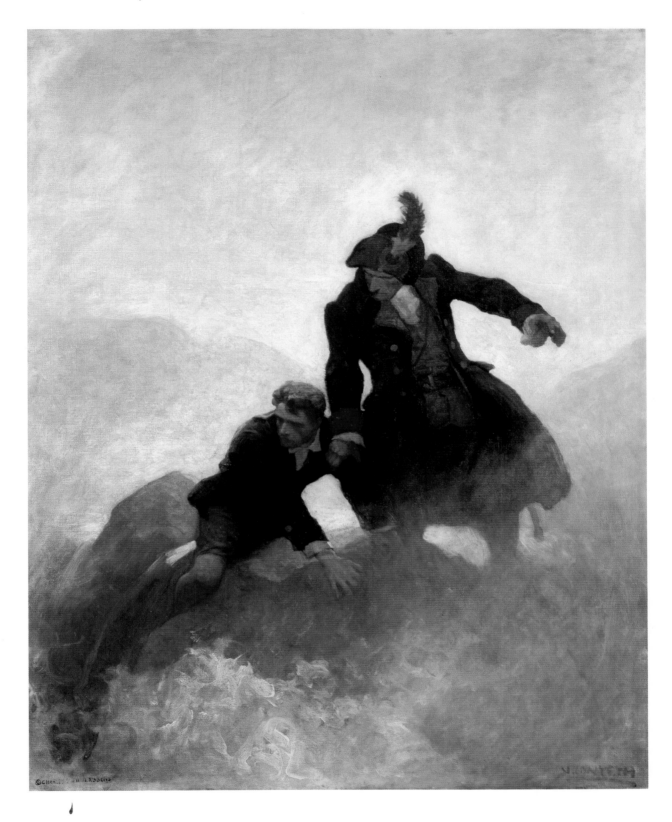

N. C. WYETH

The Torrent in the Valley of Glencoe, 1913

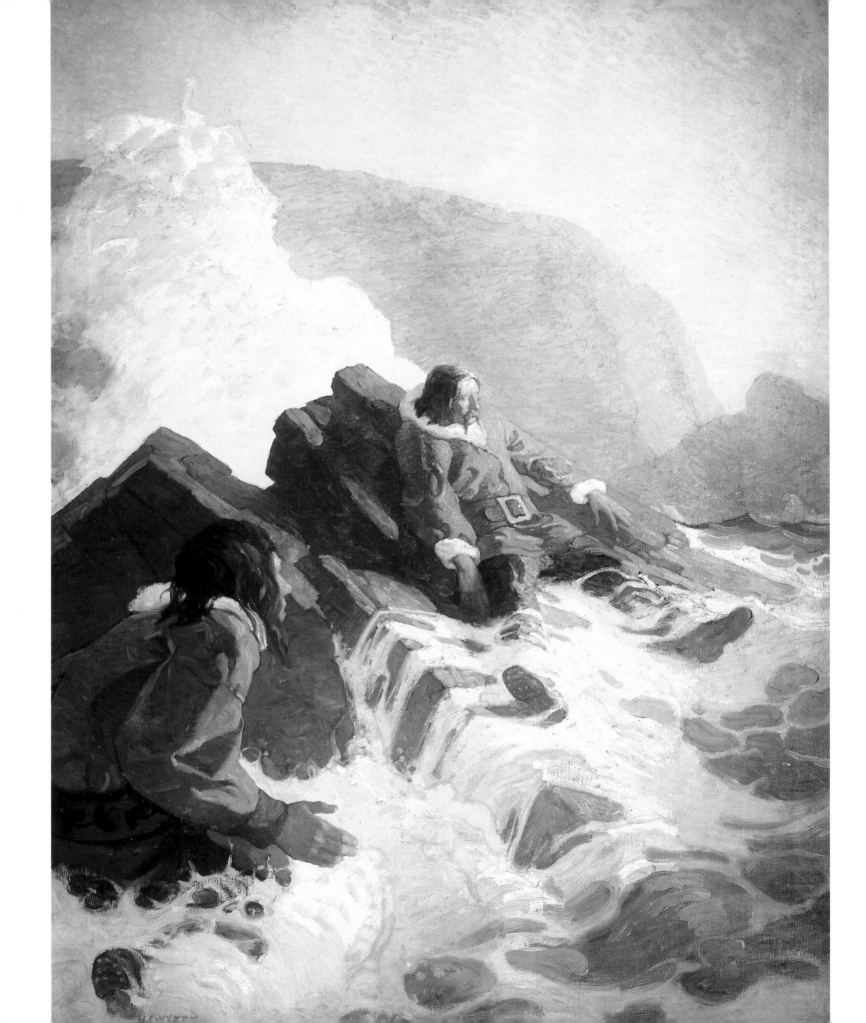

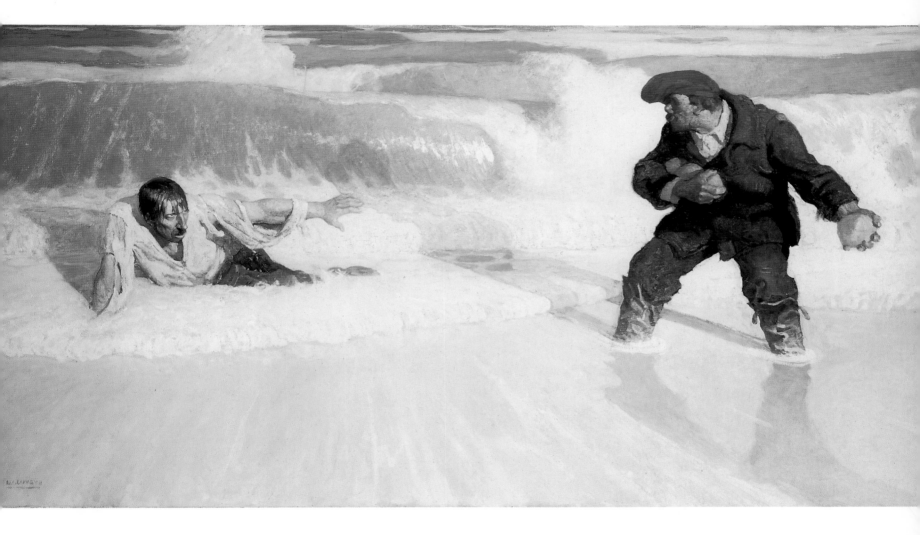

N. C. WYETH

"When I tried with cracked lips . . ." 1914

N. C. WYETH

<

The Death of Finnward Keelfarer, 1914

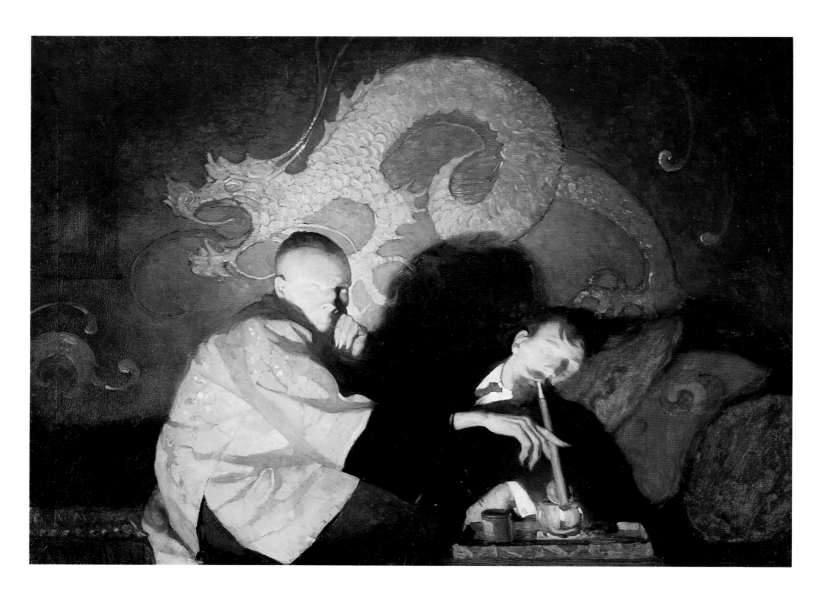

N. C. WYETH

The Opium Eater, 1913

N. C. WYETH >

Captain Nemo, 1918

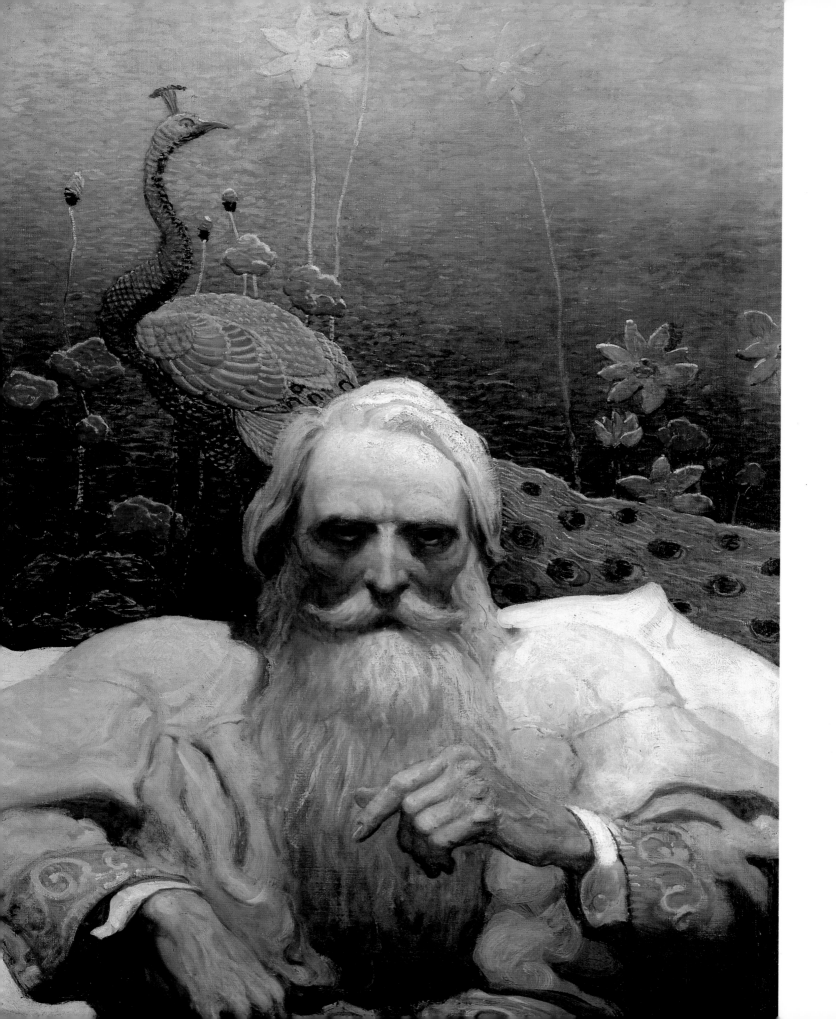

N. C. WYETH

The Great Minus, 1913

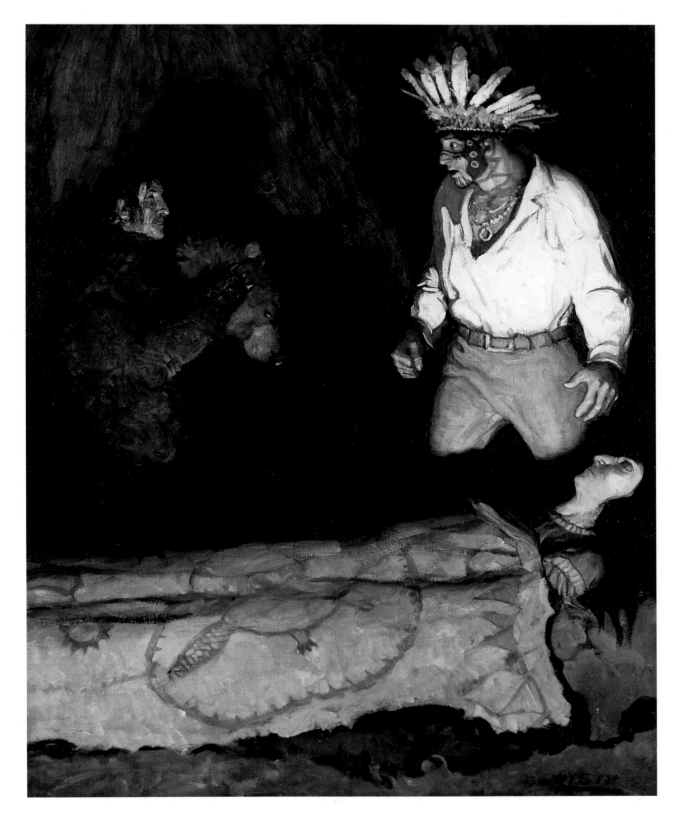

N. C. WYETH
The Masquerader, 1919

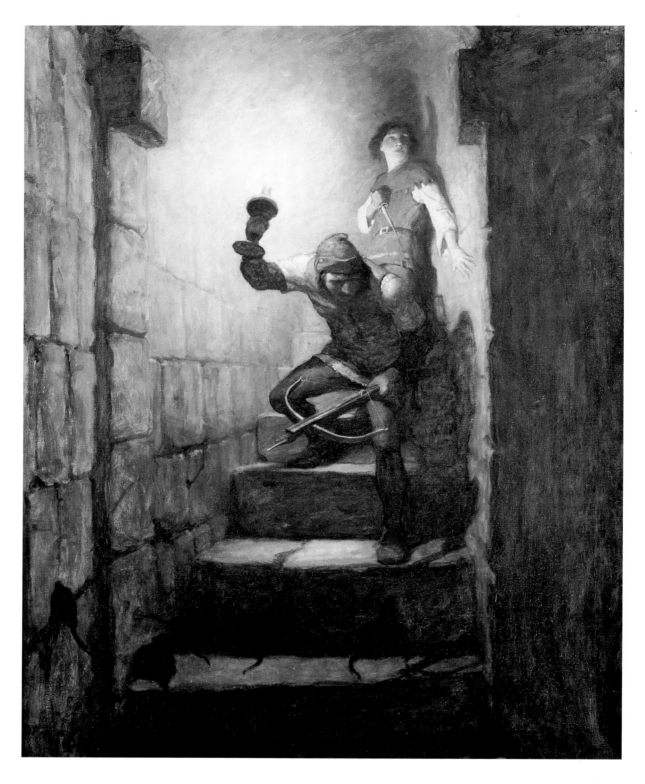

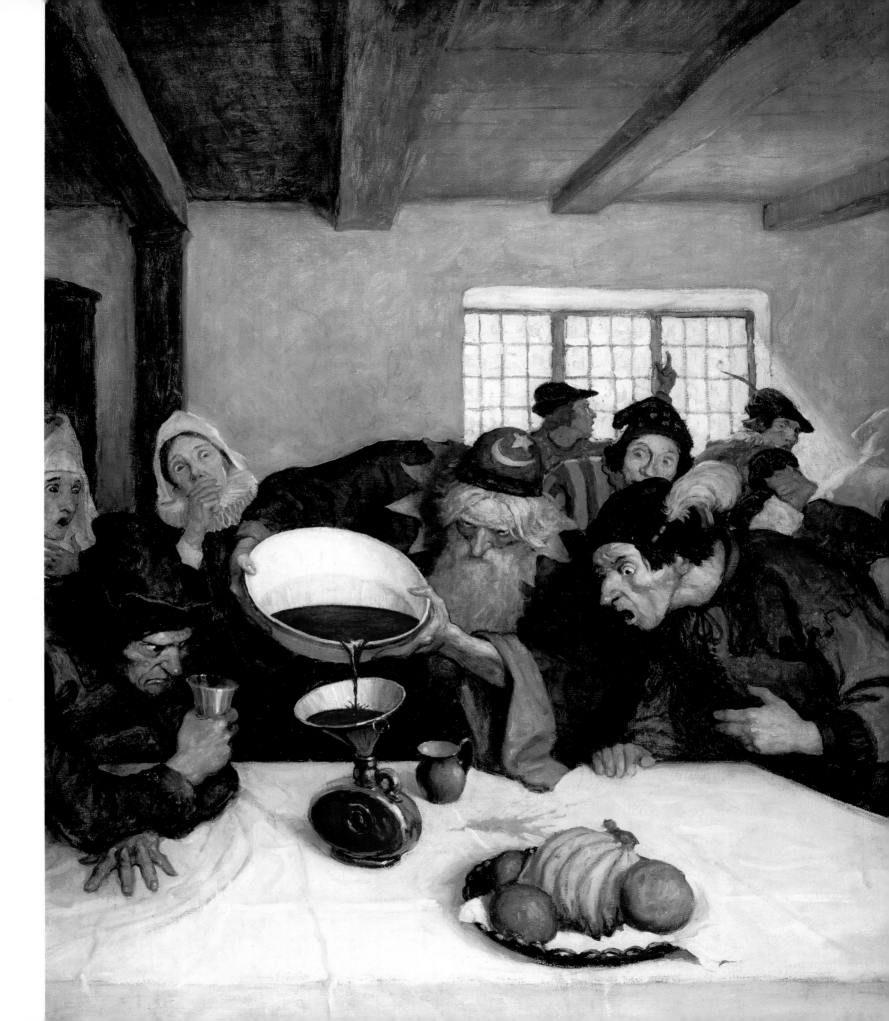

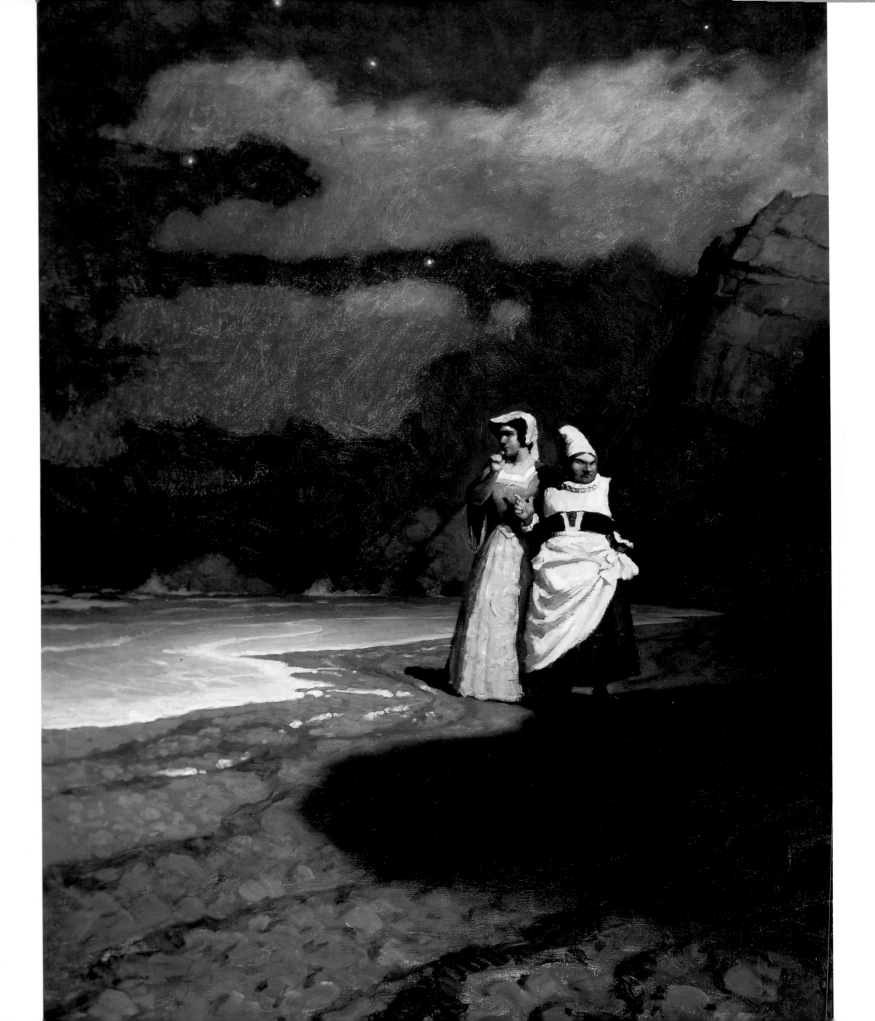

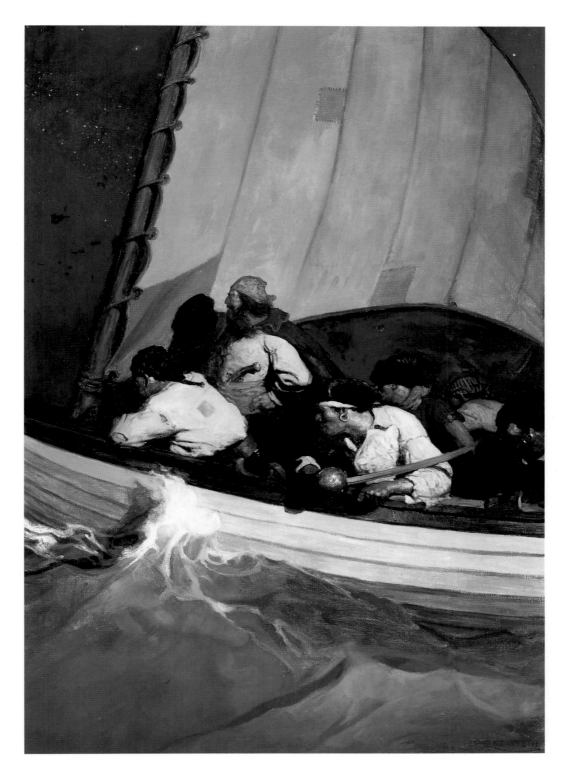

*"Oh, Morgan's men are out for you; and
Blackbeard-Buccaneer!"* 1917

< *Rose Salterne and the White Witch, 1920*

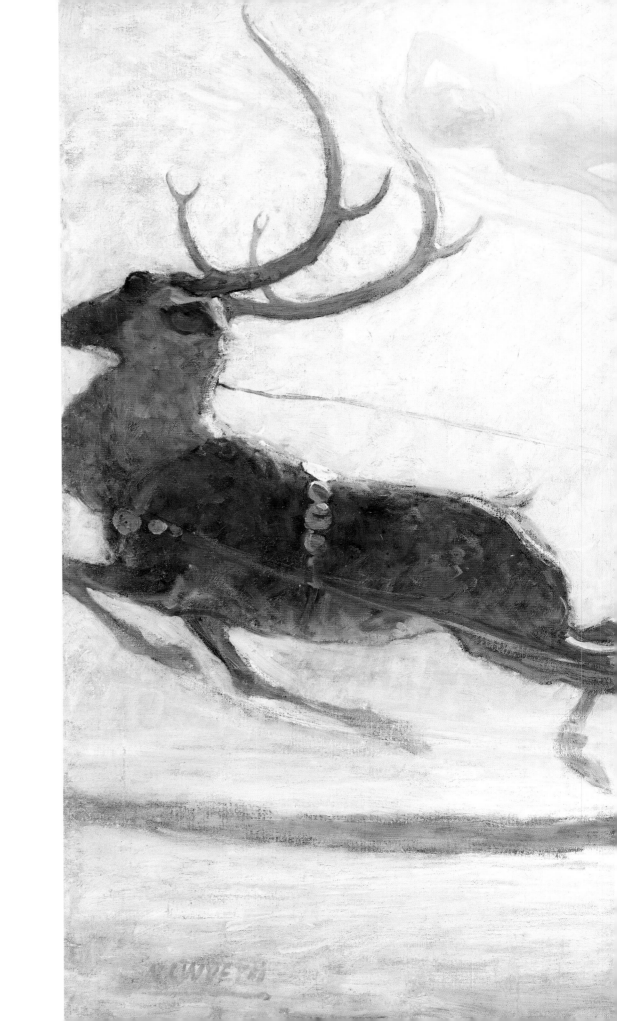

N. C. WYETH

The Magician and the Maid of
Beauty, 1912

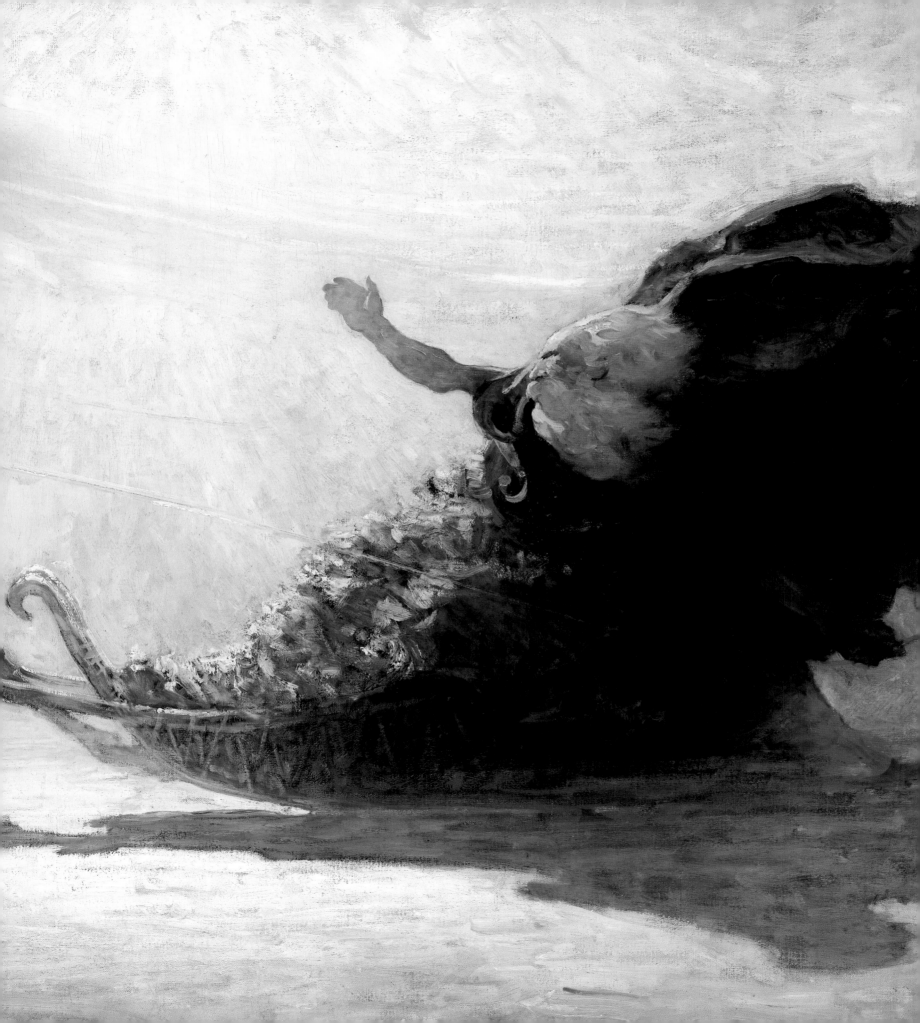

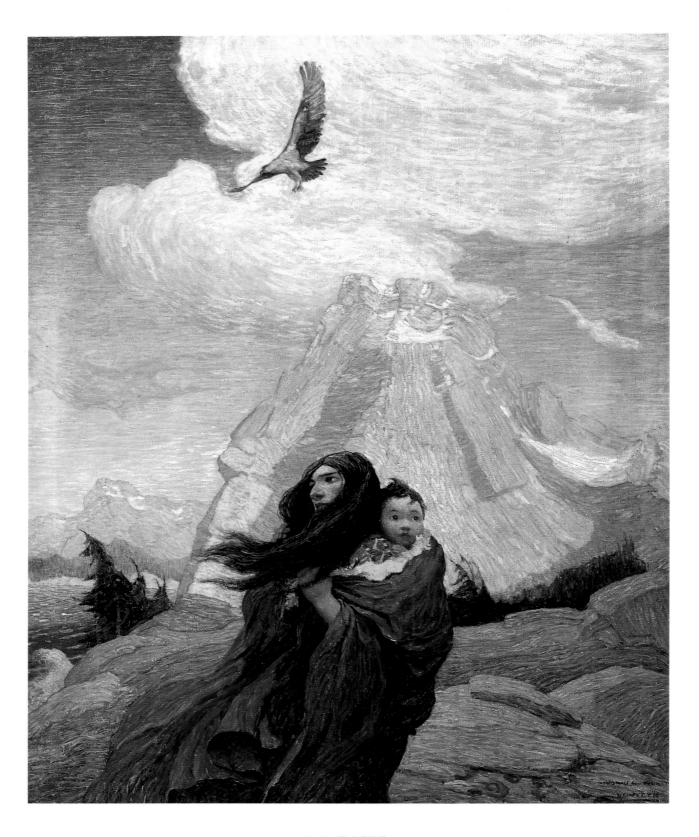

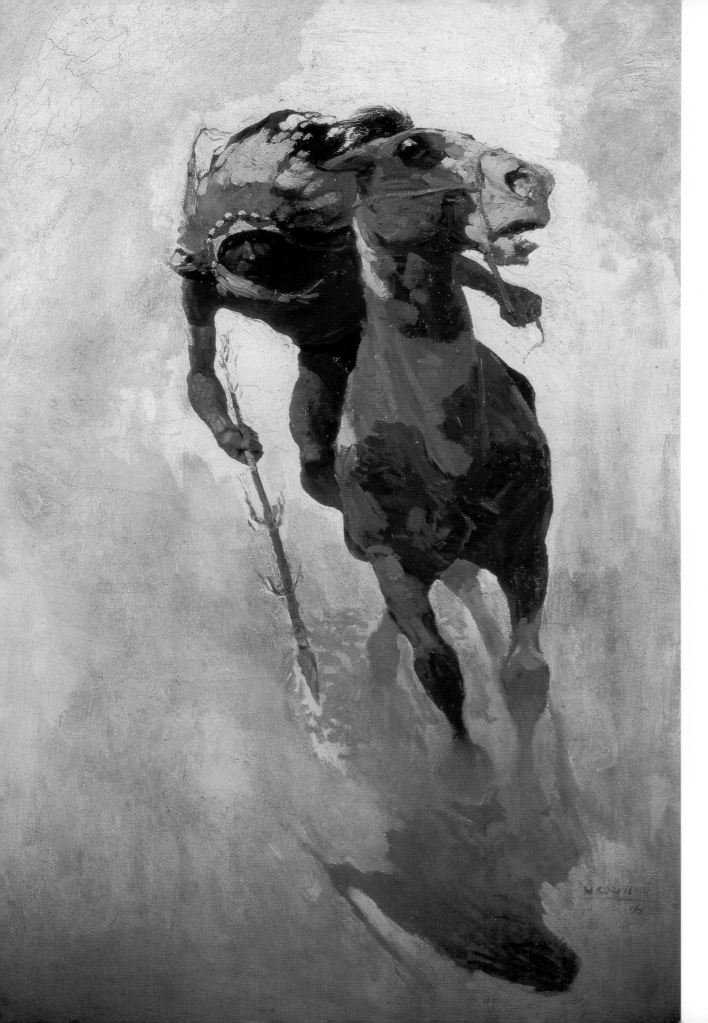

N. C. WYETH

The Indian Lance, 1909

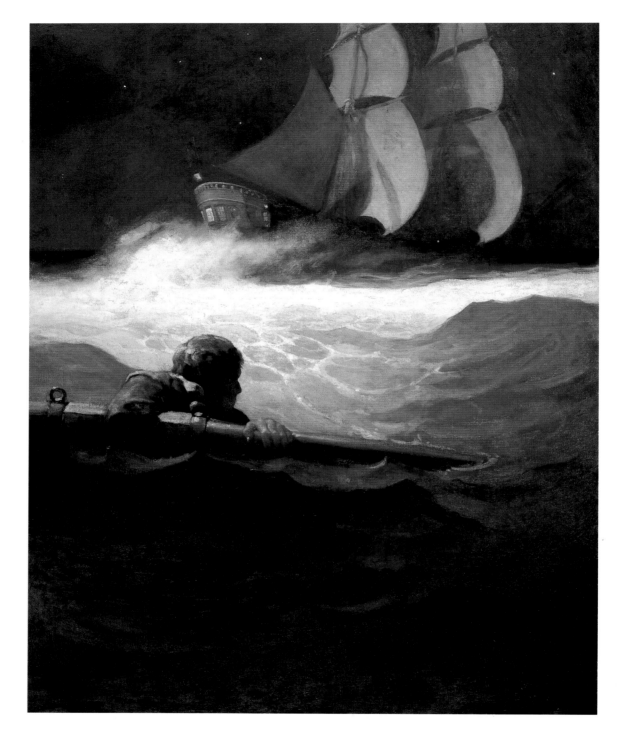

N. C. WYETH

The Wreck of the "Covenant," 1913

N. C. WYETH >

The Battle with the Armada, 1920

N. C. WYETH

Magua Captures Alice, 1918

N. C. WYETH >

The Giant, 1923

[86]

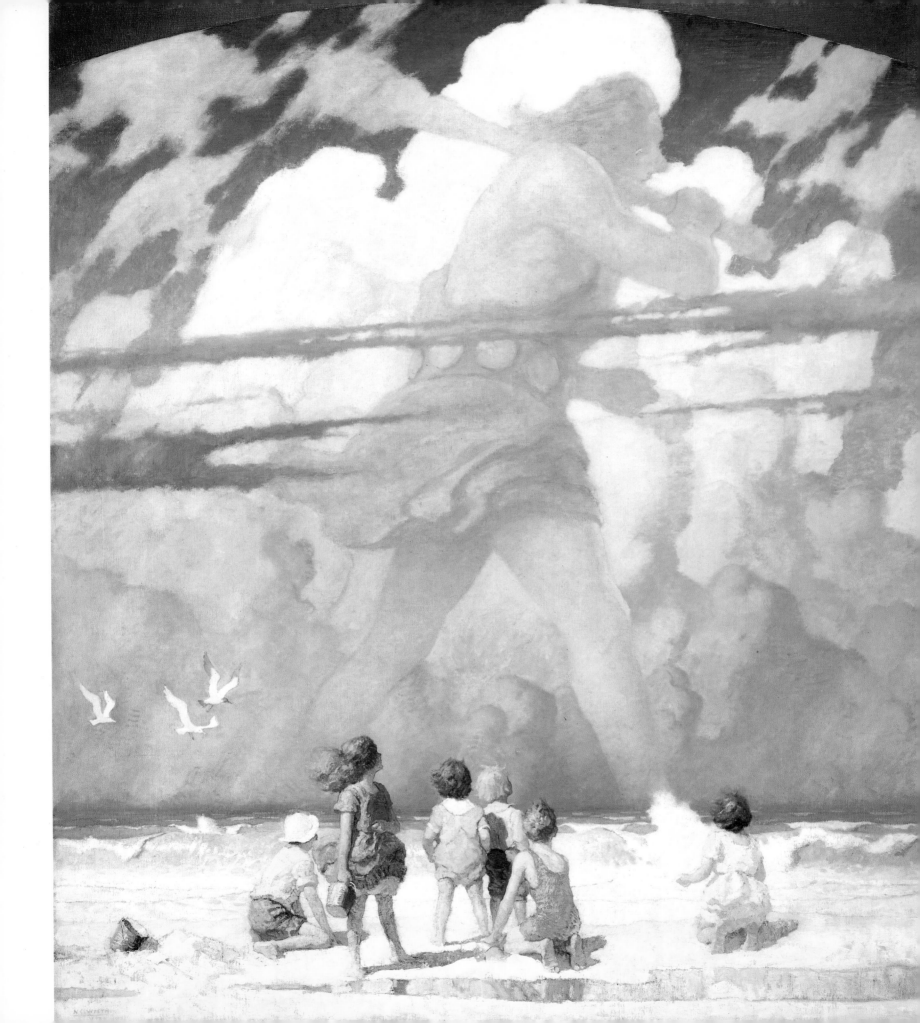

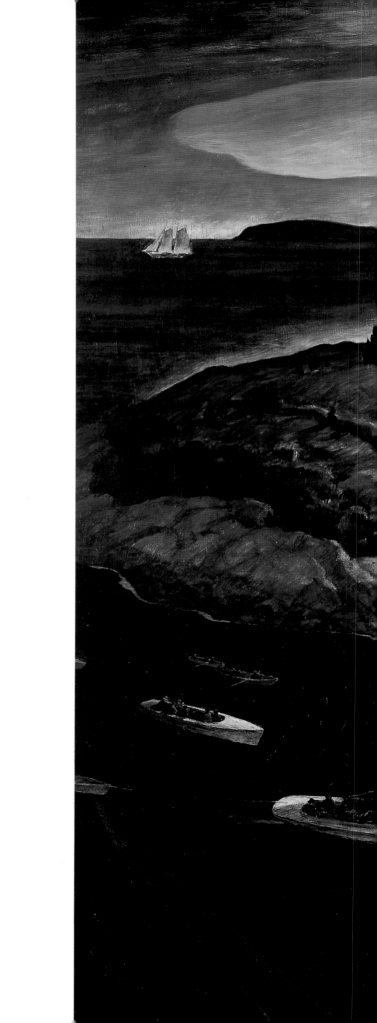

N. C. WYETH

The Island Funeral, 1939

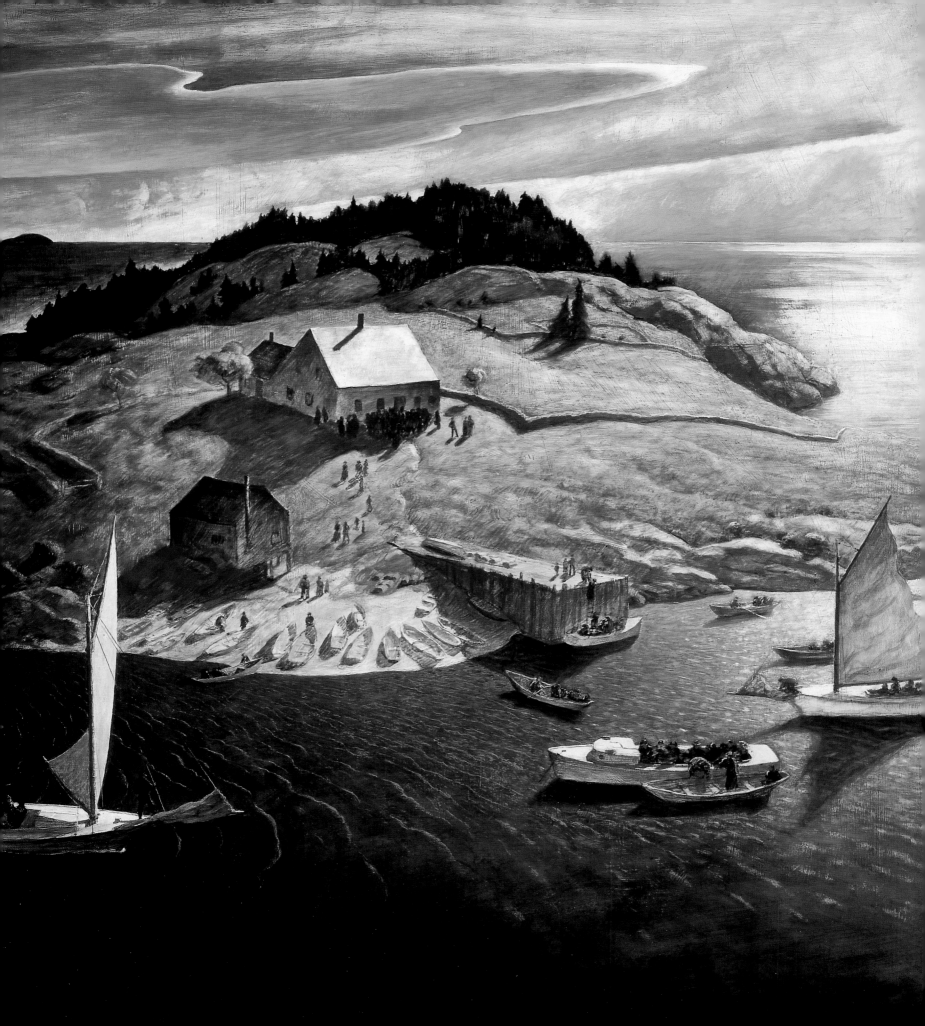

Andrew Wyeth

Essay by Theodore F. Wolff

There are elements of the gothic, as well as of Edgar Allan Poe, in Andrew Wyeth. Not obviously, of course, and not to a significant degree, but sufficiently so to provide an undercurrent of wonder and mystery to a number of Wyeth's paintings, and to underscore his fascination with the darker and more awesome aspects of human experience.

This interest in the macabre and fantastic was already apparent in Wyeth's childhood. Dracula, witches, brave knights defending justice, Dr. Jekyll and Mr. Hyde, dominated his imagination during his formative years and continued to hold a special attraction for him well into his maturity.

Even today, Wyeth delights in painting the wonderful and strange, especially if they can be presented in everyday form and in as straightforward a manner as possible. The result, not surprisingly, is that his art is not always what it seems.

Actually, Wyeth's extraordinary painterly verisimilitude, exacting technique, and commitment to painstakingly authentic images of rural and small-town individuals, places, and events are merely the surface manifestations of a creative vision that is both rich and uncommon, and even, at times, somewhat exotic.

The 1993 tempera *Marriage* (page 99) is a good case in point. In a darkened room, apparently at dawn, a middle-aged couple sleep soundly in their bed. Above them looms a bulky bedpost, and beyond, a window provides a glimpse of open fields. Nothing could be more normal than this picture of marital domesticity. And yet, a second glance suggests that everything is not quite as it appears. Something is amiss. Questions

arise. Are the man and woman really asleep, or are they dead? Why is the bedpost so prominent and vaguely menacing? And, most important, why does the bed with its occupants seem poised to slip through the window toward the distant horizon and beyond?

There are no clear-cut answers to these questions, only subtle hints. Indeed, for some viewers, *Marriage* probably raises no questions and is precisely—and only—what its title indicates: a painting of a sleeping married couple.

Even these individuals, however, would undoubtedly sense a deeper and more ominous dimension to *Adrift* (1982; page 118) than is suggested by its title. The picture's unremitting air of stillness and finality creates the suspicion that the old man in the boat depicted in it is dead, rather than asleep.

On a less grim, but no less provocative note, *Flint* (1975; page 112), which portrays nothing more unusual than a huge boulder, as well as a few crab shells, lobster claws, and seagull droppings, manages somehow to transcend its commonplace subject matter to become a haunting reminder of the immensity of time and the inexorable forces of nature. By successfully playing the finite (the boulder and wildlife residue) off against the infinite (time and space) in this dramatic, theatrically illuminated composition, Wyeth not only fashioned one of his most compelling images, he proved as well that wonder and awe lie very close to the center of his creative universe.

This sense of wonder manifests itself in a variety of ways. It touches upon matters of cosmic magnitude, as in *Flint*; revels in the magic of unusual natural phenomena (*Night Hauling,* 1944;

page 111); examines the annual cycle of death and regeneration (*Spring,* 1977; pages 108–109); explores hidden recesses of the human mind (*Moon Madness,* 1982; page 98); delights in the textural complexity and richness of nature (*Trodden Weed,* 1951; page 102); and even enters into the realm of the surreal (*Christmas Morning,* 1944; page 100).

But perhaps the most moving demonstrations of Wyeth's feeling of wonder can be found in those works that present veiled and fleeting glimpses into the more private and protected areas of his vision and sensibilities.

Night Shadow (1978; page 97) and *Night Sleeper* (1979; page 96) are high on the list of these special creations. The former because, in it, Wyeth successfully employed his sleeping model to memorialize the emotions he felt upon viewing his father, N. C. Wyeth, in his casket thirty-four years earlier. And the latter because it so brilliantly embodies Wyeth's obviously meaningful but profoundly personal feelings and intuitions without revealing their exact nature, that it will forever remain as tantalizingly enigmatic as it was on the day it was completed.

Night Sleeper represents Wyeth at his best and most "wondrous strange." Everything in it, from the seemingly asleep but quietly watchful dog, to the exquisitely understated moonlit landscape, is perfectly realized, both in itself and as an essential element in the painting's dreamlike mood. It is this mood, together with the work's formal integrity, that gives this composition its wonderfully enigmatic quality. *Night Sleeper* can never be satisfactorily explained. Like Henri Rousseau's *The Sleeping Gypsy,* it raises more questions that it answers.

But why should art not be impenetrable? Beyond easy comprehension? It presents challenges and opportunities, not easy answers and simple solutions.

Wyeth has always understood this. Even such very early works as *Christmas Morning, Trodden Weed,* and *The Revenant* (1949; page 101) challenge the viewer to go beyond the obvious, to probe into the elusive, often ambiguous creative vision and imagery of an artist whose quality and significance evolved independently of both a powerful father's professional example and modernist ideals and dogmas.

The Revenant, for instance, could only have been painted by a non-modernist, someone who did not bother to turn his back on modernism, but simply ignored it. This independence of mind has always served Wyeth well. It is apparent, not only in such major paintings as *Night Sleeper* and *Flint,* but also in more modest works such as *The Duel* (page 119), *Sea Boots* (page 121), and *Jack Be Nimble* (page 94), all from 1976. In these images, simple, everyday objects assume new identities by means of imaginative juxtapositions and placements. Thus, in *Sea Boots,* a missing fisherman's presence is evoked by his heavy, well-worn boots planted dramatically in the picture's foreground. And in *The Duel,* a slender oar leans casually against a massive boulder, suggesting thereby an imminent "duel" of opposites.

Wyeth has also, upon occasion, ventured into the fantastic. Probably the most startling of his paintings in this vein is his 1981 tempera *Dr. Syn* (page 117). It depicts the artist as a seated skeleton wearing a War of 1812 navy officer's jacket and staring out to sea from within his ship's cabin. At other times, Wyeth's prankish side predominates, as in his 1990 watercolor *No Trespassing* (page 104). Here, two large spook-like eyes glare out from a tree to warn strangers away. But for sheer unsettling strangeness, nothing else Wyeth painted can compare with his 1977 tempera *Spring* (pages 108–109), in which a sleeping man is revealed in a melting mound of ice and snow.

On the whole, however, the origins and deeper significance of Wyeth's imagery tend to remain hidden and to reveal themselves only indirectly or subliminally. As noted before, the exacting, down-to-earth naturalism of his paintings can be deceptive. Who would suspect, for instance, that the intriguing but otherwise quite ordinary-looking *Trodden Weed* is actually a self-portrait, and that it was intended to represent death indiscriminately crushing life underfoot?

Interestingly enough, even when Wyeth himself offers an explanation (as he did for *Trodden Weed*), it somehow doesn't altogether fit. There is always more to his paintings than their origins indicate. And why not? Wyeth is an artist with a world of interesting things bubbling away beneath the surface, many of which find their way into his art one way or another.

It is what occurs in a Wyeth painting between conception and completion that sets it apart from the work of almost every other contemporary realist and gives it that added dimension of character, conviction, and, upon various occasions, wonder and enchantment, that is so recognizably his. Wyeth embarks upon a painting as though upon a journey. He may know precisely where he is going, and how he is going to get there, but, more often than not, his deepest creative satisfaction, as well as the special significance of a particular work of art, derive, not so much from his successful arrival at this destination, as from what he discovers and invents along the way.

The deeper one's involvement with Wyeth's art, the more one realizes how totally and happily he exists in every square inch of his paintings, and how seriously and imaginatively he considers how best to transform even the most insignificant detail of what lies before him into art. *That*, as much as the frequently provocative nature of his themes, the subtly brooding aura of his imagery, and the formal perfection of his compositions, is the source of the exceptional "wondrous strange" nature of much of his art.

Wyeth's paintings are not, as the misinformed may believe, solely about skill, attachment to the past, or a commitment to appearance. They represent, rather, a passionate desire to objectify, give significance to, and share profoundly private feelings and intuitions he believes to be of value and interest in the most efficient and convincing manner possible.

For an artist of Wyeth's family background and training, the only honest and effective way to achieve those objectives was through sensitively crafted representationalism utilizing the appearance of the world around him as its basic raw material. Once that was determined—and his earliest watercolors and paintings reveal how sure he was of his direction even as a teenager—everything else followed logically, if not, perhaps, always easily.

Even so, nothing deterred him. He never wavered in his overall objectives—although he has, now and again, indulged himself by touching upon the fantastic and the macabre in his paintings, much as he did as a boy when he was introduced to the wondrously strange world of Dracula and Dr. Jekyll and Mr. Hyde.

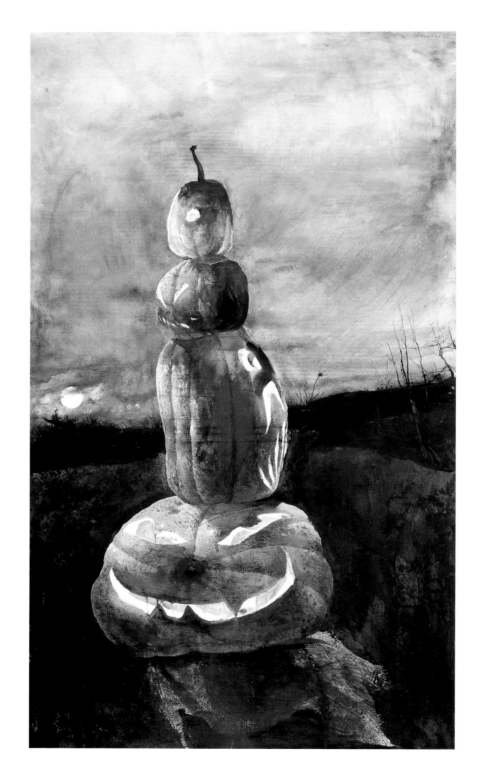

ANDREW WYETH

Jack Be Nimble, 1976

ANDREW WYETH >

New Moon, 1985

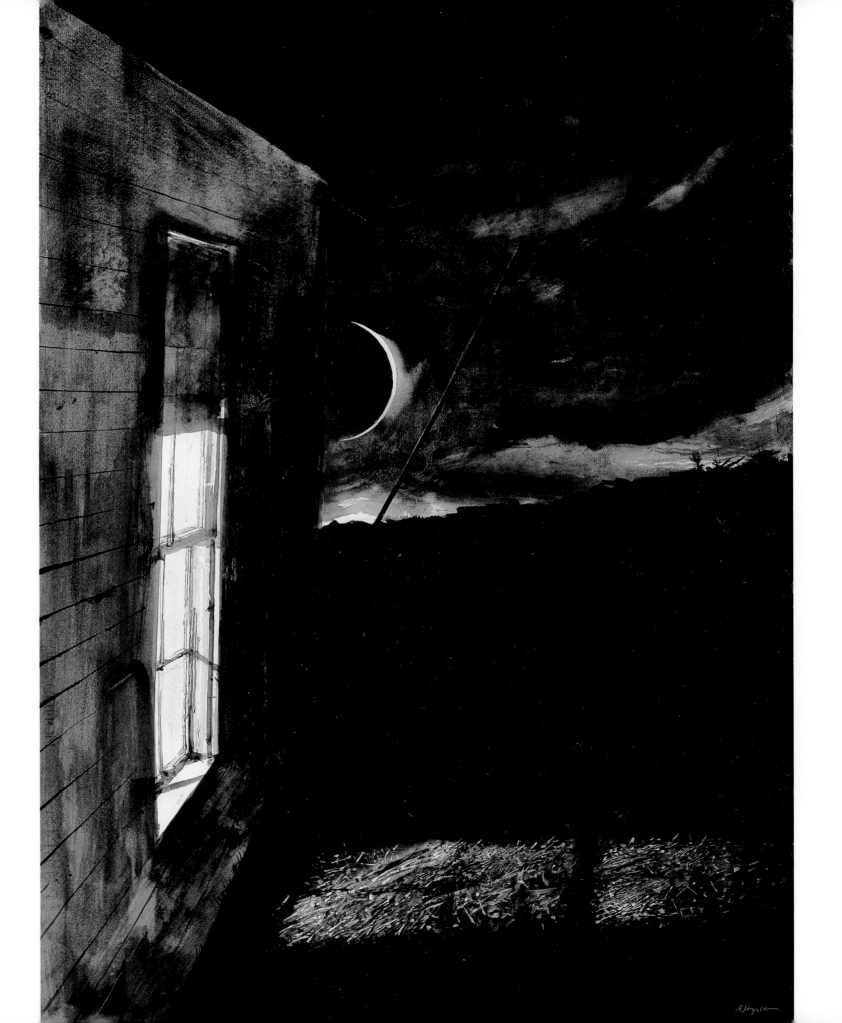

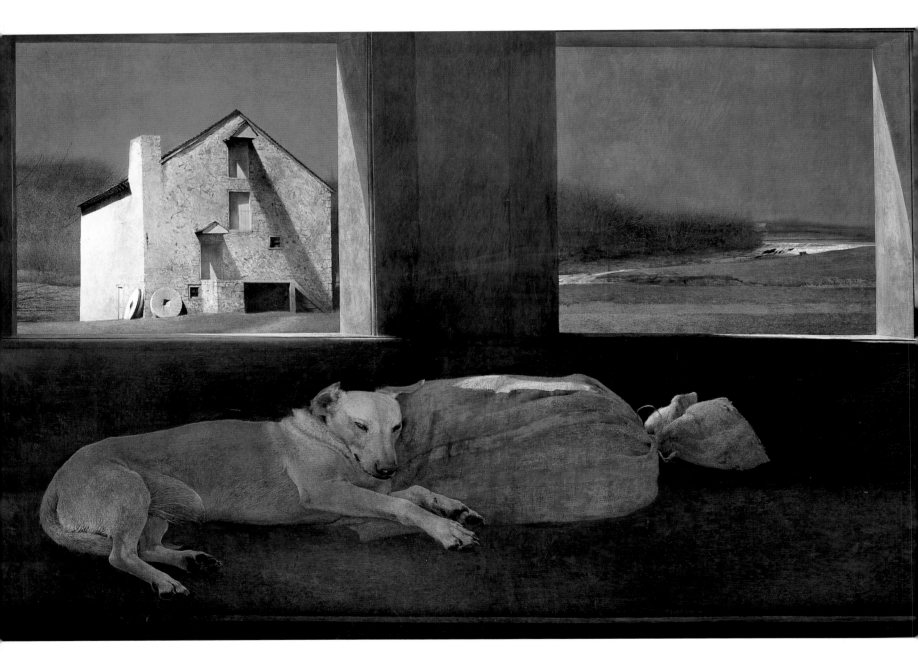

ANDREW WYETH

Night Sleeper, 1979

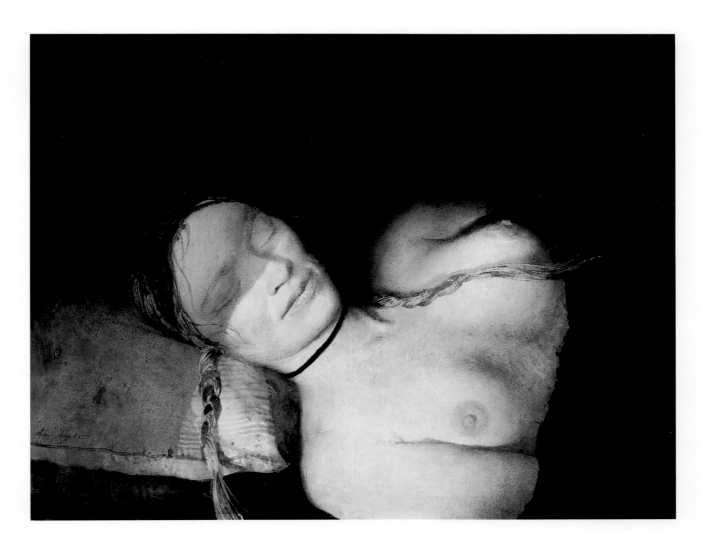

ANDREW WYETH
Night Shadow, 1978

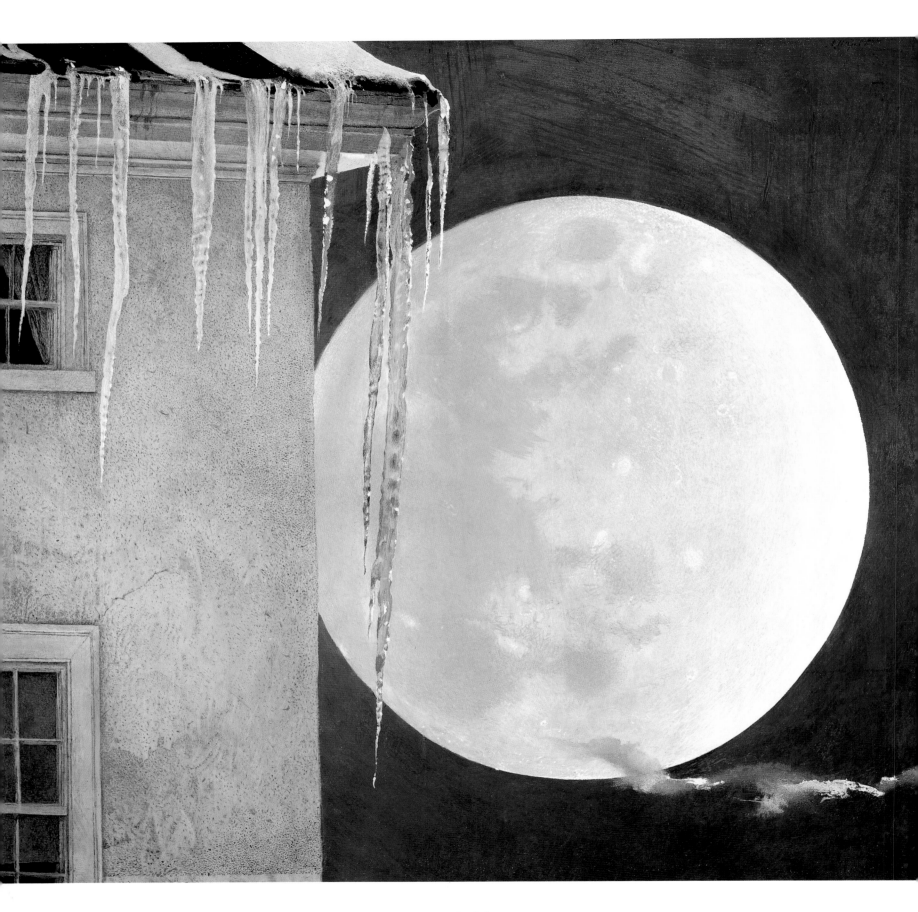

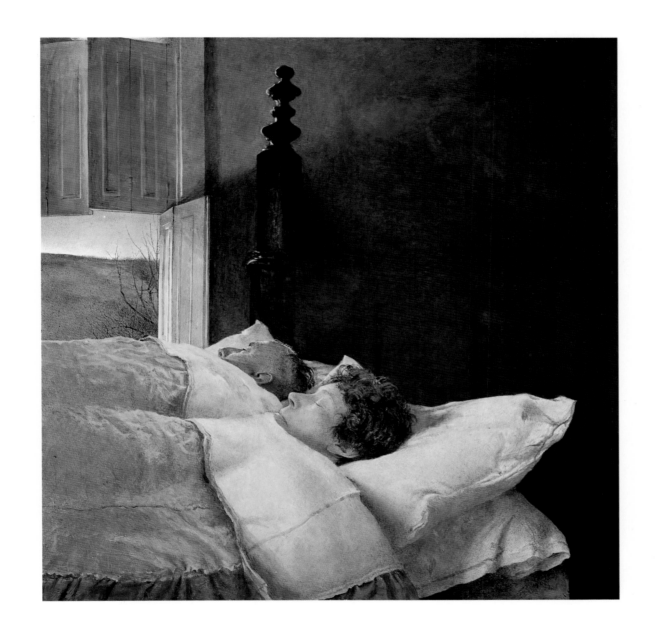

ANDREW WYETH

Marriage, 1993

ANDREW WYETH

< *Moon Madness, 1982*

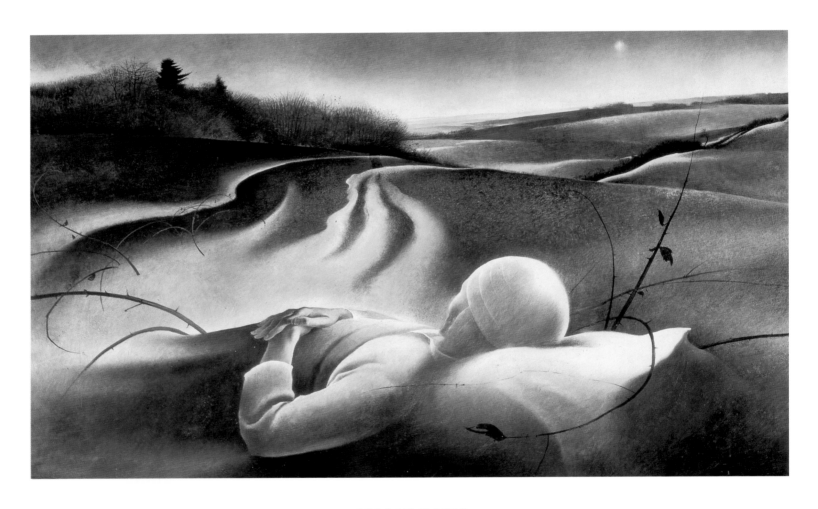

ANDREW WYETH

Christmas Morning, 1944

ANDREW WYETH >

The Revenant, 1949

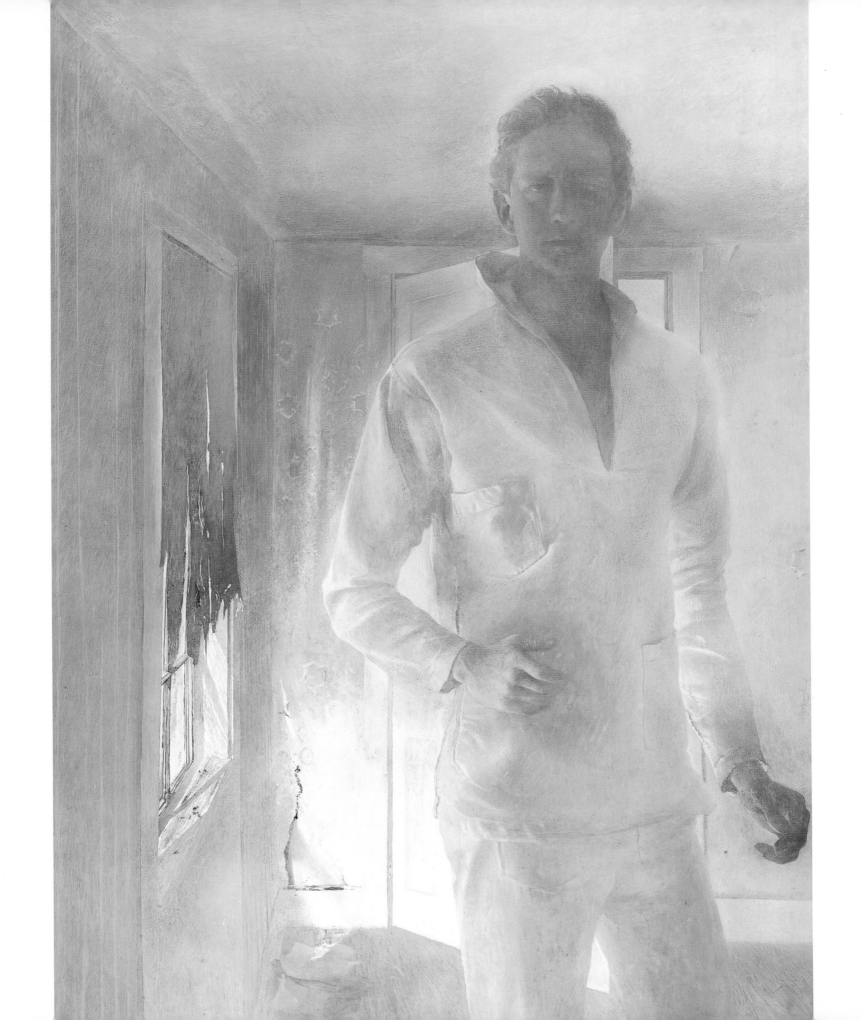

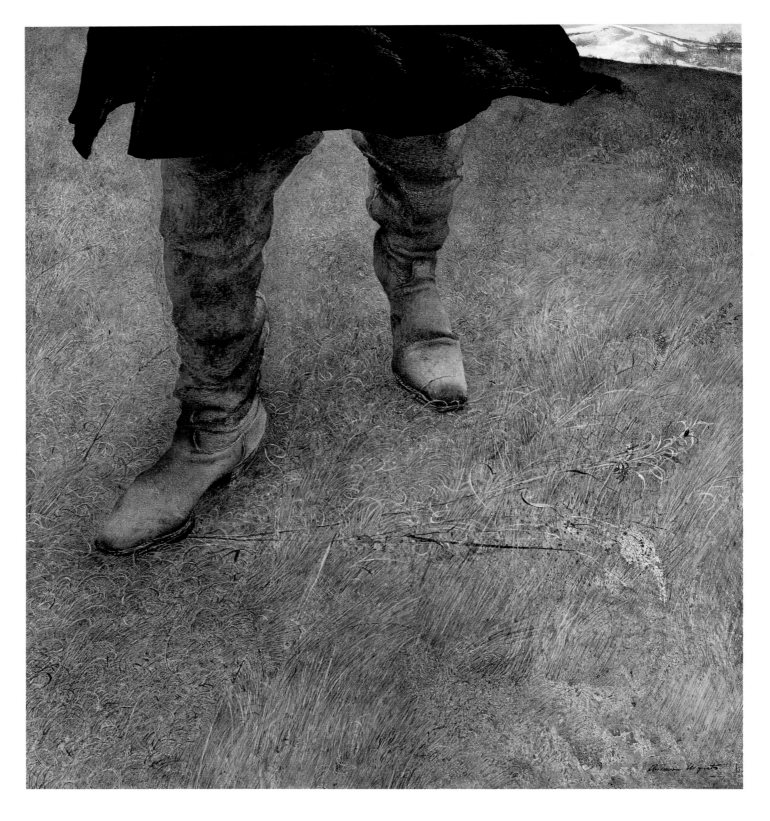

ANDREW WYETH
Trodden Weed, 1951

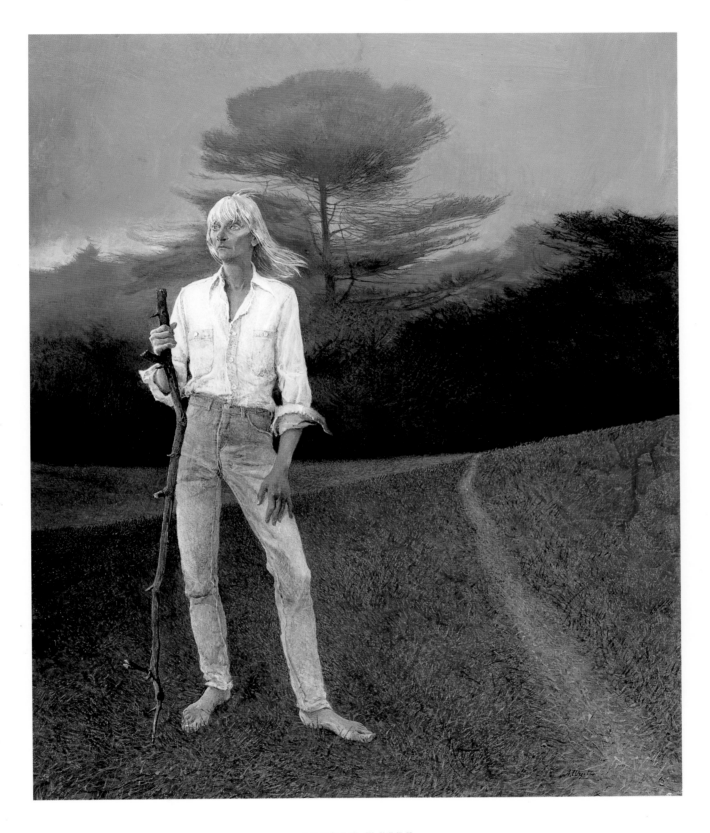

ANDREW WYETH

Witches Broom, 1990

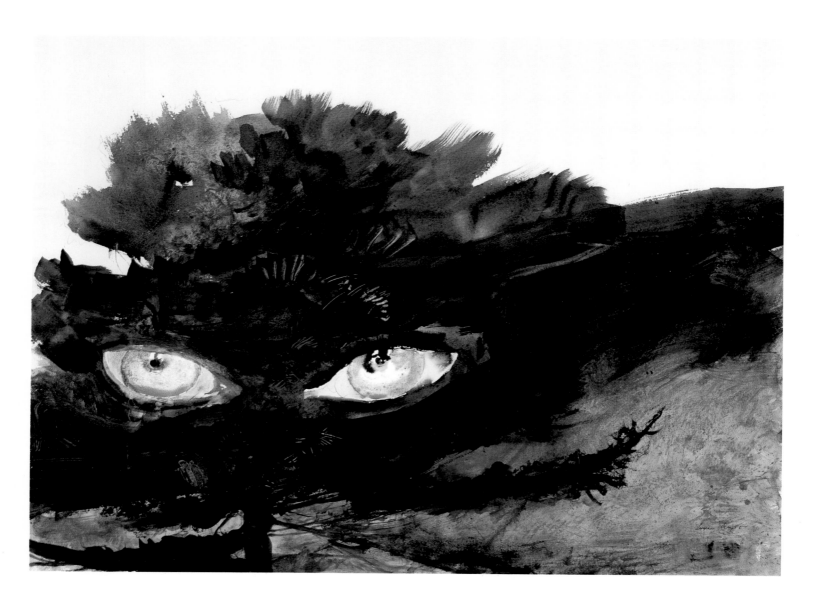

ANDREW WYETH
No Trespassing, 1990

ANDREW WYETH >
Raven's Grove, 1985

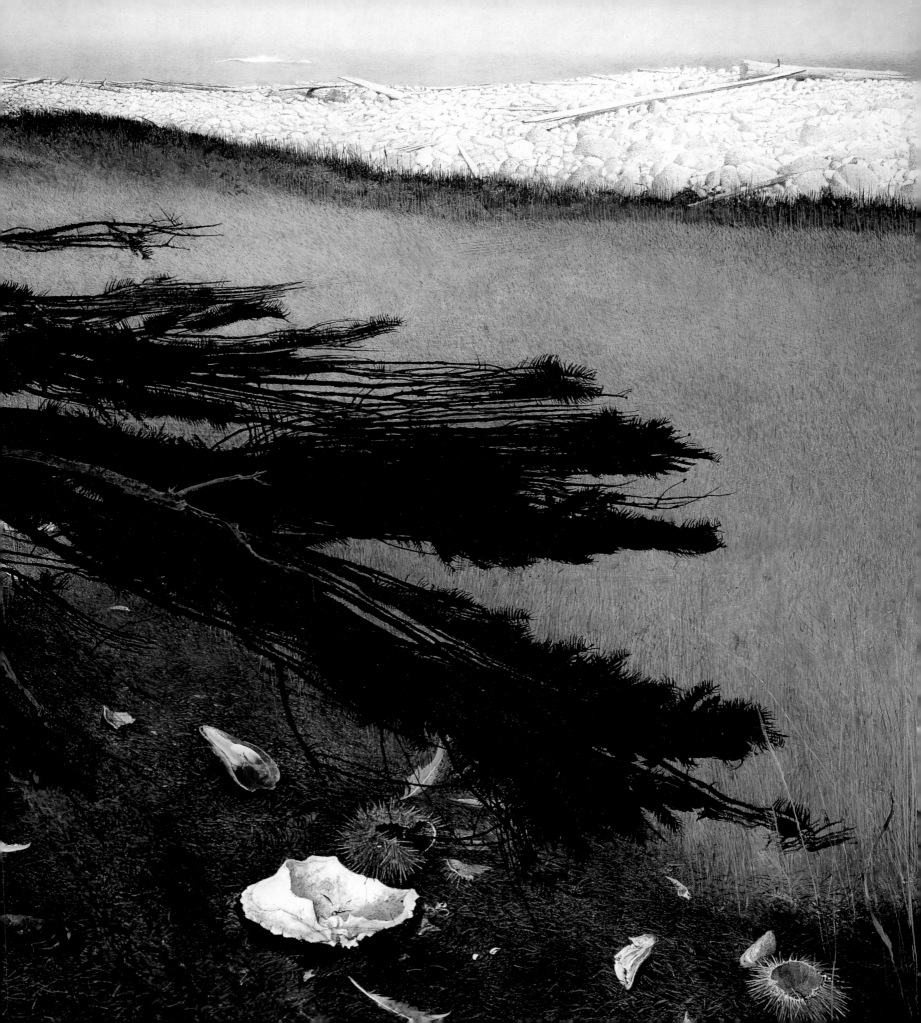

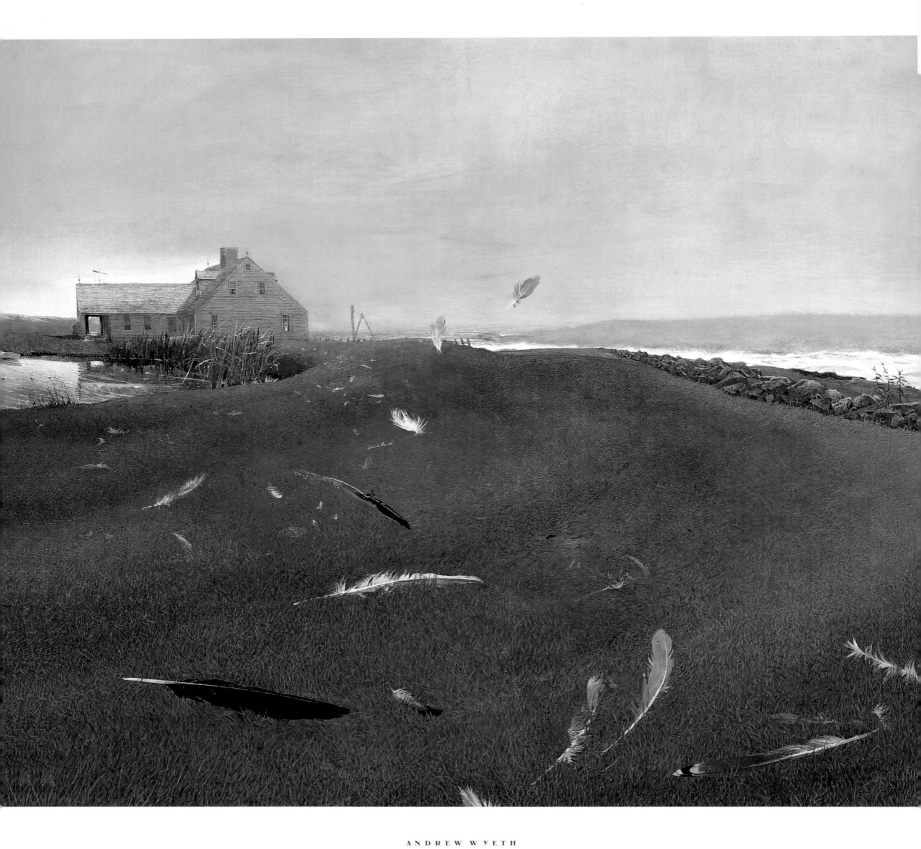

ANDREW WYETH
Airborne, 1996

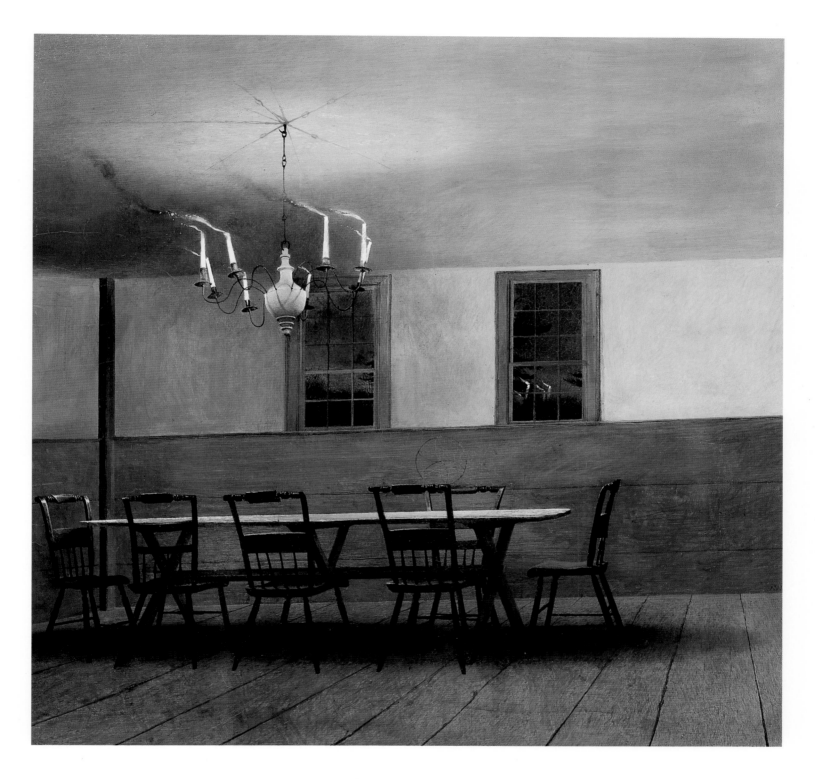

ANDREW WYETH
Witching Hour, 1977

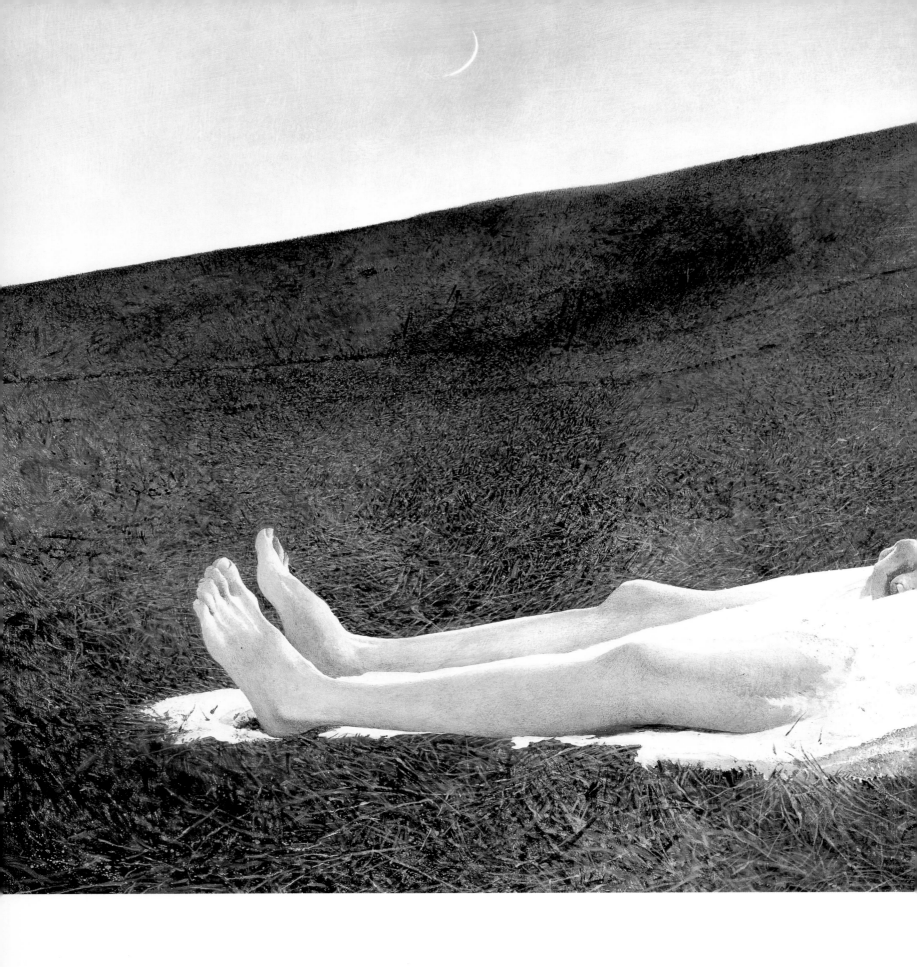

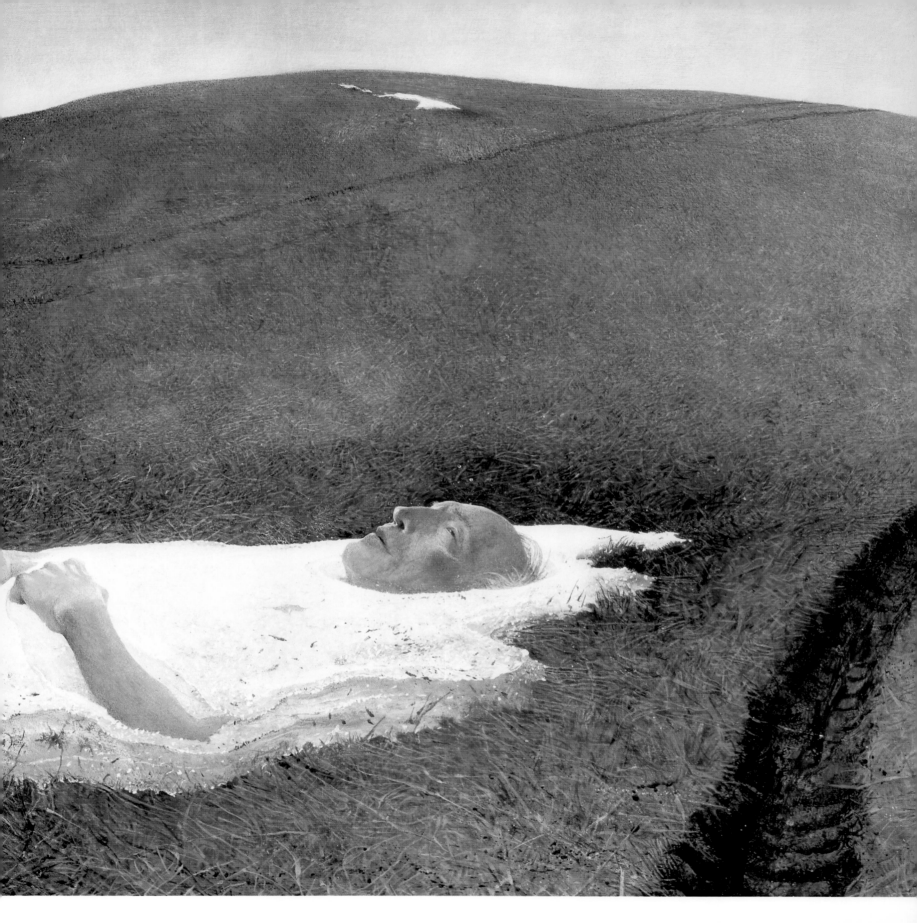

ANDREW WYETH

Spring, 1977

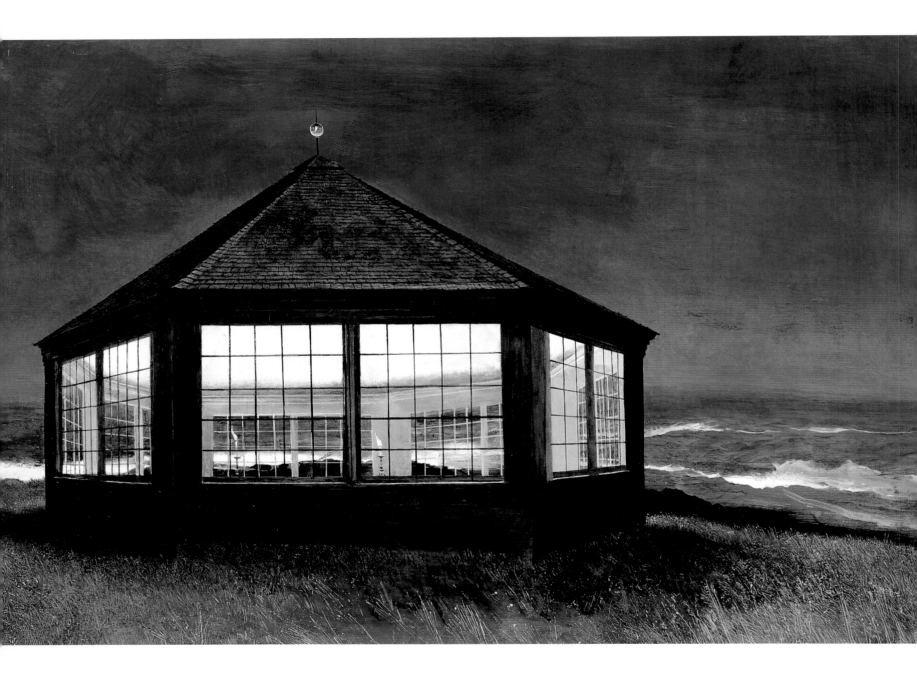

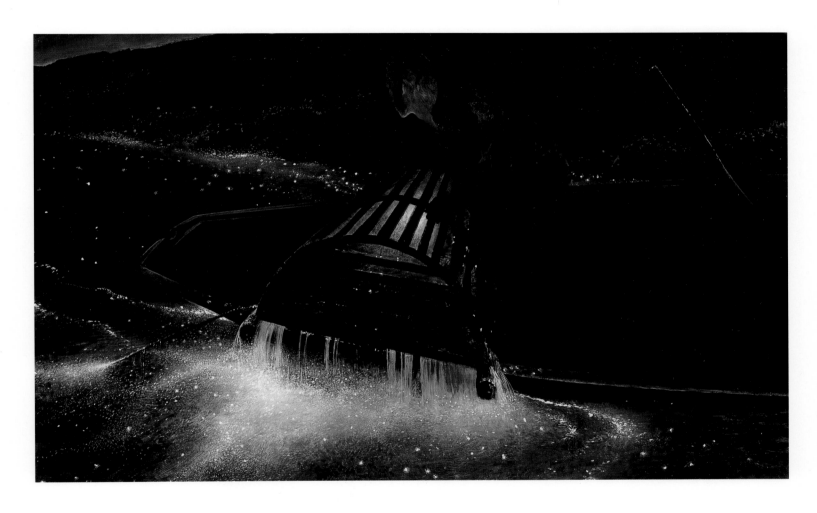

ANDREW WYETH
Night Hauling, 1944

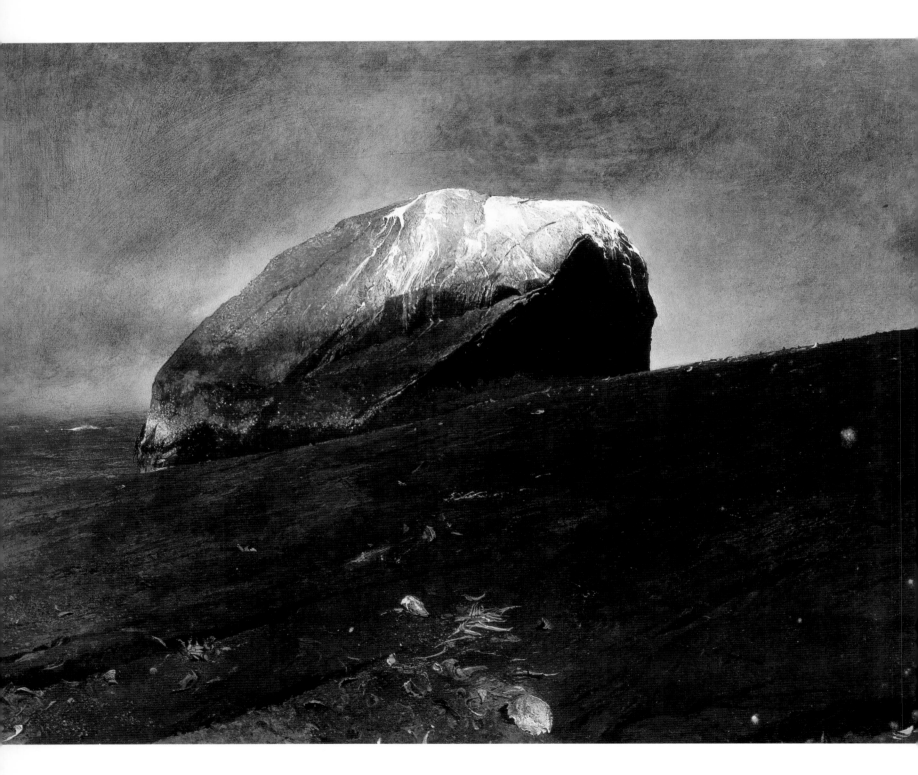

ANDREW WYETH
Flint, 1975

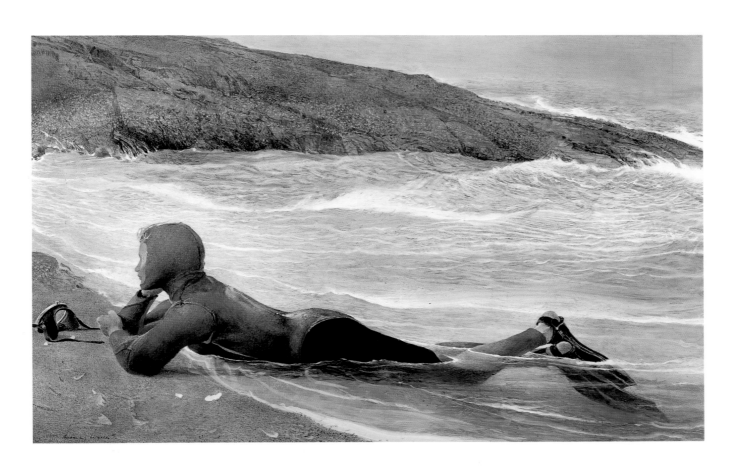

ANDREW WYETH

Scuba, 1994

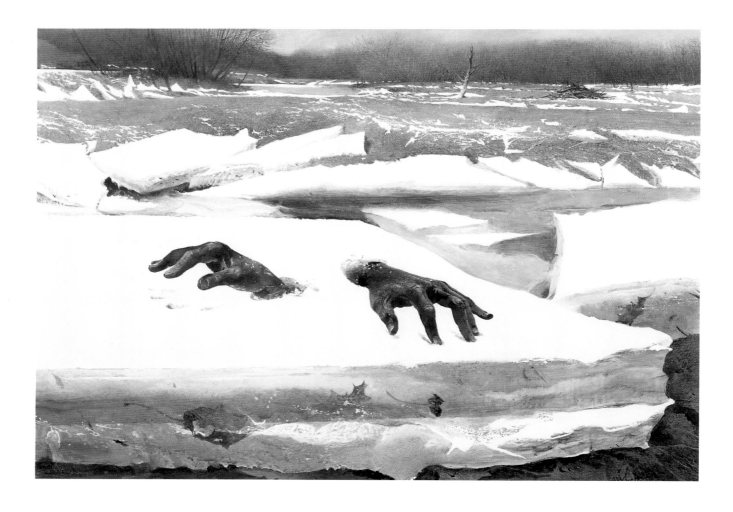

ANDREW WYETH
Breakup, 1994

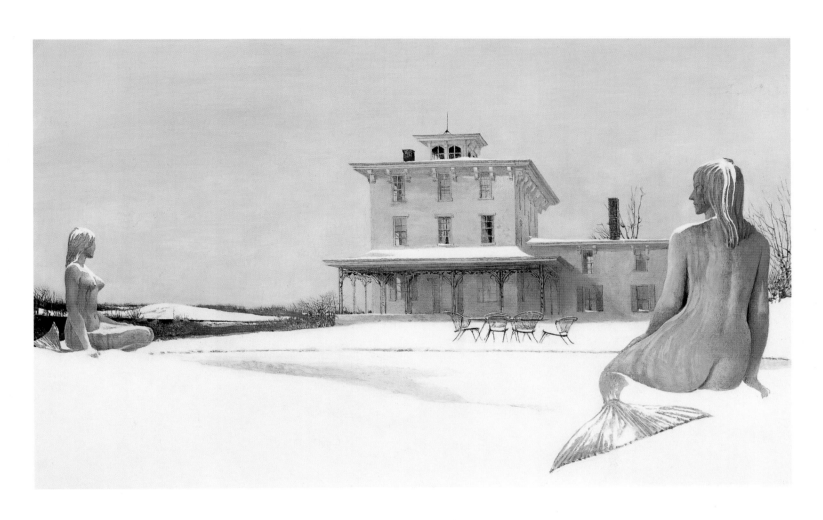

ANDREW WYETH
Painter's Folly, 1989

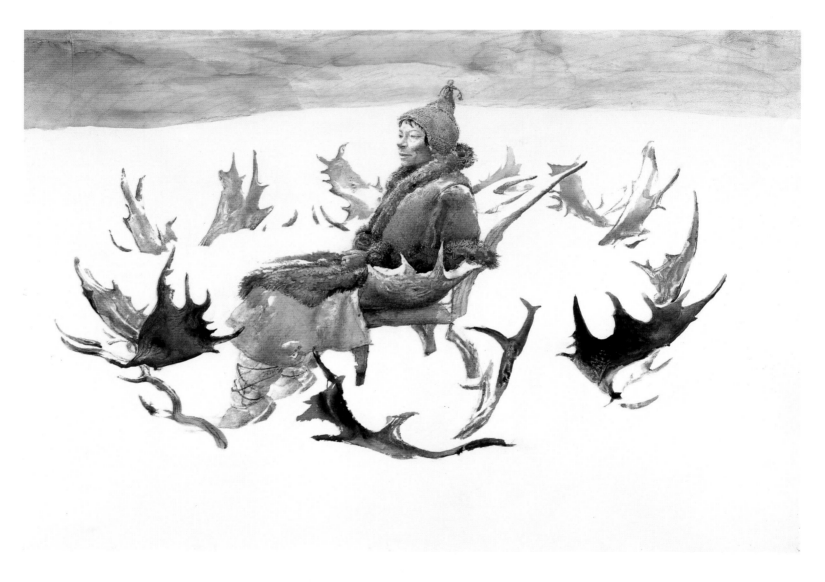

ANDREW WYETH
Arctic Circle, 1996

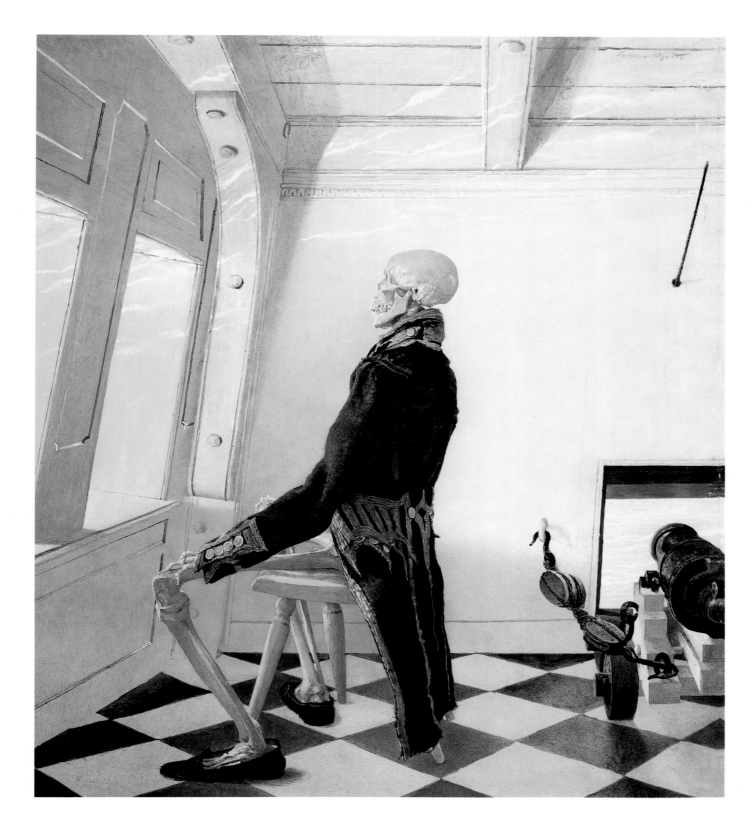

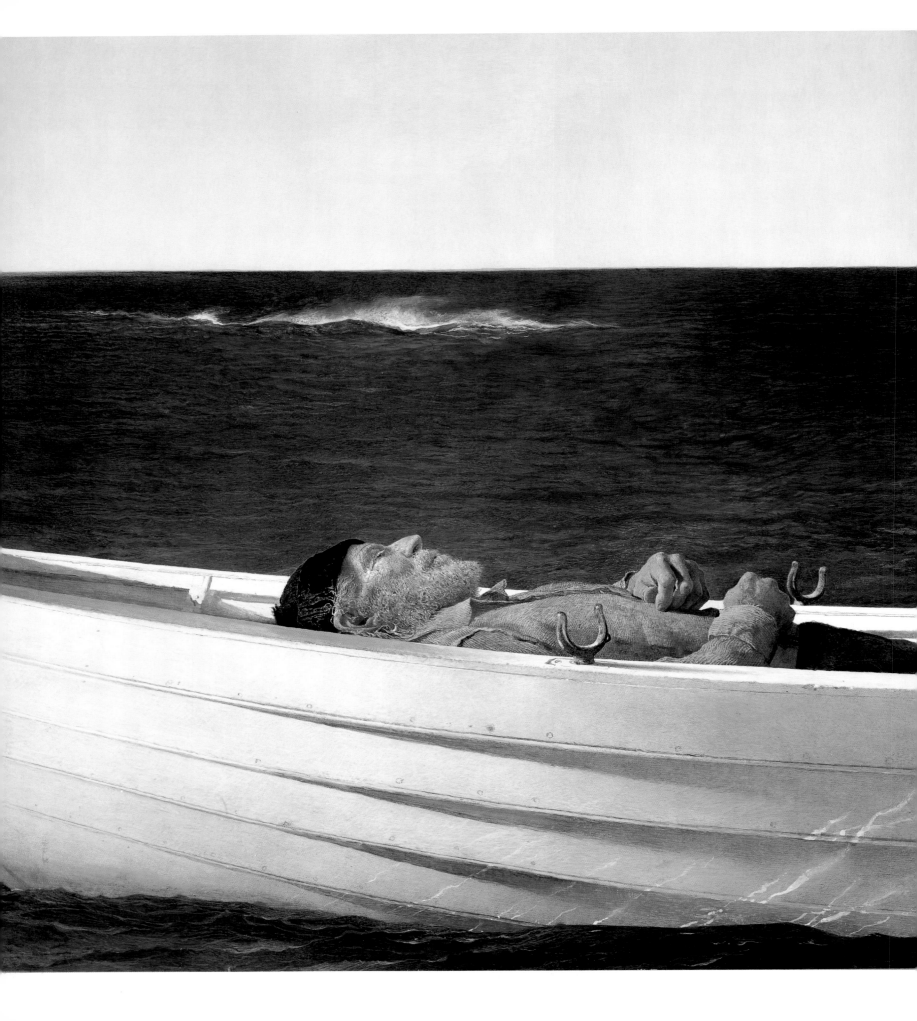

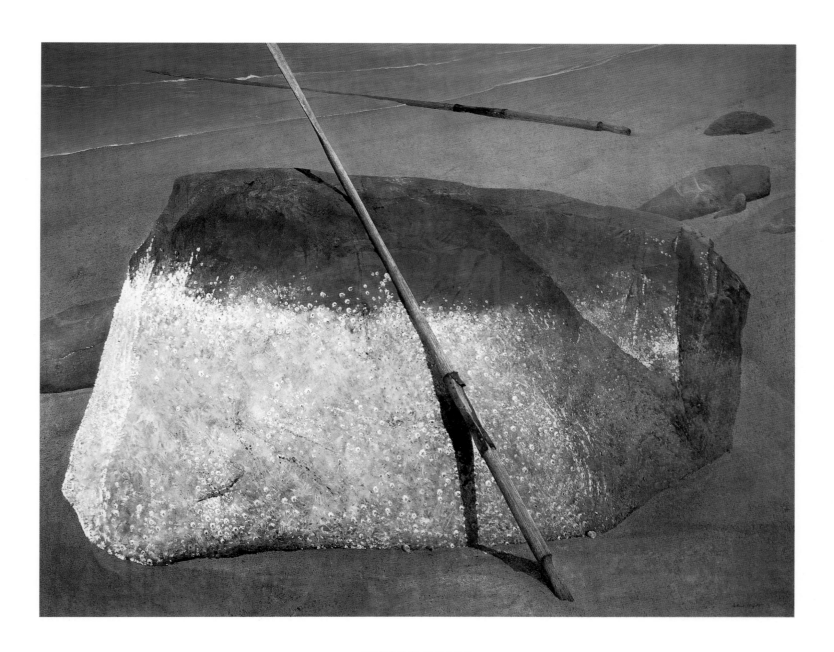

ANDREW WYETH
The Duel, 1976

< ANDREW WYETH
Adrift, 1982

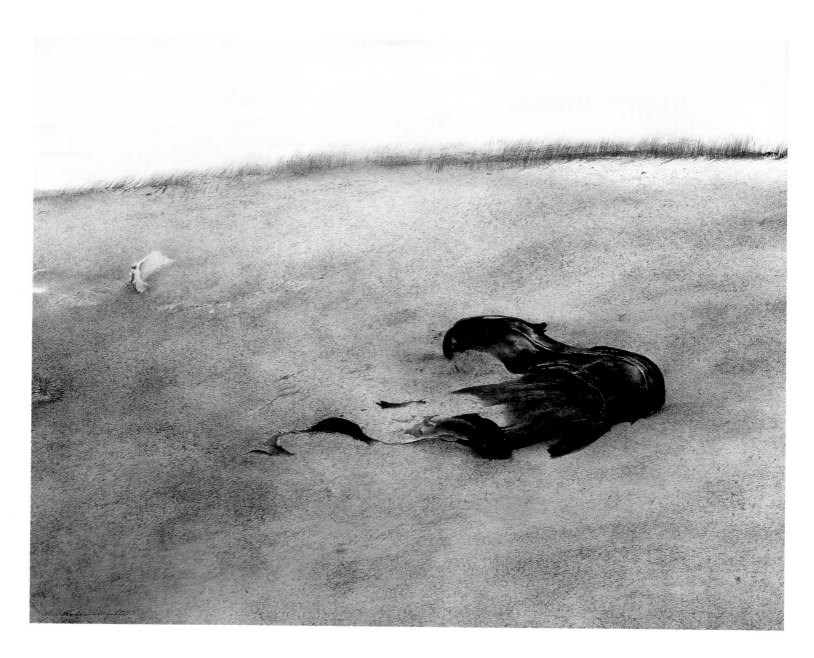

ANDREW WYETH
His Boot, 1951

ANDREW WYETH >
Sea Boots, 1976

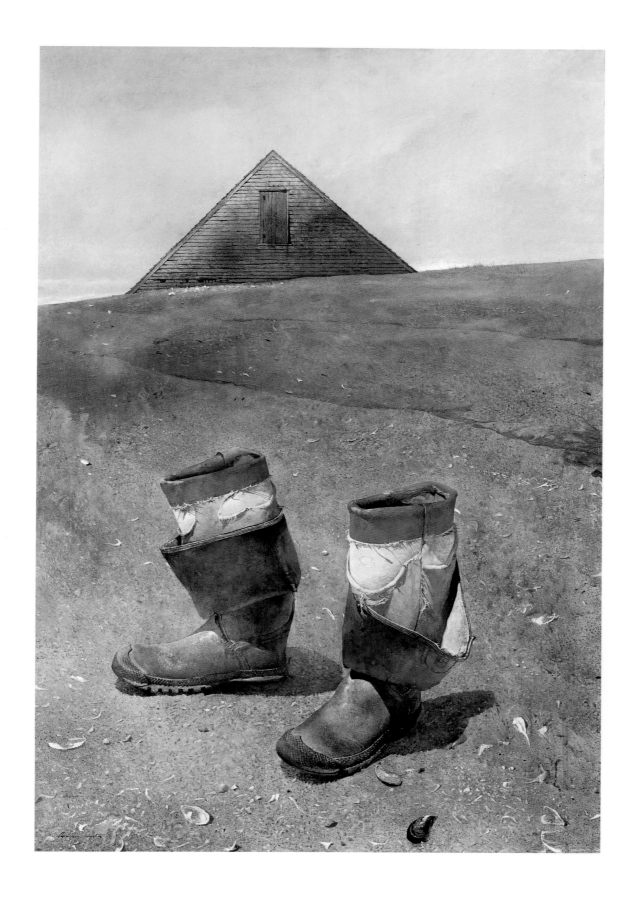

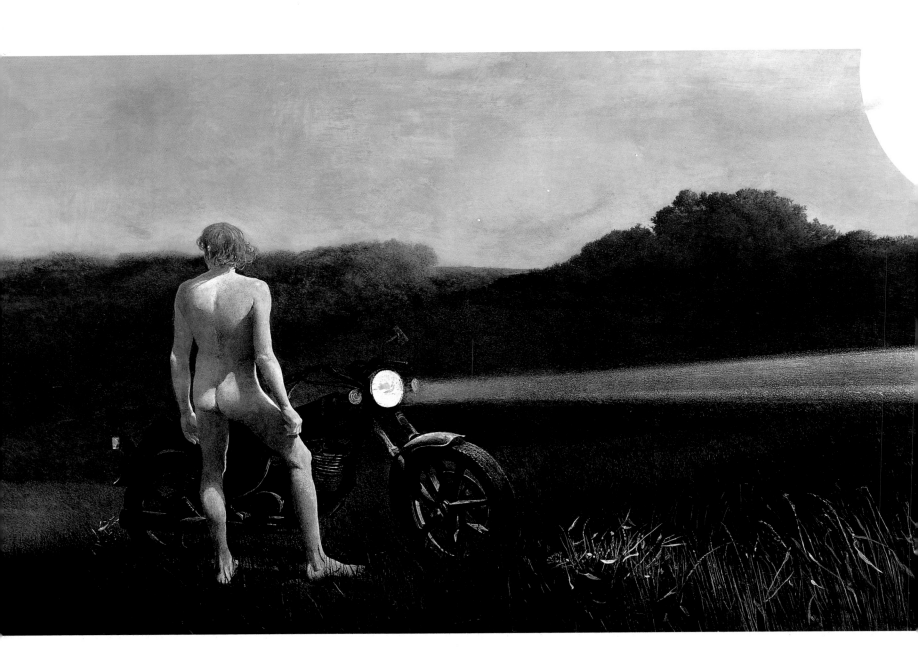

ANDREW WYETH
Man and the Moon, 1990

ANDREW WYETH >
Omen, 1997
(overleaf)

ANDREW WYETH
Malemute, 1976

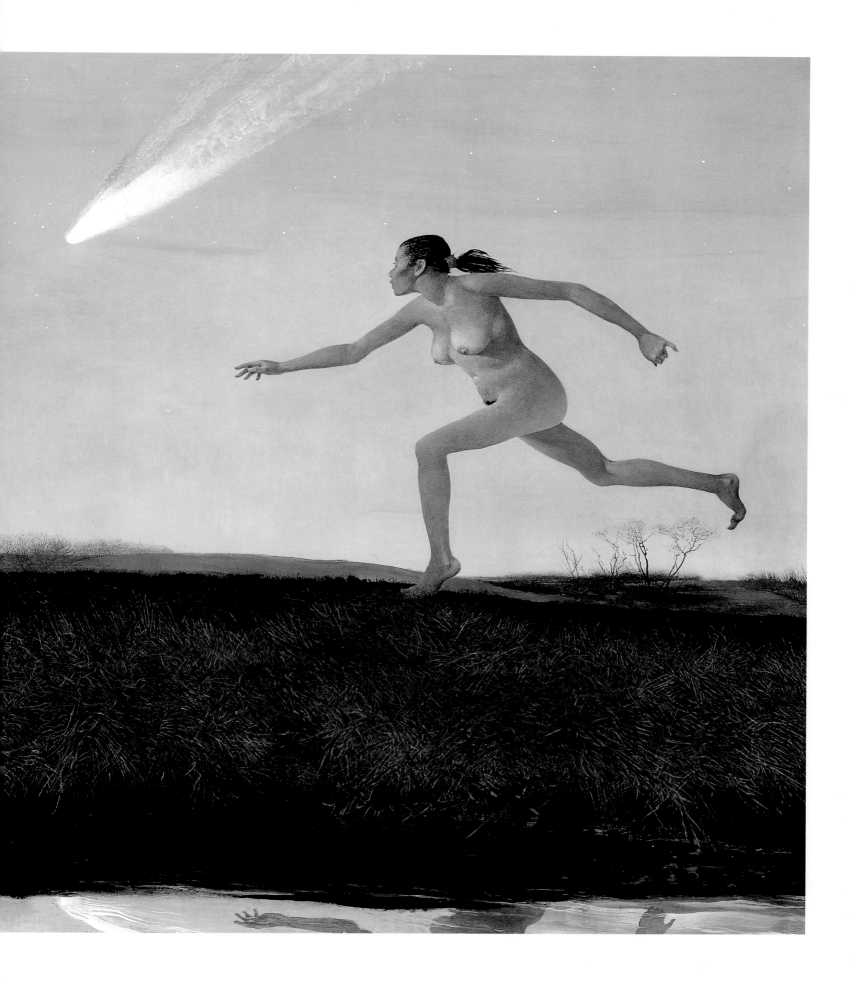

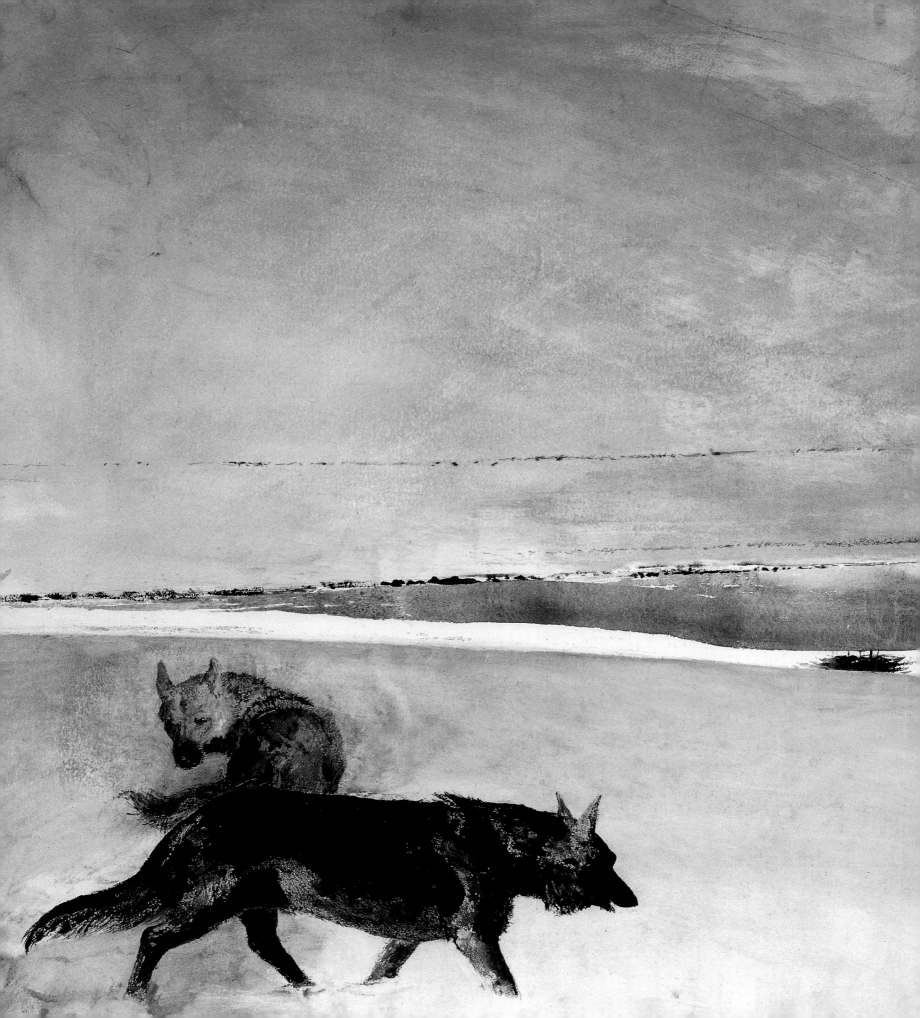

James Wyeth

Essay by Christopher Crosman

STAGGERING AS IF HE WERE DRUNK, MEAULNES SLOWLY SET OFF ALONG THE ROAD TO SAINTE-AGATHE, WITH HIS SHOULDERS HUNCHED AND HIS HANDS IN HIS POCKETS, WHILE THE OLD BERLIN, HIS LAST LINK WITH THE MYSTERIOUS CELEBRATION, LEFT THE GRAVEL OF THE ROAD AND JOLTED SILENTLY AWAY ON THE GRASS OF THE SHORTCUT. SOON NOTHING COULD BE SEEN OF IT [THE LOST DOMAIN] BUT THE DRIVER'S HAT, DANCING ABOVE THE HEDGES.

—HENRI ALAIN-FOURNIER, *THE WANDERER*

OH, HE LOVED BROOKS. THE MOVING WATER GOING THROUGH A LANDSCAPE AND THE WAY IT WANDERED. HE ALSO LOVED THE IDEA OF A PATH. HE THOUGHT A PATH COULD INDICATE THE QUALITY OF THE PERSON.

—ANDREW WYETH ON N. C. WYETH[1]

The seamless blending of dream-like imagery and closely observed detail is characteristic of many of the paintings of Howard Pyle and N. C. and Andrew Wyeth, but nowhere is it more apparent than in the work of Jamie Wyeth. Born in 1946 he is at mid-career and has developed a fully independent vision, one that he freely acknowledges owes much to his father, grandfather, and Pyle. Jamie's recent work, especially, seems indelibly informed by N.C., who carried a particular variant of nineteenth-century realism—owing much to Pyle— into the present century. It is a type of realism, invented to meet the demands of illustration and mechanical reproduction, that N.C. largely perfected: dramatic intensity through theatrical lighting effects; a bold, although relatively limited palette of saturated color; strong, firm outline; close-up per-

spective placing the viewer in the action of the depicted scene; elimination of all superfluous detail to concentrate attention on the critical, telling moment. At the same time Jamie Wyeth is a child of the post–World War II era who is deeply conversant with the art of his own time. His imagination wanders freely between past and present—his family's remarkable legacy and the contemporary milieu—accounting, perhaps, for a sense of dislocation in his paintings, of betwixt-ness and wonderment, of sentiment deftly colored by irony, of narrative translated by memory.

A part of the strange and wondrous mood at the end of the present century that seems to fascinate the Wyeths may have been identified much earlier by an obscure French author, Alain-Fournier, who wrote one of the first truly "modern" novels, *The Wanderer*, in 1912, shortly before the outbreak of World War I. It is a book that Jamie Wyeth discovered only a few years ago, although the book seems to have been a great favorite of his father and grandfather too. Not so much direct inspiration, *The Wanderer* seems to confirm a kind of parallel sensibility seen in certain Wyeth images.[2] Subtitled "The End of Youth," *The Wanderer* is a semi-autobiographical story told through a scrim of memory and in a way that evokes both the Pre-Raphaelite's emphasis on dream-like vision and precise detail and late Symbolist poetry's sense of loss and languorous, shadowed regret. The images and descriptive "voice" of the book recall the words of Pre-Raphaelite painter Edward Burne-Jones, who once said: "I mean by a picture a beautiful

romantic dream of something that never was, never will be—in a light better than any light that ever shone—in a land no one can define or remember, only desire. . . ."³ A number of mysterious images and scenes in the novel—indistinct figures in shadows or passing through or opening closed doors and traversing moonlit landscapes (for example, "the corridor that was once full of whisperings and strange passings")—are recurring motifs in various paintings by both Jamie and Andrew.⁴

One of the key images in the novel is that of an elaborately decorated vest worn by the young protagonist, Meaulnes: "It was a charmingly quaint garment, of the kind that must have been worn by young men when they danced with our grandmothers at balls of the eighteen-thirties."⁵ Meaulnes's elegant vest "of a marquis" is the only vestige from a magical night spent at a mysterious château in "the lost domain" where he falls in love with a girl he meets briefly at a strange celebration. Whether or not the authentic War of 1812 naval tunic worn by the figure in Jamie Wyeth's *The Wanderer* (1993; page 154) is a conscious reference to the novel is probably irrelevant. It does, however, invest this contemporary youth, Orca Bates, with an otherness as he looks across the inlet toward the lights of modern Tenants Harbor, Maine. It is the same jacket that was owned by Howard Pyle, that was passed on to N.C. and then to Andrew (where it appears in *Dr. Syn* [page 117], among other works), a mantle literally passed on to succeeding generations with its own resonant history of historical artifact and studio prop. Wearing the past while looking with hesitation and desire toward an uncertain future is a recurrent theme in Jamie Wyeth's paintings. *Meteor Shower* (1993; pages 156–157) is even stranger, conjuring associations with the bird-like masks of the French Carnival and Pierrot—tramp, thief, and

good-hearted, sad clown of country fairs as portrayed in Alain-Fournier's novel as well as in roughly contemporaneous paintings by Picasso. The literal wondrousness of a meteor shower and its awe-inspiring display is juxtaposed to a fantastic being, part dandy, part scarecrow, who suggestively turns away from the mainland village, neither allowed nor desiring to belong there.

It has been suggested that "'adolescence' is an invention of the twentieth century."⁶ If so, no other contemporary artist has portrayed this complex passage with greater poetic precision and insightfulness than Jamie Wyeth. Recently Wyeth has depicted another model, a girl on the edge of womanhood who, like Orca Bates, has a certain androgynous appearance, reinforcing a quality of betweenness, of a momentary state of becoming. She appears in *Other Voices*, (1995; page 135) with her hand pressed against a closed door. Not coincidentally, images of delicate, thin, outstretched fingers are seen throughout the paintings of Pyle, N. C., and Andrew Wyeth, almost as a kind of leitmotif for the varying moods and degrees of wondrous strangeness evoked by each of the artists. The child-woman subject of *If Once You Have Slept on an Island* (1996; page 155) sits on the edge of a bed, her eyes wide and fixed as if daydreaming, unconscious of a breeze stiffening her hair or the churning, light-inflected sea outside her window. It is an image that recalls Howard Pyle's illustration *Vitia and the Governor* (page 33), less in the paintings' similar bedroom settings than in a comparable, fluid handling of paint and the play of warm, glowing light across the bed linens in both pictures. Wyeth's narrative is, however, ambiguous and open-ended. Memory? Desire? Wakeful dreams of sleeping fantasy? In such paintings Wyeth comes close to capturing what John Fowles suggests is a fundamental condition of adolescence: "It is above

all when we first grasp the black paradox at the heart of the human condition: that the satisfaction of the desire is also the death of the desire."[7]

Another important body of paintings by Wyeth centers on birds and other animals, both domestic and wild. Gulls and especially ravens refer, as mute witnesses, perhaps, to tales of gothic horrors and to dark, secret places. Wyeth's ravens and gulls are scavengers. Ravens, in particular, fascinate Wyeth, possibly for their curious habit of "stealing" shiny objects, including rings, watches, and—from Wyeth himself—antique toy soldiers. Gulls and ravens represent nature's primeval wanderers, wheeling across leaden skies, screeching into the wind in a constant, instinctual search for survival in a harsh environment. They "own" much of the Maine coast by right of ubiquity and sheer cussedness. While these paintings of birds and animals are remarkably accurate, there is something well beyond rational, scientific observation—the primal gestures, the unsettling eyes, perhaps, stirring in the viewer archetypal memories anterior to culture. Conceptually and spiritually, if not in a strict narrative sense, these portraits of birds and other animals belong to the world of N.C., to the passion and *terribilità* of his finest illustrations. Wyeth paints as if he were observing from the bird's unique perspective and identity, a feat that would surely please his grandfather.

Indeed, one of his most recent paintings, *Saltwater Ice* (1997; page 145), puts us at bird's-eye level on a precarious ice floe with no trace of land and a breaking wave threatening to wash over the temporary refuge. Wyeth would have us experience the ice floe and wave from the ravens' point of view, to somehow think and feel the wind, water, and ice. Wyeth puts us on the ice, with the ravens, and leaves us there with the uncomfortable realization that birds, though not mere human beings, can simply fly away in the face of disaster. The immediacy of the image, its agitated brushwork, close-up forms, and the concentration on a few major elements, are qualities we find in the work of Pyle and especially N. C. Wyeth. This, more than the echo of romantic shipwrecks and marooned souls cast adrift, connects Wyeth to the earlier illustrations.

As pointed out by Susan Larsen in her introduction, the history of American realism, and especially the Wyeths' role therein, is perhaps more complex than previously thought. Jamie Wyeth wanders fruitfully in the hidden (to the "official" art world, anyway) garden of his family's proud legacy. He remains among, and urges us to join, the "children that we were . . . captivated by anything that was more impressive and serious than real life."[8]

1. Andrew Wyeth, "N. C. Wyeth," in *An American Vision: Three Generations of Wyeth Art.* Boston: New York Graphic Society/Little, Brown, in association with the Brandywine River Museum, 1987, p. 87.
2. Alain-Fournier, *The Wanderer: Or the End of Youth (Le Grand Meaulnes),* trans., Lowell Blair. New York: The New American Library, 1971.
3. Quoted in Philippe Roberts-Jones, *Beyond Time and Place: Non-Realist Painting in the Nineteenth Century.* Oxford: Oxford University Press, 1978, p. 85.
4. Alain-Fournier, *The Wanderer,* p. 168.
5. Ibid., pp. 36–37.
6. Christopher Knight, "Who Will Be Remembered in the Year 2022." *Art News,* November 1977, p. 201.
7. John Fowles, "Afterword," *The Wanderer,* p. 209.
8. Alain-Fournier, *The Wanderer,* p. 96.

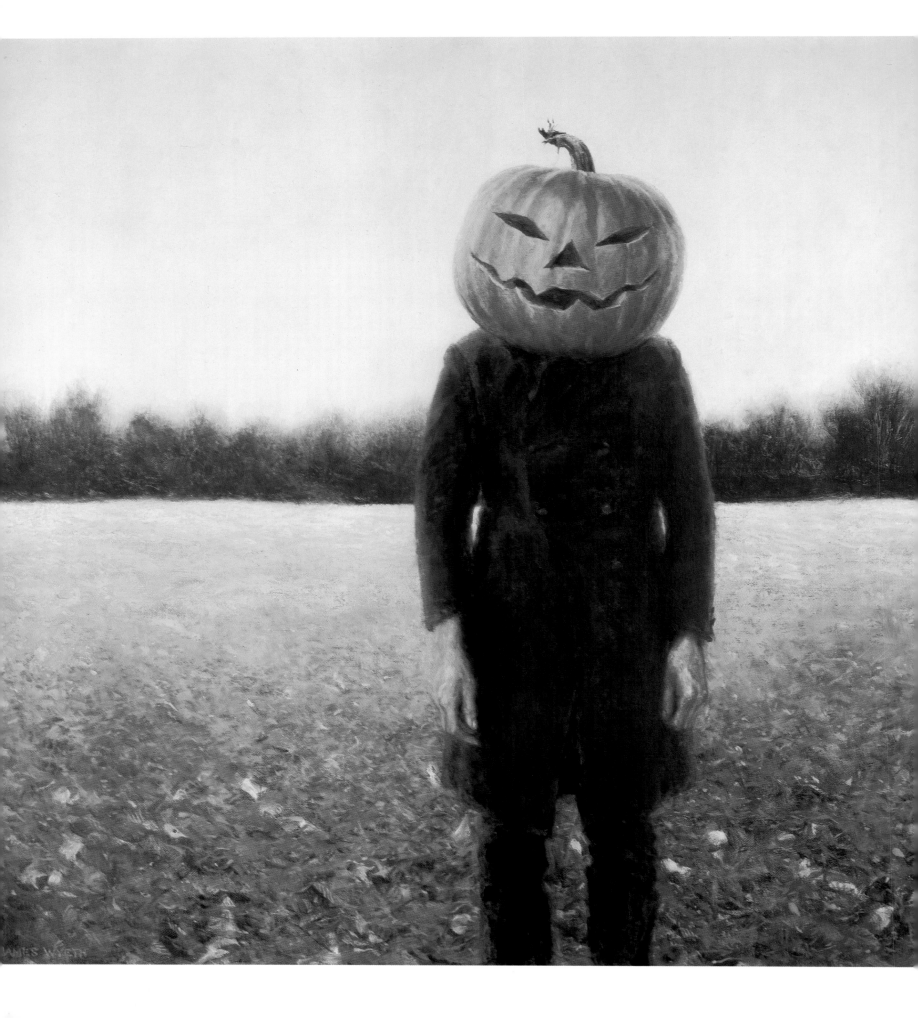

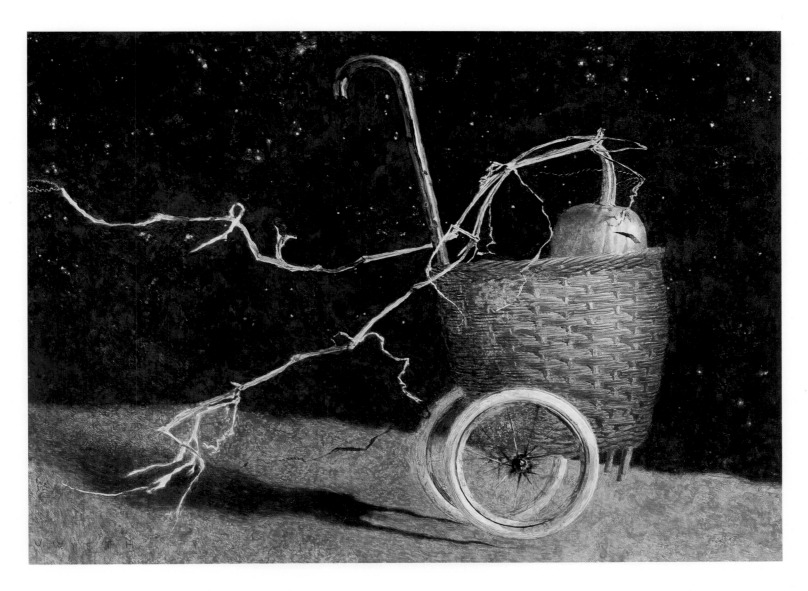

JAMES WYETH
Mischief Night, 1986

< **JAMES WYETH**
Pumpkinhead—Self-Portrait, 1972

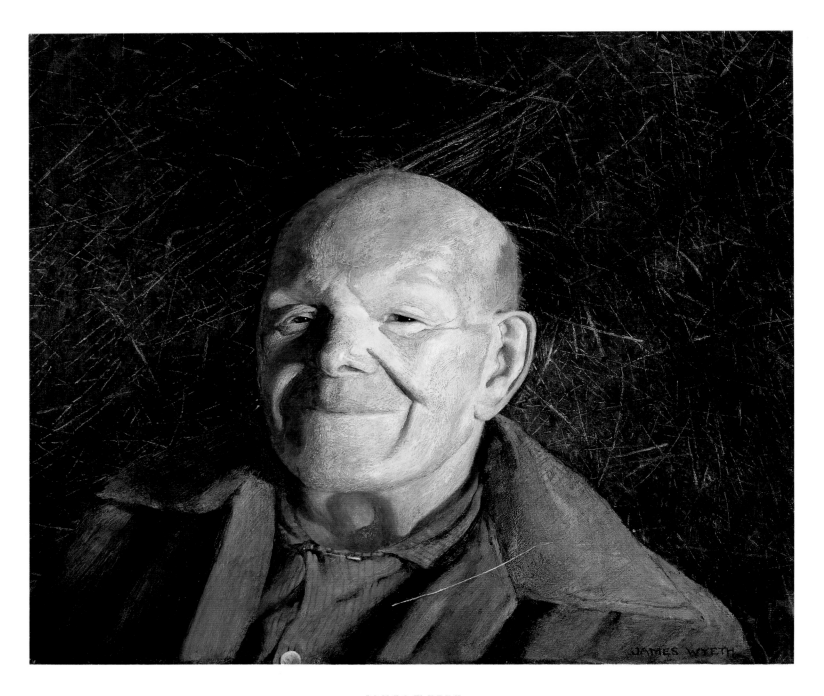

JAMES WYETH
Halloween, 1964

JAMES WYETH >
Automaton, 1979

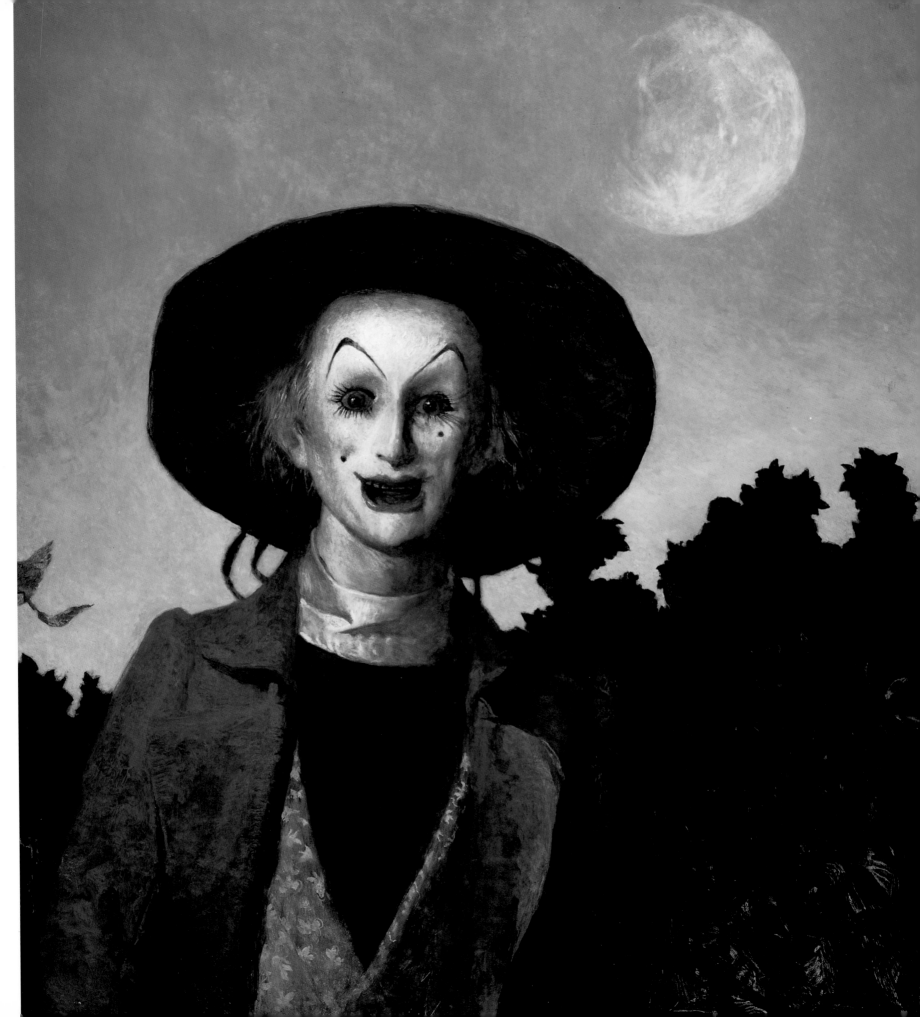

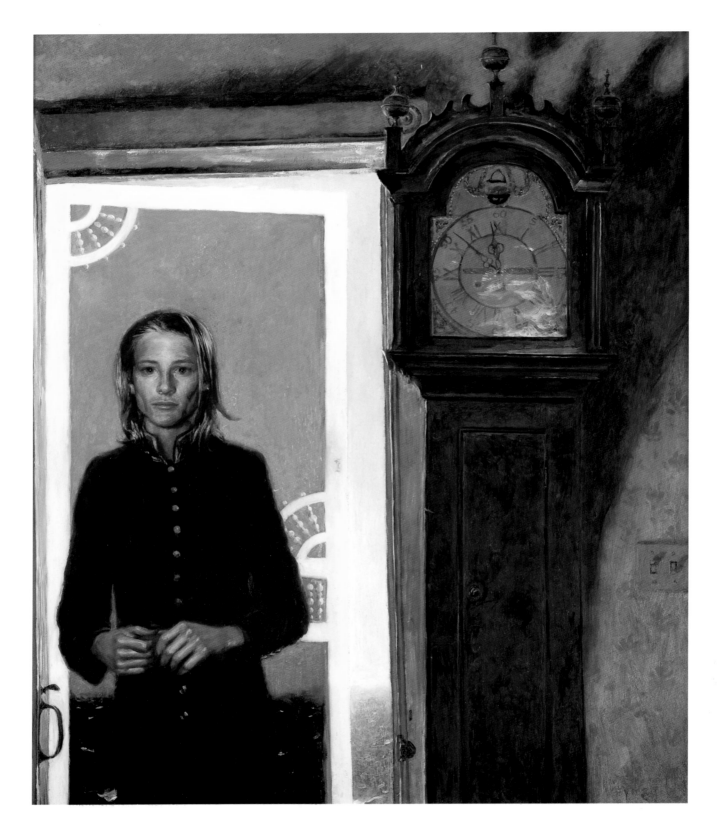

JAMES WYETH

Screen Door to the Sea, 1994

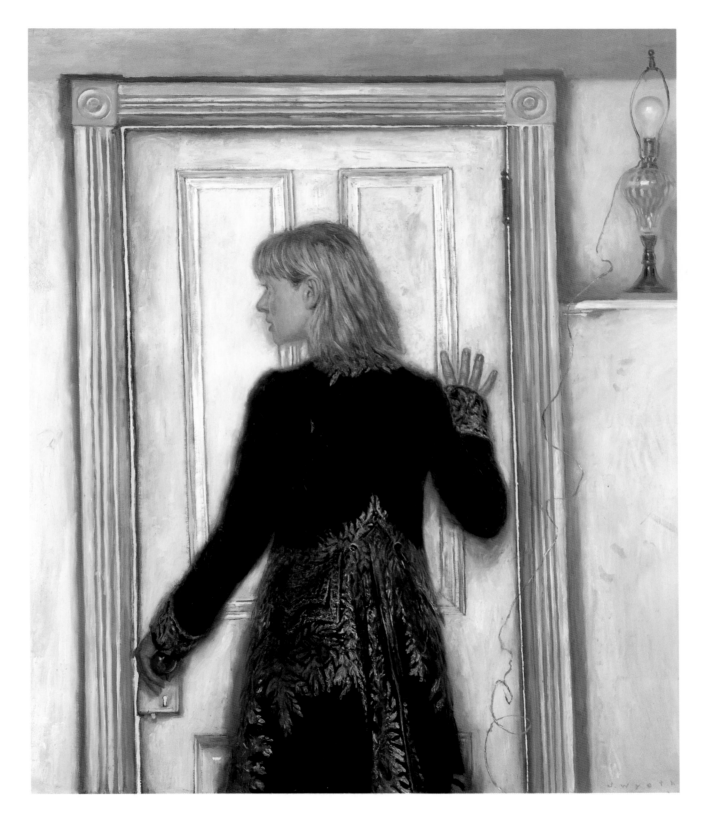

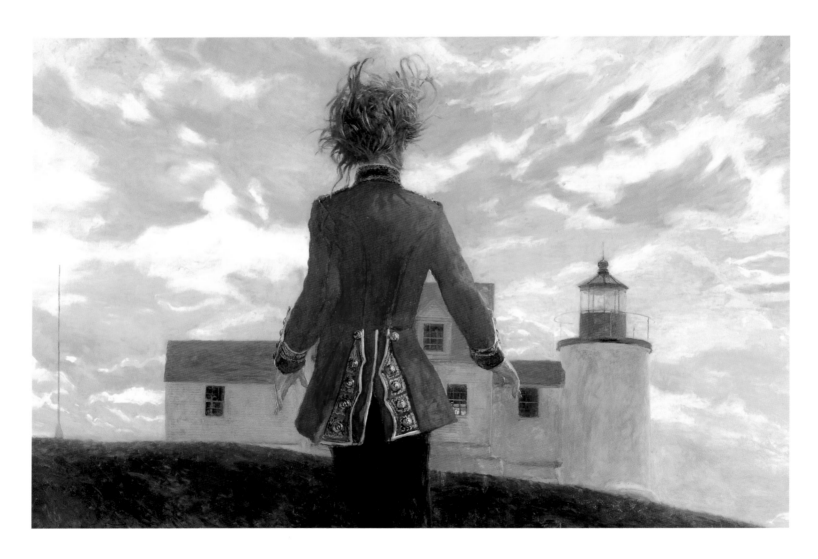

JAMES WYETH
Lighthouse, 1993

JAMES WYETH >
Comet, 1997

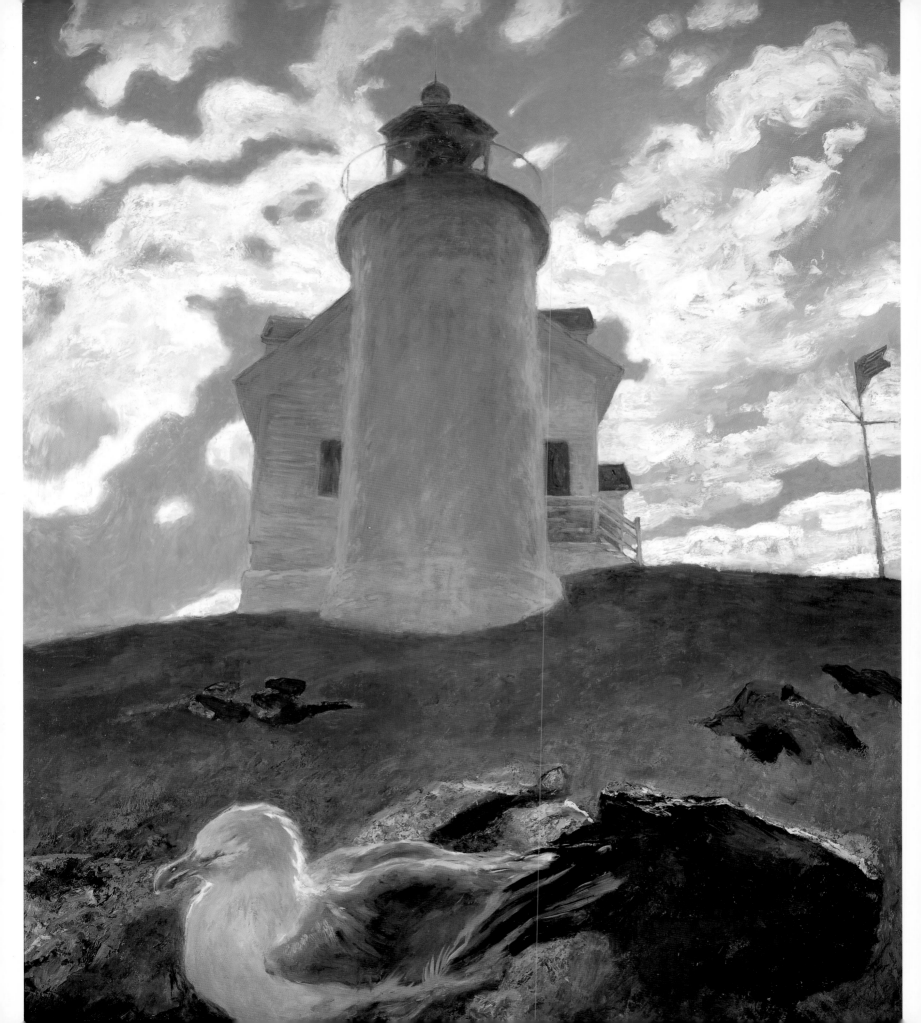

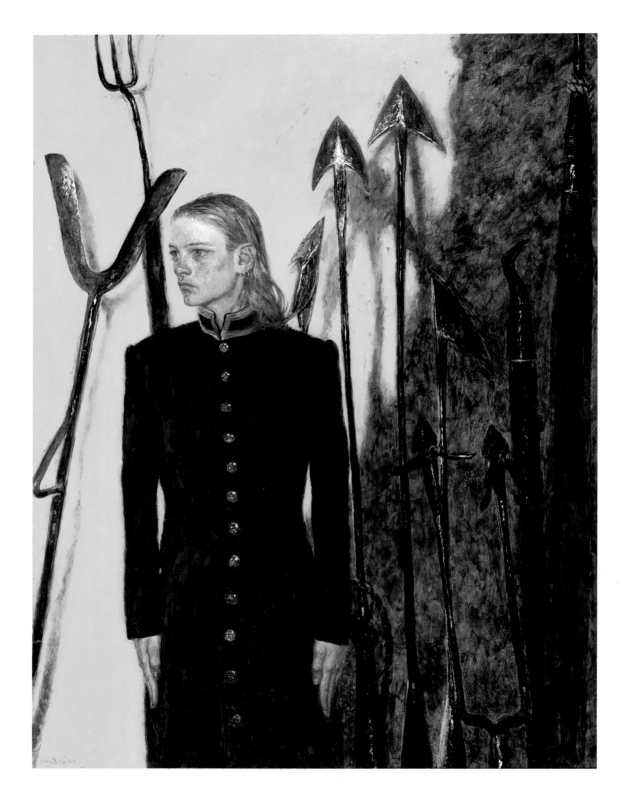

JAMES WYETH
Orca, 1990

JAMES WYETH >
Black Spruce, 1994

[138]

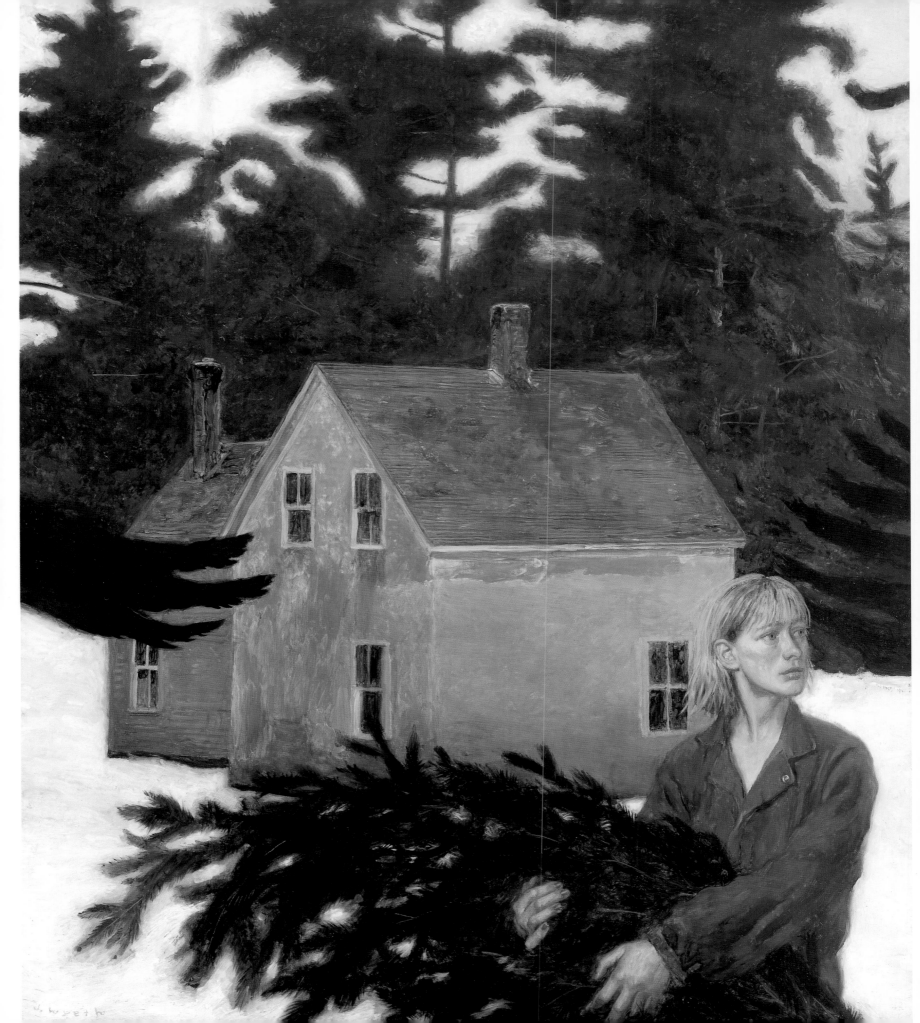

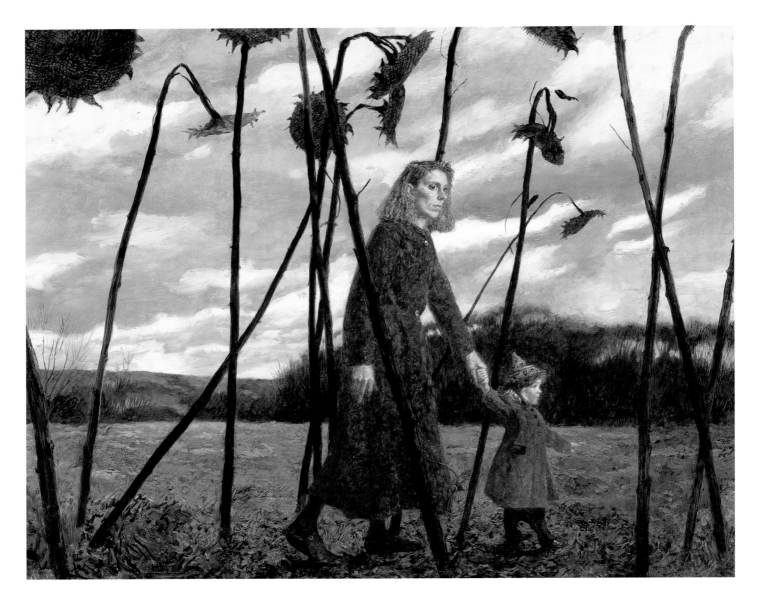

JAMES WYETH

Giuliana and the Sunflowers, 1987

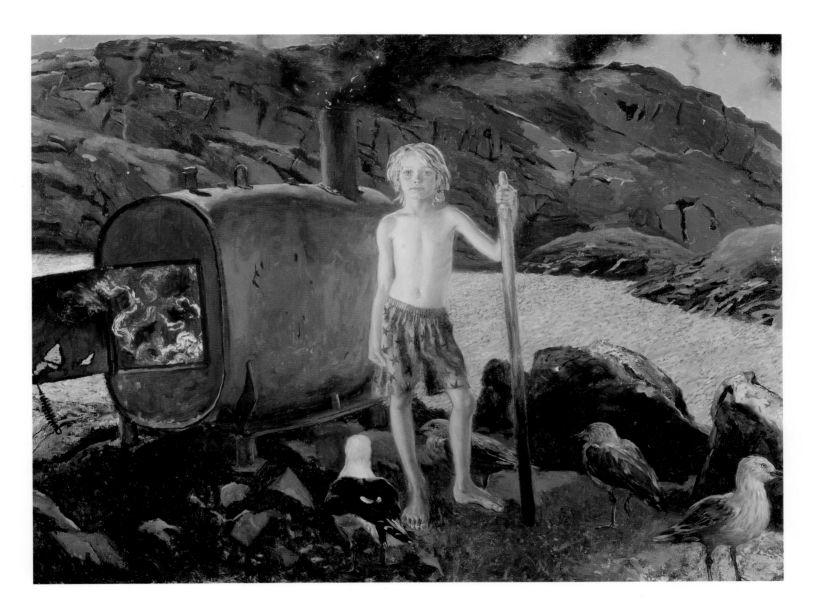

JAMES WYETH

Cat Bates of Monhegan, 1995

(overleaf)

JAMES WYETH

*Lighthouse
Dandelions, 1997*

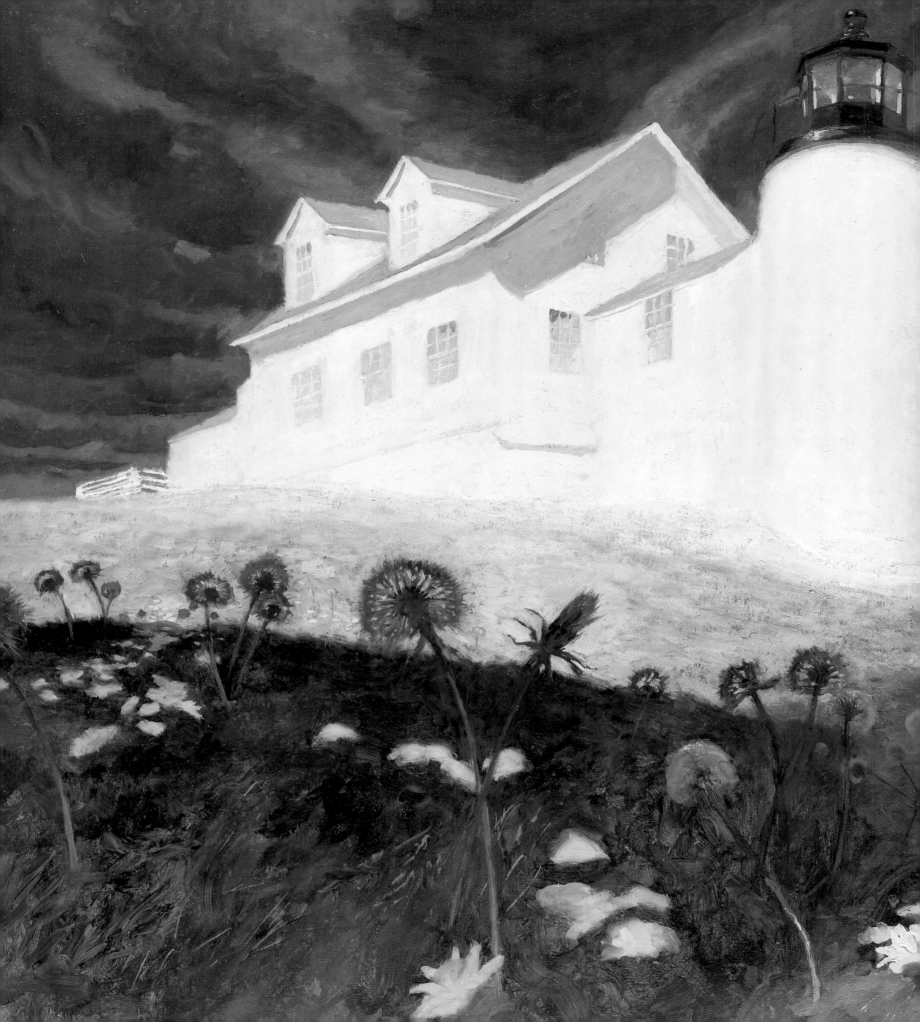

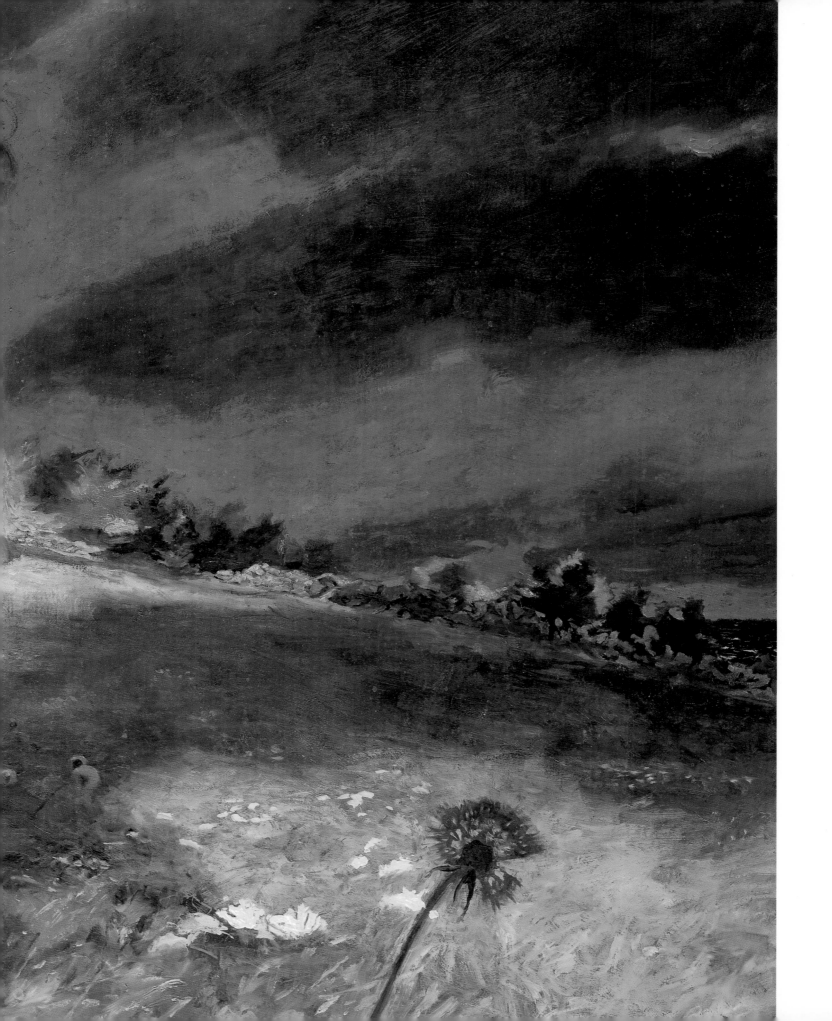

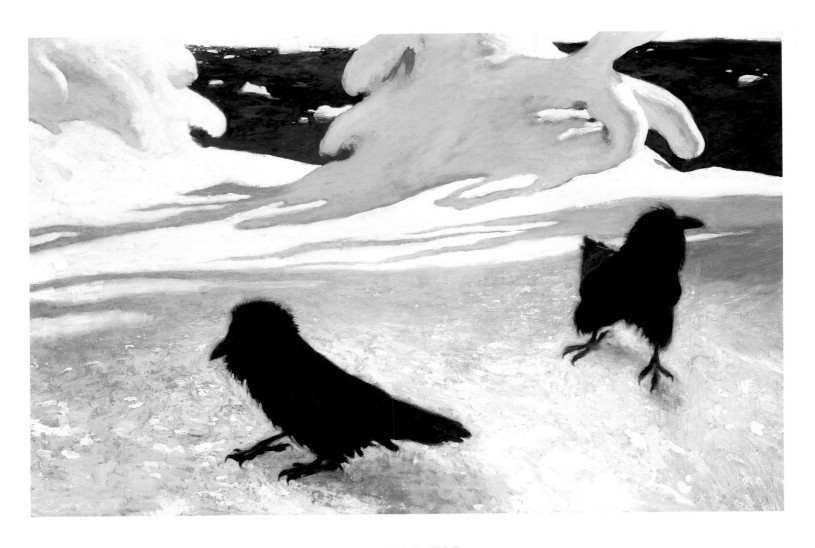

JAMES WYETH

Ice Storm, Maine, 1998

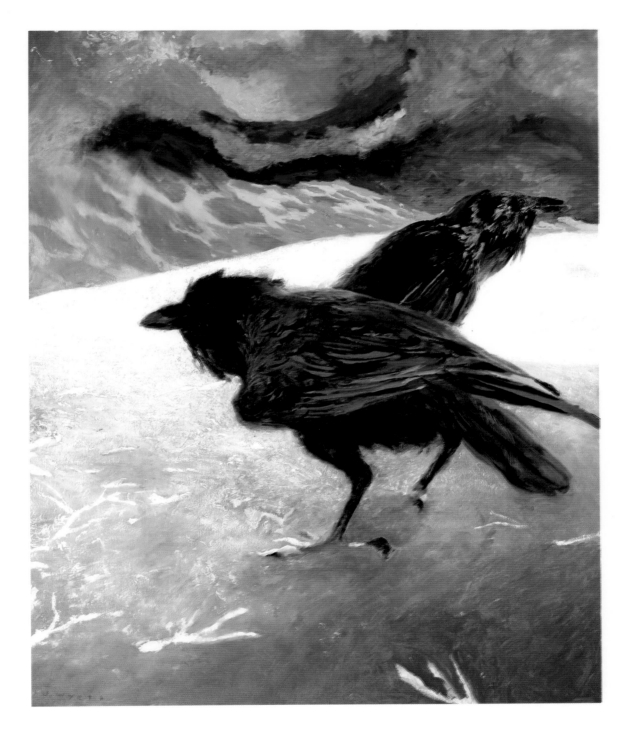

JAMES WYETH
Saltwater Ice, 1997

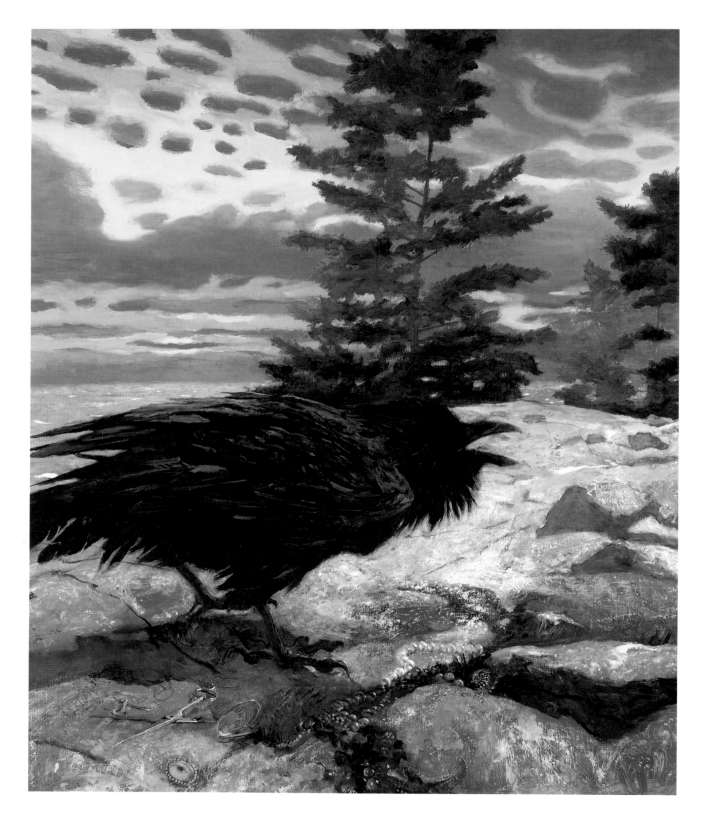

JAMES WYETH
The Thief, 1996

JAMES WYETH
Feeding Ledge, 1992

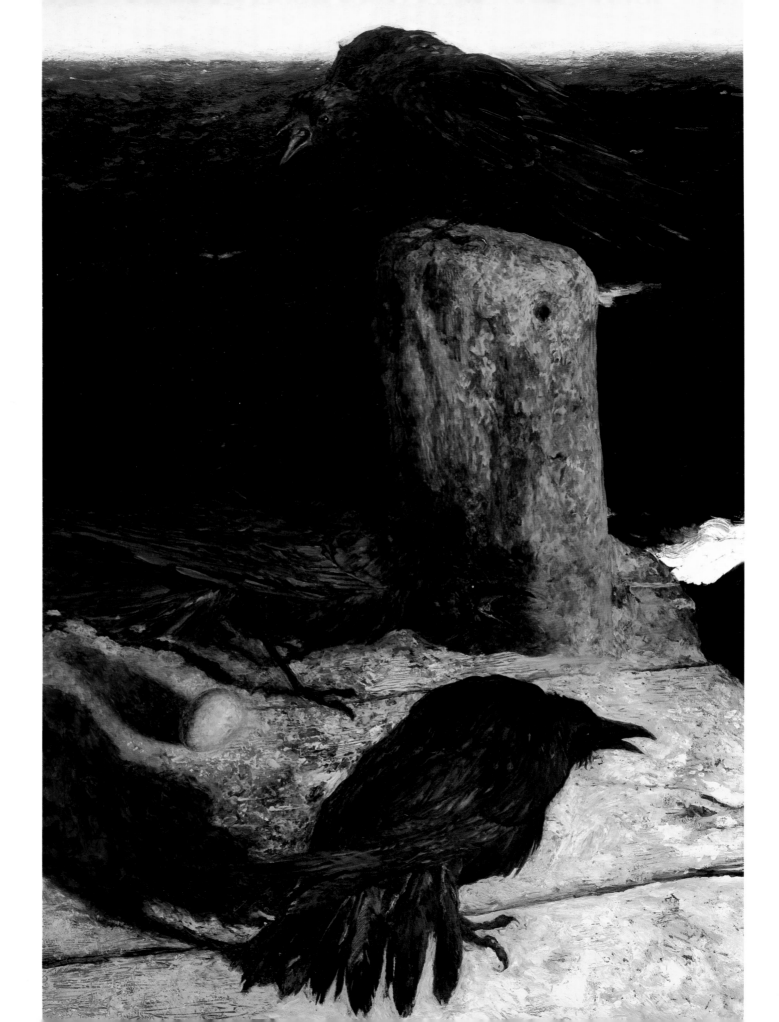

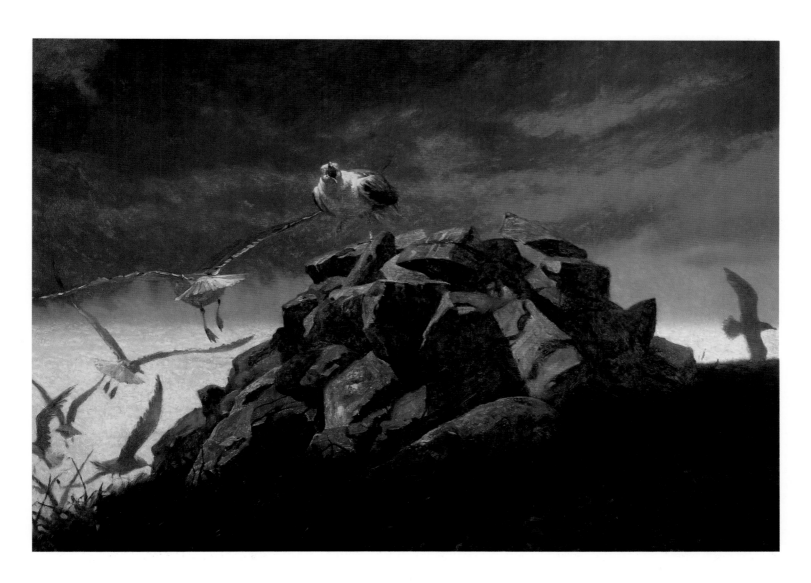

JAMES WYETH

The Rookery, 1977

< JAMES WYETH

Gull's Egg, 1988

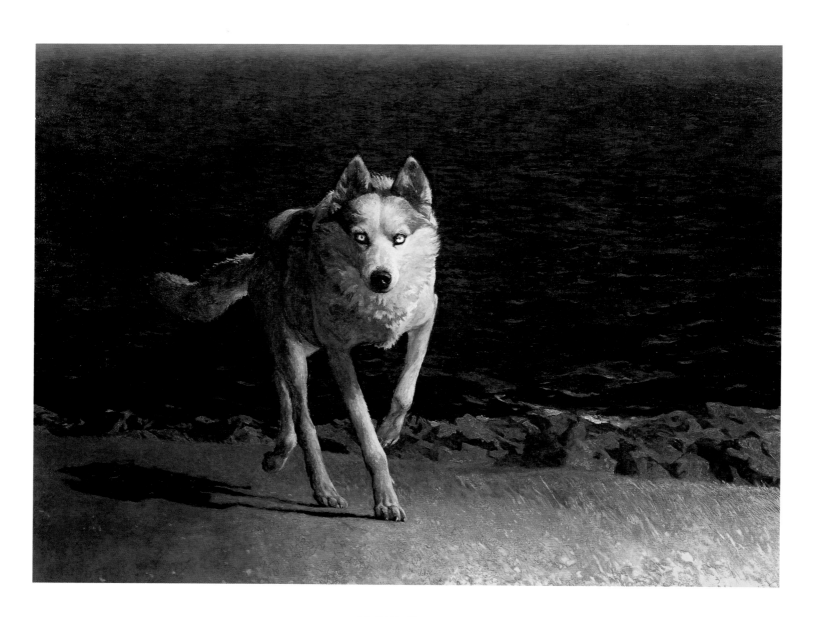

JAMES WYETH
Wolf Dog, 1976

JAMES WYETH >
Angeload, 1979

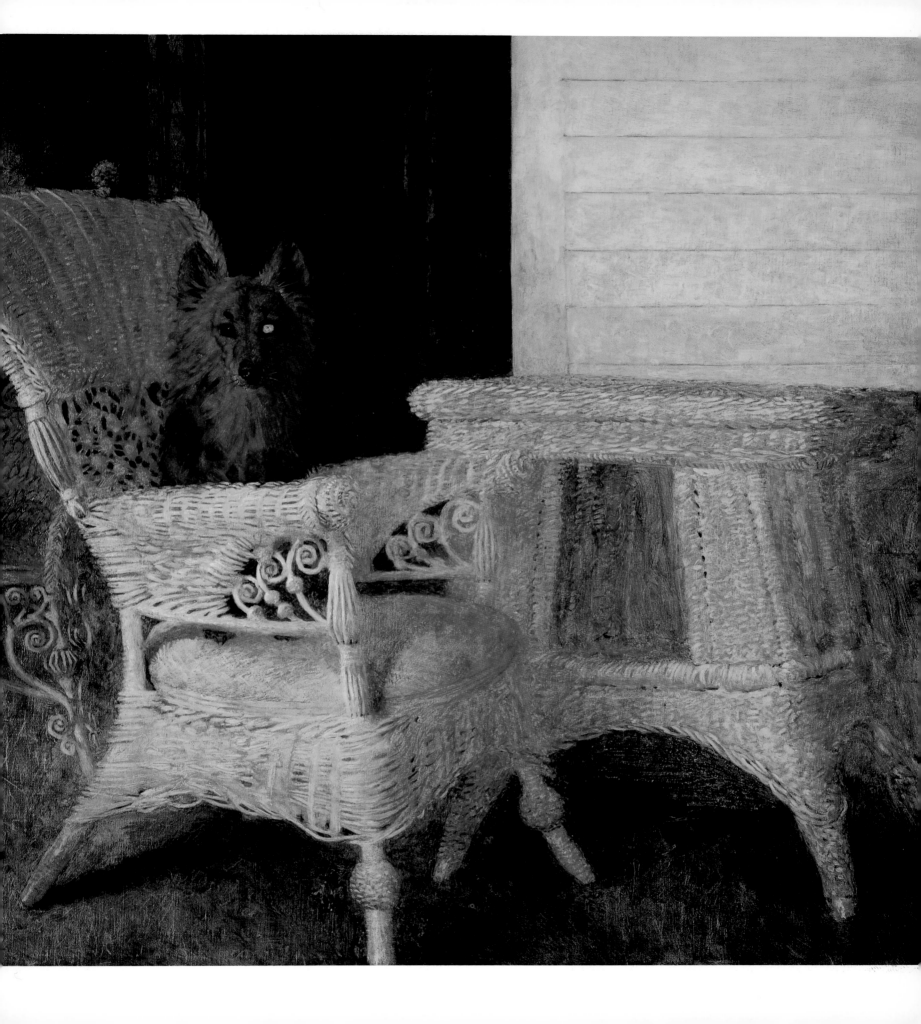

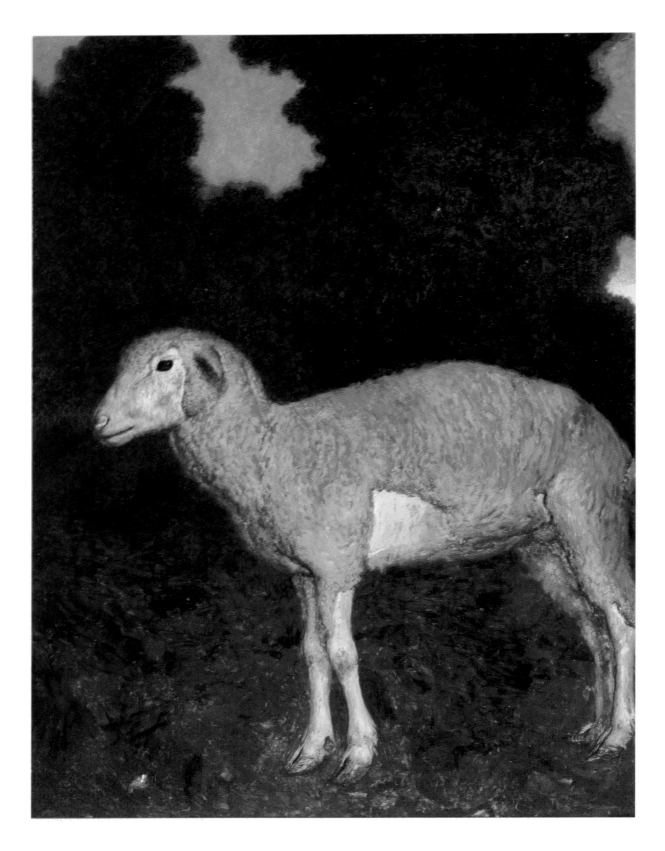

JAMES WYETH
Brandywine Raceway, 1989

[152]

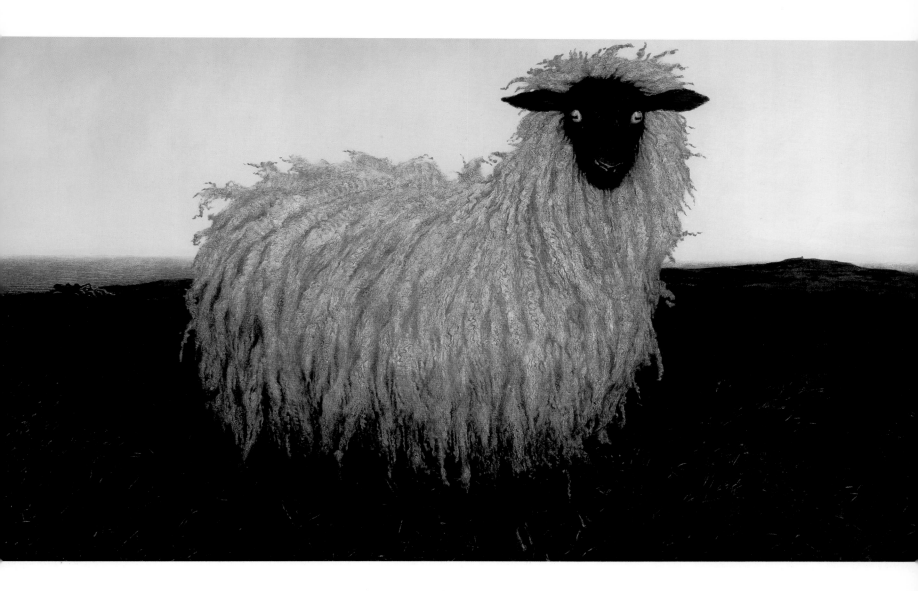

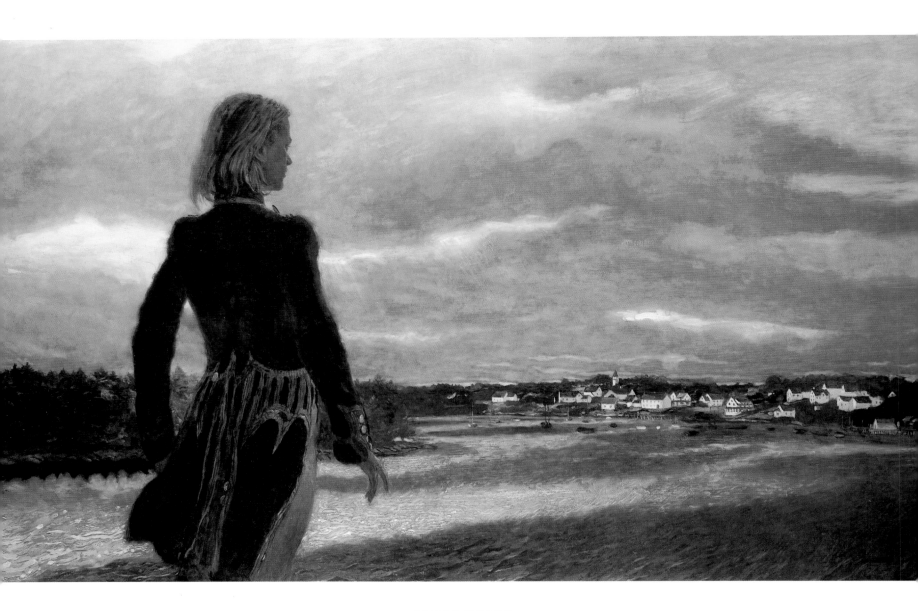

JAMES WYETH
The Wanderer, 1992

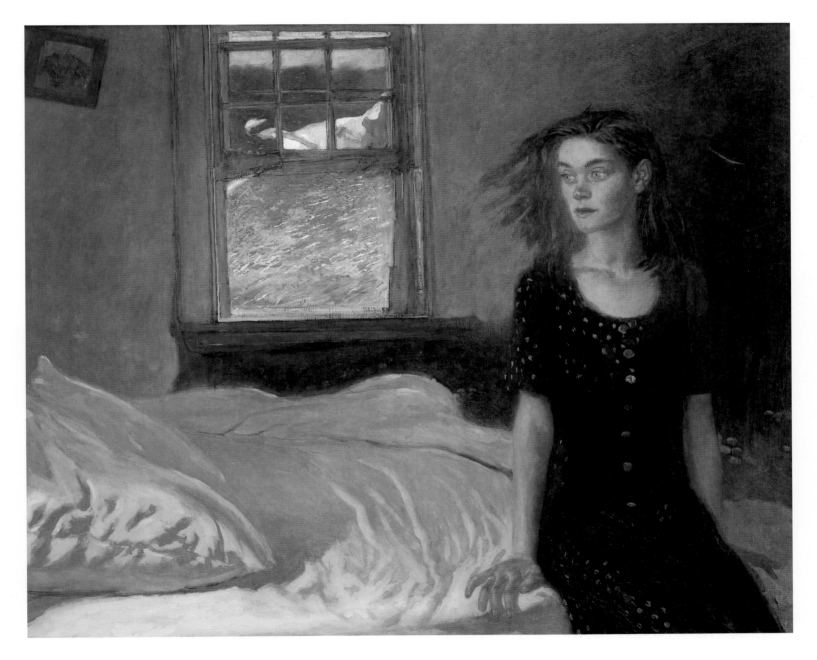

If Once You Have Slept on an Island,
1996

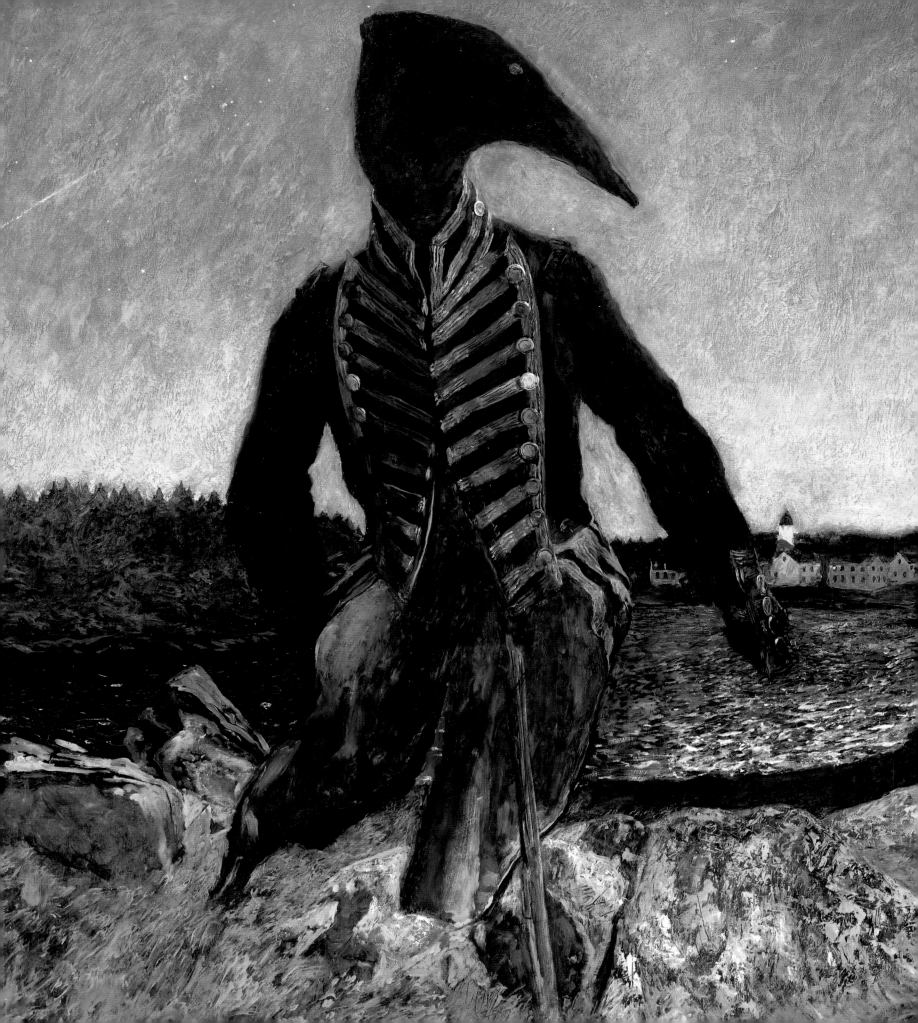

JAMES WYETH

Meteor Shower, 1993

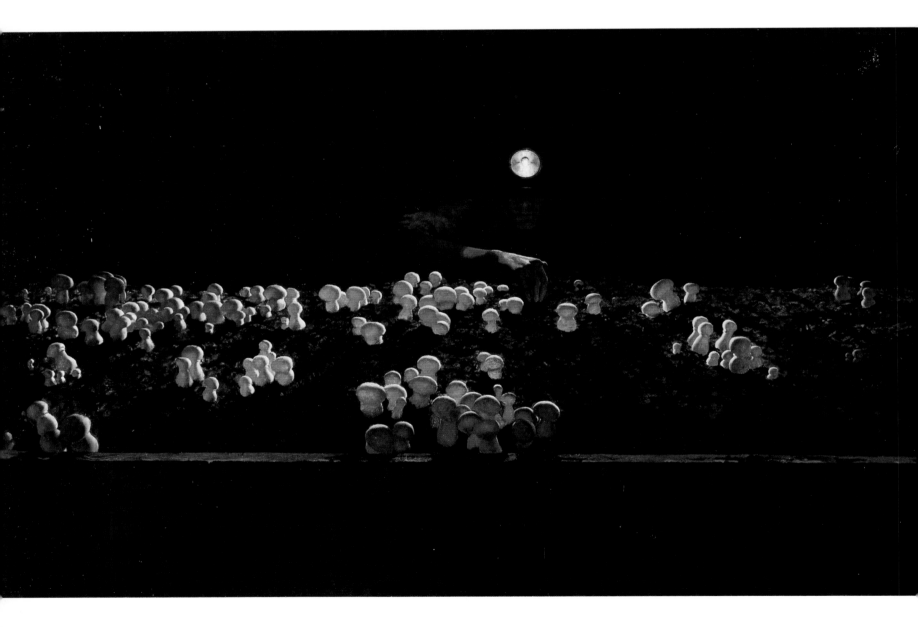

JAMES WYETH

Mushroom Picker, 1963

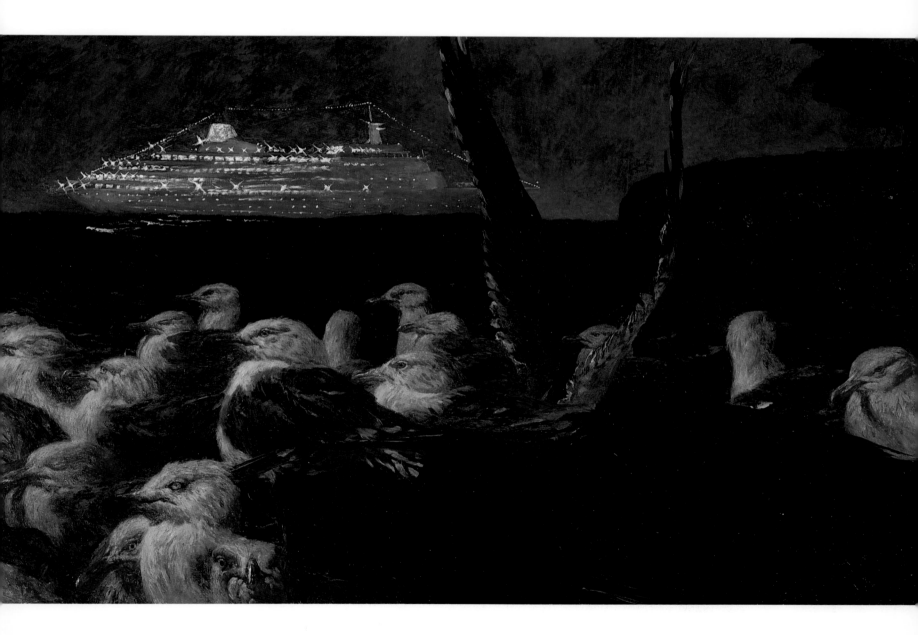

JAMES WYETH
Scotia Prince, 1987

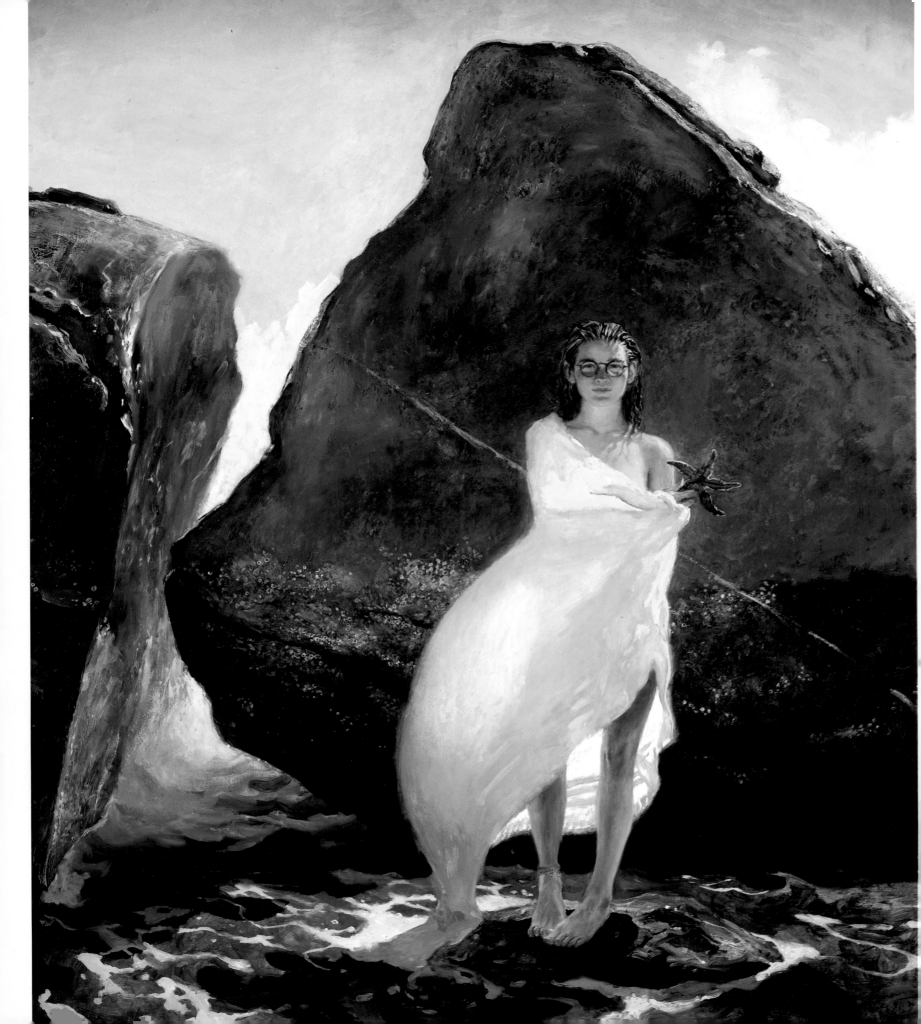

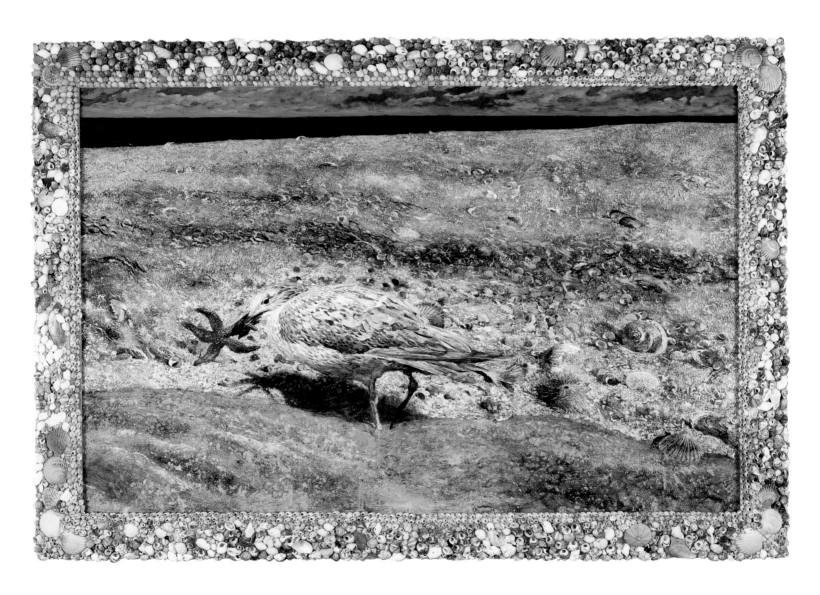

JAMES WYETH
Sea Star, 1986

< JAMES WYETH
Sophomore at Bowdoin, 1996

List of Plates

HOWARD PYLE

[10] *"Once it chased Dr. Wilkinson into the very town itself,"* 1909
Illustration from "The Salem Wolf" by Howard Pyle. *Harper's Monthly Magazine*, December 1909.
Oil on canvas, 28 x 18 inches
Collection of Mr. and Mrs. Howard P. Brokaw

[24] *"Catch a gleam from her wicked eye,"* 1892
Illustration for *The One Hoss Shay* by Oliver Wendell Holmes. Boston: Houghton Mifflin and Company, 1892.
Ink on paper, 6 $^1/_2$ x 4 $^1/_2$ inches
Collection of Mr. and Mrs. Andrew Wyeth

[25] *"Barbarously murdered the first, and grievously wounded the latter,"* 1895
Illustration from "New York Colonial Privateers" by Thomas A. Janvier, in *Harper's New Monthly Magazine*, February 1895.
Oil on board, 15 $^1/_2$ x 10 inches
Collection of Mr. and Mrs. Andrew Wyeth

[26] *"She drew bridle, listening—there was no sound,"* 1905
Illustration from "Special Messenger" by Robert W. Chambers. *Harper's Monthly Magazine*, February 1905.
Oil on canvas, 24 x 16 inches
Collection of Mr. and Mrs. Howard P. Brokaw

[27] *"Catherine Duke quickened her steps,"* 1904
Illustration from "The Gold" by Mary E. Wilkins Freeman. *Harper's Monthly Magazine*, December 1904.
Oil on canvas, 20 x 16 inches
Collection of Mr. and Mrs. Howard P. Brokaw

[28] *The Fight on Lexington Common,* 1898
Illustration from "The Story of the Revolution" by Woodrow Wilson. *Scribner's Magazine*, January 3, 1898.
Oil on canvas, 23 $^1/_4$ x 35 $^1/_4$ inches
Delaware Art Museum, Museum Purchase, 1912

[30] *General Wayne Endeavoring to Quell the Mutiny of the Pennsylvania Regiments at Morristown, NJ,* 1901
Illustration from "The United States Army" by Francis V. Greene. *Scribner's Magazine*, September 1901.
Oil on canvas board, 23 $^1/_2$ x 15 $^3/_8$ inches
Delaware Art Museum, Museum Purchase, 1916

[31] *Untitled,* 1896
Illustration from "Through Inland Waters" by Howard Pyle. *Harper's New Monthly Magazine*, June 1896.
Oil on board, 10 $^1/_2$ x 12 inches
Delaware Art Museum, Gift of Marion Mahony Manning in Memory of Mary Poole Mahony

[32] *"Her head and shoulders hung over the space without,"* 1904
Illustration from "The Maid of Landevennec" by Justus Miles Forman. *Harper's Monthly Magazine*, September 1904.
Oil on canvas, 24 $^1/_4$ x 16 inches
Herbert F. Johnson Museum of Art, Cornell University, Gift of Samuel B. Bird

[33] *Vitia and the Governor,* 1909
Illustration from "The Garden of Eden" by Justus M. Forman. *Harper's Monthly Magazine*, May 1909.
Oil on canvas, 24 x 16 inches
Collection of Mr. and Mrs. Howard P. Brokaw

[34] *Assassination of LaSalle,* 1897
Illustration from *Works of Francis Parkman*, Vol. 6. Boston: Little, Brown and Company, 1897.
Oil on canvas, 22 x 14 inches
Collection of the Laurel Public Library, Laurel, Delaware

[35] *"The little gentleman in black emitted a piercing scream,"* 1907
Illustration from "The Ruby of Kishmoor" by Howard Pyle. *Harper's Monthly Magazine*, August 1907.
Oil on board, 11 x 8 inches
Collection of Mr. and Mrs. Andrew Wyeth

[36] *"We started to run back to the raft for our lives,"* 1902
Illustration from "Sinbad on Burrator" by A. T. Quiller-Couch. *Scribner's Magazine*, August 1902.
Oil on canvas, 23 $^3/_4$ x 15 $^3/_4$ inches
Delaware Art Museum, Museum Purchase, 1912

[37] *"The boat and I went by him with a rush,"* 1902
Illustration from "Sinbad on Burrator" by A. T. Quiller-Couch. *Scribner's Magazine*, August 1902.
Oil on canvas, 23 $^3/_4$ x 15 $^3/_4$ inches
Delaware Art Museum, Museum Purchase, 1912

[38] *"I clutched at his ankle,"* 1902
Illustration from "Sinbad on Burrator" by A. T. Quiller-Couch. *Scribner's Magazine*, August 1902.
Oil on canvas, 23 $^3/_4$ x 15 $^3/_4$ inches
Delaware Art Museum, Museum Purchase, 1912

[39] *The Fishing of Thor and Hymir,* 1902
Illustration from "North Folk Legends of the Sea" by Howard Pyle. *Harper's Monthly Magazine*, January 1902.
Watercolor on paper, 7 $^3/_4$ x 4 $^1/_8$ inches
Delaware Art Museum, Museum Purchase, 1912

[40] *The Pirates Fire upon the Fugitives,* 1895
Illustration from "Jack Ballister's Fortunes" by Howard Pyle. *St. Nicholas*, April 1895.
Oil on board, 16 x 10 inches
Collection of Mr. and Mrs. Howard P. Brokaw

[41] *"The rest were shot and thrown overboard,"* 1907
Illustration from "The Cruise of the Caribbee" by
Thomas V. Briggs. *Harper's Monthly Magazine,*
December 1907.
Oil on board, 16 x 10 inches
Collection of Mr. and Mrs. Howard P. Brokaw

[42] *"He lost his hold and fell, taking me with him,"*
1909
Illustration from "The Grain Ship" by Morgan
Robertson. *Harper's Monthly Magazine,* March
1909.
Oil on canvas, 28 1/2 x 18 7/8 inches
Delaware Art Museum, Museum Purchase, 1912

[43] *"Then the real fight began,"* 1908
Illustration from "Pennsylvania's Defiance of the
United States" by Hampton L. Carson. *Harper's
Monthly Magazine,* October 1908.
Oil on canvas, 29 1/2 x 19 3/4 inches
Collection of Mr. and Mrs. Thomas C. T.
Brokaw

[44] *"So the treasure was divided,"* 1905
Illustration from "The Fate of a Treasure Town"
by Howard Pyle. *Harper's Monthly Magazine,*
December 1905.
Oil on canvas, 19 1/2 x 29 1/2 inches
Delaware Art Museum, Museum Purchase, 1912

[46] *The Flying Dutchman,* 1900
Illustration from "The Flying Dutchman,"
Collier's Weekly, December 8, 1900.
Oil on canvas, 71 3/8 x 47 1/2 inches
Delaware Art Museum, Museum Purchase, 1912

[47] *The Flying Dutchman,* 1902
Illustration from "North Folk Legends of the
Sea" by Howard Pyle. *Harper's Monthly Magazine,*
January 1902.
Watercolor on paper, 7 1/4 x 4 5/8 inches
Delaware Art Museum, Museum Purchase, 1912

[48] *"Pirates used to do that to their captains now and
then,"* 1894
Illustration from "The Sea Robbers of New

York" by Thomas A. Janvier. *Harper's Monthly
Magazine,* November 1894.
Oil on board, 8 1/2 x 16 inches
Collection of Mr. and Mrs. Andrew Wyeth

[49] *"The gigantic monster dragged and hacked the
headless corpse of his victim up the staircase,"* 1896
Illustration from *In Ole Virginia* by Thomas
Nelson Page. New York: Charles Scribner's Sons,
1896.
Oil on board, 15 5/8 x 11 3/8 inches
Delaware Art Museum, Museum Purchase, 1916

[50] *Kidd on the Deck of the "Adventure Galley,"* 1902
Illustration from "The True Captain Kidd" by
John D. Champlin. *Harper's Monthly Magazine,*
December 1902.
Watercolor on paper, 16 3/4 x 10 3/4 inches
Delaware Art Museum, Museum Purchase, 1912

[51] *An Attack on a Galleon,* 1905
Illustration from "The Fate of a Treasure Town"
by Howard Pyle. *Harper's Monthly Magazine,*
December 1905.
Oil on canvas, 29 1/2 x 19 1/2 inches
Delaware Art Museum, Museum Purchase, 1912

[52] *"Who are we that heaven should make of the old sea
a fowling net?"* 1909
Illustration from "The Second Chance" by James
Branch Cabell. *Harper's Monthly Magazine,*
October 1909.
Oil on canvas, 28 x 18 inches
Delaware Art Museum, Bequest of Hazel Hyde
Rumford, 1961

[53] *The Mermaid,* 1909
Oil on canvas, 57 x 39 inches
Delaware Art Museum, Gift of the Children of
Howard Pyle in Memory of Their Mother, Anne
Poole Pyle, 1940

[54] *Marooned,* 1909
Oil on canvas, 40 x 60 inches
Delaware Art Museum, Museum Purchase, 1912

N. C. WYETH

[14] *Winter ("Death"),* 1909
Illustration for "The Moods," a poem by George
T. Marsh. *Scribner's Magazine,* December 1909.
Oil on canvas, 33 x 29 1/2 inches
Collection of Mr. and Mrs. Andrew Wyeth

[59] *The Hag of the Rock,* 1912
Illustration for *The Sampo* by James Baldwin.
New York: Charles Scribner's Sons, 1912.
Oil on canvas, 47 x 33 1/2 inches
Collection of Jamie Wyeth

[60] *Death of Edwin,* 1921
Illustration for *The Scottish Chiefs* by Jane Porter.
New York: Charles Scribner's Sons, 1921.
Oil on canvas, 40 x 32 3/8 inches
Brandywine River Museum, Gift of Mr. and
Mrs. Harl McDonald

[61] *Paul Revere,* 1922
Illustration for *Poems of American Patriotism* by
Brander Matthews. New York: Charles Scribner's
Sons, 1922.
Oil on canvas, 40 x 30 inches
Collection of the Hill School, Pottstown, PA

[62] *Blind Pew,* 1911
Illustration for *Treasure Island* by Robert Louis
Stevenson. New York: Charles Scribner's Sons,
1911.
Oil on canvas, 47 x 38 inches
Collection of Mr. and Mrs. Andrew Wyeth

[63] *Captain Bill Bones,* 1911
Illustration for *Treasure Island* by Robert Louis
Stevenson, New York: Charles Scribner's Sons,
1911.
Oil on canvas, 47 1/4 x 38 1/4 inches
Brandywine River Museum, Bequest of
Gertrude Haskell Britton

[64] **The Black Spot,** 1911
Illustration for *Treasure Island* by Robert Louis
Stevenson. New York: Charles Scribner's Sons, 1911.
Oil on canvas, 46 x 37 $^1/_2$ inches
Collection of Mr. and Mrs. Andrew Wyeth

[65] **The Treasure Cave!,** 1911
Illustration for *Treasure Island* by Robert Louis
Stevenson. New York: Charles Scribner's Sons, 1911.
Oil on canvas, 47 $^3/_8$ x 38 $^1/_4$ inches
Collection of the Central Children's Room, Donnell
Library Center, the New York Public Library, Astor,
Lenox, and Tilden Foundations

[66] **"The children were playing at marriage by capture,"**
1911
Illustration for "Growing Up" by Gouverneur Morris.
Harper's Monthly Magazine, November 1911.
Oil on canvas, 46 $^1/_2$ x 38 inches
Collection of Mr. and Mrs. Andrew Wyeth

[67] **The Murderer of Roy Campbell,** 1913
Illustration for *Kidnapped* by Robert Louis Stevenson.
New York: Charles Scribner's Sons, 1913.
Oil on canvas, 40 x 32 inches
Collection of the Central Children's Room, Donnell
Library Center, the New York Public Library, Astor,
Lenox, and Tilden Foundations

[68] **On the Island of Earraid,** 1913
Illustration for *Kidnapped* by Robert Louis Stevenson.
New York: Charles Scribner's Sons, 1913.
Oil on canvas, 40 x 32 inches
Private Collection

[69] **The Torrent in the Valley of Glencoe,** 1913
Illustration for *Kidnapped* by Robert Louis Stevenson.
New York: Charles Scribner's Sons, 1913.
Oil on canvas, 39 $^3/_{16}$ x 31 $^3/_4$ inches
Collection of the Central Children's Room, Donnell
Library Center, the New York Public Library, Astor,
Lenox, and Tilden Foundations

[70] **The Death of Finnward Keelfarer,** 1914
Illustration for "The Waif Woman" by Robert Louis
Stevenson. *Scribner's Magazine,* December 1914.

Oil on canvas, 44 $^1/_2$ x 32 $^1/_2$ inches
Collection of Somerville Manning Gallery

[71] **"When I tried with cracked lips . . ."** 1914
Illustration for "At the World's Outposts" by
James Francis Dwyer, *Collier's Weekly,* July 17, 1915.
Oil on canvas, 29 $^1/_8$ x 56 inches
The Kelly Collection of American Illustration

[72] **The Opium Eater,** 1913
Illustration for "A Modern Opium Eater."
American Magazine, June 1914.
Oil on canvas, 32 x 44 inches
Collection of Richard Stein

[73] **Captain Nemo,** 1918
Illustration for *The Mysterious Island* by Jules Verne.
New York: Charles Scribner's Sons, 1918.
Oil on canvas, 40 $^3/_{16}$ x 30 $^1/_8$ inches
Collection of Mr. and Mrs. Andrew Wyeth

[74] **The Great Minus,** 1913
Illustration for "The Great Minus" by Gilbert
Parker. *Scribner's Magazine,* December 1913.
Oil on canvas, 44 $^1/_8$ x 32 $^1/_8$ inches
Collection of Mr. and Mrs. Andrew Wyeth

[75] **The Masquerader,** 1919
Illustration for *The Last of the Mohicans* by James
Fenimore Cooper. New York: Charles Scribner's
Sons, 1919.
Oil on canvas, 40 x 32 inches
Private Collection

[76] **"We must be in the dungeons,"** 1916
Illustration for "The Black Arrow-A Tale of Two
Roses" by Robert Louis Stevenson. Scribner and
Sons, 1916.
Oil on canvas, 39 $^1/_4$ x 31 $^1/_4$ inches
Courtesy of Judy Goffman for the American
Illustrators Gallery, New York City

[77] **The Astrologer Emptied the Whole of the Bowl**
into the Bottle, 1916
Illustration for *The Mysterious Stranger* by Mark
Twain. New York: Harper & Brothers, 1916.

Oil on canvas, 39 $^7/_8$ x 31 $^7/_8$ inches
Private Collection

[78] **Rose Salterne and the White Witch,** 1920
Illustration for *Westward Ho!* by Charles Kingsley.
New York: Charles Scribner's Sons, 1920.
Oil on canvas, 40 $^5/_8$ x 30 $^1/_8$ inches
Brandywine River Museum, Bequest of Carolyn
Wyeth

[79] **"Oh, Morgan's men are out for you; and**
Blackbeard-Buccaneer!" 1917
Illustration for "The Golden Galleon" by Paul
Hervey Fox. *Scribner's Magazine,* August 1917.
Oil on canvas, 50 $^1/_4$ x 35 $^1/_8$ inches
Private collection

[80] **The Magician and the Maid of Beauty,** 1912
Illustration for *The Sampo* by James Baldwin.
New York: Charles Scribner's Sons, 1912.
Oil on canvas, 33 x 46 $^1/_2$ inches
Collection of Jamie Wyeth

[82] **The Song of the Eagle That Mates with the Storm,**
1916
Illustration for "The Wild Woman's Lullaby" by
Constance Lindsay Skinner. *Scribner's Magazine,*
December 1916.
Oil on canvas, 40 x 32 inches
Private Collection

[83] **The Indian Lance,** 1909
Oil on canvas, 38 x 25 inches
Private Collection

[84] **The Wreck of the "Covenant,"** 1913
Illustration for *Kidnapped* by Robert Louis
Stevenson. New York: Charles Scribner's Sons, 1913.
Oil on canvas, 41 $^3/_4$ x 33 $^3/_4$ inches
Brandywine River Museum, Bequest of Mrs.
Russell G. Colt

[85] **The Battle with the Armada,** 1920
Illustration for *Westward Ho!* by Charles Kingsley.
New York: Charles Scribner's Sons, 1920.
Oil on canvas, 36 x 30 inches
Private Collection

JAMES WYETH

[130] *Pumpkinhead—Self-Portrait,* 1972
Oil on canvas, 30 x 30 inches
Private Collection

[131] *Mischief Night,* 1986
Mixed media on paper, 22 1/$_2$ x 31 inches
Delaware Art Museum, F. V. du Pont
Acquisition Fund

[132] *Halloween,* 1964
Oil on canvas, 17 x 20 inches
Collection of George B. Sordoni

[133] *Automaton,* 1979
Oil on panel, 29 1/$_4$ x 34 1/$_2$ inches
Private Collection

[134] *Screen Door to the Sea,* 1994
Oil on panel, 36 x 30 inches
The Farnsworth Art Museum, Anonymous
Gift, 1996

[135] *Other Voices,* 1995
Oil on panel, 35 3/$_4$ x 29 3/$_4$ inches
Private Collection

[136] *Lighthouse,* 1993
Oil on panel, 30 x 45 inches
Private Collection

[137] *Comet,* 1997
Oil on panel, 48 x 40 inches
Private Collection

[138] *Orca,* 1990
Oil on panel, 30 x 40 inches
Private Collection

[139] *Black Spruce,* 1994
Oil on panel, 36 x 30 inches
William T. Kemper Charitable Trust, UMB
Bank, N.A. and R. Crosby Kemper, Trustees

[140] *Giuliana and the Sunflowers,* 1987
Oil on board, 16 x 20 inches
Brandywine River Museum, Museum
Purchase

[141] *Cat Bates of Monhegan,* 1995
Oil on panel, 36 x 48 inches
Frye Art Museum, Seattle, Washington

[142] *Lighthouse Dandelions,* 1997
Oil on panel, 30 x 48 inches
Private Collection

[144] *Ice Storm, Maine* 1998
Oil on canvas, 40 x 60 inches
Private Collection

[145] *Saltwater Ice,* 1997
Oil on panel, 36 3/$_4$ x 30 1/$_2$ inches
Private Collection

[146] *The Thief,* 1996
Oil on panel, 36 1/$_2$ x 30 1/$_2$ inches
Private Collection

[147] *Feeding Ledge,* 1992
Watercolor on paper, 28 x 20 1/$_2$ inches
Private Collection

[148] *Gull's Egg,* 1988
Oil on panel, 36 x 24 inches
Private Collection

[149] *The Rookery,* 1977
Oil on canvas, 31 x 43 inches
Private Collection

[150] *Wolf Dog,* 1976
Oil on canvas, 30 x 40 inches
Private Collection

[151] *Angeload,* 1979
Oil on canvas, 25 x 25 inches
Courtesy of James Graham and Sons Gallery,
New York

[152] *Brandywine Raceway,* 1989
Oil on panel, 40 x 30 inches
Private Collection

[153] *Portrait of Lady,* 1968
Oil on canvas, 36 x 63 1/$_2$ inches
Private Collection

[154] *The Wanderer,* 1992
Oil on panel, 28 x 48 inches
Private Collection

[155] *If Once You Have Slept on an Island,* 1996
Oil on panel, 30 x 36 inches
Private Collection

[156] *Meteor Shower,* 1993
Oil and essence of pearl on panel, 33 x 48
inches
Collection of Mr. and Mrs. Andrew Wyeth

[158] *Mushroom Picker,* 1963
Oil on canvas, 30 x 49 inches
Collection of Mr. and Mrs. Henry L. Hillman,
Pittsburgh, Pennsylvania

[159] *Scotia Prince,* 1987
Oil on canvas, 24 x 38 inches
Private Collection

[160] *Sophomore at Bowdoin,* 1996
Oil on panel, 48 x 40 inches
Collection of Mr. and Mrs. Michael O'Gorman

[161] *Sea Star,* 1986
Oil on canvas with integral shell frame,
37 x 52 inches
Private Collection

Acknowledgments

This book and the accompanying exhibition are the result of a wonderful collaboration between two American museums whose past and future owe so much to the four artists represented here. The Delaware Art Museum's very existence can be traced to Howard Pyle. His untimely death in 1911 was the catalyst for the establishment of a society whose mission to perpetuate an understanding and appreciation of Pyle's legacy came to full fruition with the opening of the Museum in 1938.

The Farnsworth Art Museum has intimate ties to the Wyeth family. Among its earliest acquisitions for the permanent collection were four watercolors purchased in the early 1940s, several years before the Museum opened to the public in 1948. In addition, the Farnsworth co-organized Andrew Wyeth's first major museum exhibition (with the Currier Gallery of Art, 1951) and presented Jamie Wyeth's first solo show in 1968. N.C.'s paintings were also included in numerous one-person and group shows from the very earliest days of the Farnsworth down to the present.

We extend a special thanks to the many lenders to the exhibition who were willing to part with such cherished treasures. Their permission to reproduce the images found in this publication add immeasurably to a greater public awareness of this unique artistic tradition, and we are indeed grateful.

Details and logistics related to the exhibition and publication are mind-boggling at best, and we give well-deserved recognition to the staff members of our two institutions who have put countless hours into this project to ensure its success. First and foremost, to Dr. Mary F. Holahan, Registrar at the Delaware Art Museum, who kept the project moving forward in the most professional manner. Dr. Holahan's colleagues on staff, Liz Dickinson, Curatorial Assistant; Harriet Memeger, Head Librarian; Karen Colburn, Assistant Librarian; and Bill Gehrman, Director of Marketing, are also commended for their participation in the project. In the same spirit, we recognize the entire staff at the Farnsworth Art Museum, who have aided in the development of this endeavor, especially Edith P. Murphy, Registrar; Lynne M. Taggart, Director of Marketing;

and, of course, Susan C. Larsen, Ph.D., Chief Curator. As always, we are indebted to the Trustees of the Delaware Art Museum and the Farnsworth Art Museum.

Sincere thanks to Mary Landa, Dolly Parker, and Helene Sutton, who have worked diligently on behalf of the Wyeth family, and without whose devotion this project would not have been possible. In addition, we offer our appreciation to Christine Podmaniczky, Registrar at the Brandywine River Museum, for her efforts in securing many of the N. C. Wyeth loans; Robert Lescher, literary agent for the Wyeth family; and Janet Bush, Executive Editor, Bulfinch Press/Little, Brown, and her colleagues Ann Eiselein, Sandra Klimt, Melissa Langen, and David Coen.

Many corporations and their executives within our communities have shown an exemplary commitment to the arts, and we are proud of and thankful for our ongoing relationship with them. In particular, we must recognize the immeasurable support offered by MBNA, whose president and CEO, Charles M. Cawley, has taken an enlightened interest in bringing the exhibition to MBNA's two hometowns and sharing it with the world through this book. The support of Steve Boyden, President of the Board of the Delaware Art Museum, and Shane Flinn of MBNA cannot be overstated.

Finally, we must give enormous thanks to the Wyeth family for initiating this entire undertaking. To Betsy James Wyeth, who, with the encouragement of Ms. Penny Alderson, conceived and gave life to the theme of *Wondrous Strange*, we extend our deepest appreciation and admiration. She has been our guiding light. To work with both Andrew and Jamie Wyeth has been an honor and an experience to remember. Their vision and passion have been an inspiration to everyone involved, and we are eternally grateful.

Stephen T. Bruni Christopher Crosman
Director Director
Delaware Art Museum Farnsworth Art Museum